THE GRAPHIC WORKS OF

ODILON REDON

209 Lithographs, Etchings and Engravings

WITH AN INTRODUCTION BY
ALFRED WERNER

———————

DOVER PUBLICATIONS, INC., NEW YORK

Published in Canada by General Publishing Company, Ltd.,
30 Lesmill Road, Don Mills, Toronto, Ontario.

Published in the United Kingdom by Constable and Company, Ltd.,
10 Orange Street, London WC 2.

This Dover edition, first published in 1969, contains reproductions of (1) all the plates in the two portfolios (Plates 1–100 and 101–192) originally published by Artz & De Bois, The Hague, n.d. [1913], with the title *Odilon Redon: œuvre graphique complet*; (2) all the other graphic works of Redon for which illustrations could be located (among this group, Plates 28, 135, 177, 178, 180–190 and 198 are reproduced by courtesy of the Art Institute of Chicago, to the staff of which the publisher is particularly grateful).

The present volume also includes a new introduction by Alfred Werner, written specially for this edition, and a list of plates. The French titles of the prints have been newly translated by Mr. Werner and the editorial staff of Dover Publications.

Standard Book Number: 486–21996–8
Library of Congress Catalog Card Number: 68–14351

Manufactured in the United States of America

DOVER PUBLICATIONS, INC.
180 Varick Street
New York, N.Y. 10014

INTRODUCTION TO THE DOVER EDITION

THE world into which Odilon Redon* was born, on April 20, 1840, was the large city of Bordeaux in southwestern France. He narrowly missed having New Orleans for his birthplace, and thus being an American. His French father had emigrated to the United States, amassed a fortune in Louisiana and married a Creole woman. Odilon's older brother, Ernest, was born in New Orleans. But when Madame Redon became pregnant again, the family moved to France. All this explains the question posed by Redon's first biographer, André Mellerio: "Who knows if the artist who illustrated Edgar Poe may not some day be claimed by the Americans as a little their own?"

This charming exaggeration notwithstanding, Redon is, of course, a French artist. But for more than half a century Americans have had considerable interest in his work, sparked by his participation in the controversial Armory Show of 1913, in which he got the lion's share of space, and by the comprehensive Museum of Modern Art exhibition in 1961 which he shared with his older colleagues, Rodolphe Bresdin and Gustave Moreau, anti-Realist *grands isolés* like himself. His work has been eagerly collected by Americans, and it can be found in museums in New York, Philadelphia, Baltimore, Chicago and other American cities.

Yet, despite excellent monographs in English, by Klaus Berger and John Rewald, few of his admirers here seem to know more about the man than his name. It is true that neither these two authors nor Mellerio (who had known him personally and quite intimately) provide grist for a Hollywood movie like *Lust for Life* or *Moulin Rouge*. Indeed, this clairvoyant was one of the least erratic of the great French artists in the last century. He did not startle the habitués of a boulevard café by appearing, like the etcher Charles Méryon, with a cortège of peacocks, nor did he indulge in "lost weekends," as did so many of his colleagues. Gentle and conventionally dressed, he did not outrage the bourgeois with his behavior, as did Gauguin, Van Gogh and Toulouse-Lautrec. His work, especially his mind-haunting and often macabre prints, might lead one to believe that their creator must have lived in a sort of delirium, occupying himself with occultism and black magic, that he must have been, in some respects at least, the equivalent of Des Esseintes, the decadent hero of Huysmans' sensational

* Christened Bertrand-Jean, Redon was nicknamed Odilon after his mother's Christian name, Marie-Odile.

V

novel *A Rebours*, who, residing all alone in an isolated villa (decorated, according to the tale, with black and white works by Redon!), indulged in a variety of strange, if exquisite, narcissistic pleasures.

The unvarnished truth is that, however complex and startling his fantasy life must have been—to judge by his creations—his external life was utterly simple and uneventful. Much of his boyhood was spent in a sixteenth-century manor house on an estate near Bordeaux that belonged to the family. Peyrelebade was located in a grim, colorless landscape. "The ocean, which used to cover these desert spaces," Redon was to write many years later, "has left a breath of abandonment, of disjunction, in the aridity of their sands. Now and again, a clump of pine trees reverberates a rustling of sadness. . . ."

Precocious little Odilon, frail, sensitive, introspective, devoted his hours to watching the cloud formations pass overhead, listening to peasants' tales or to Ernest playing Beethoven or Bach. He studied painting but, to please his father, turned to architecture. He was not successful in this, nor in his brief excursion into sculpture. Redon *père* finally allowed him to follow the dictates of his heart and go to Paris, but insisted that he enroll at the Ecole des Beaux-Arts. Alas, the dry, sterile teaching of Léon Gérôme did not suit the nature of Redon, who had a disdain for academic proficiency. The master did not appreciate the student's special gifts—and Redon's formal studies came to an abrupt end.

Redon profited far more from contacts with men who stood outside Academe. One was Camille Corot, who, though a Realist, dared to paint putti and nymphs, as Redon was to note. But Corot, who was most encouraging, was forty-four years Redon's senior and a celebrity, and little more than a father image to the beginner (who so sadly lacked parental affection). Much closer was his relationship with Rodolphe Bresdin, who, despite his gifts, barely managed to eke out a wretched existence for his large family at the time the two met. The bohemian Bresdin had a beneficial influence on Redon by teaching him the technique of print making. Bresdin acquainted the young man with Dürer as well as with Rembrandt (who became Redon's favorite). One of Redon's first etchings, dated 1865, is signed with the grateful acknowledgment, "pupil of Bresdin." Forty-odd years later, Redon, as a famous old gentleman, writing the preface for a catalogue of a Bresdin memorial show, was to refer to his late master, to whom he still felt a great kinship, in terms that might be applied to himself as well: "His power was solely in imagination. He never conceived anything in advance. He improvised with joy, steadfastly completing the intertwinings of the difficultly distinguishable vegetation in his dream forests."

The great hour struck for Redon when he met Camille Falte, a young Creole woman born on a French island near Madagascar. They married on May 1, 1880. Redon was then forty. Behind him were the shattering experiences of his brief

service as a soldier in the Franco-Prussian War (it was, nonetheless, the drama and tragedy of what he saw and felt there that acted as a catalyst on his still young and undecided mind, that turned him into the Redon we know and admire). His father was dead, and he no longer derived an income from the family estate. He had just begun the artistic ventures which were to make his name widely known, but his first lithographic sequence, *Dans le Rêve* (In the Dream), received little notice and found few buyers.

Camille Redon gave birth to two sons, of whom one, Arï, is still alive, and much engaged, in a self-effacing manner, in administering his father's artistic legacy and helping those who seek information on Redon. Camille seems to have been an ideal wife for her shy, unworldly husband, for she was not only affectionate and had a deep understanding for his work, but she also created around him an atmosphere of serenity, releasing him from the many pressures of daily life. She conducted all business transactions with dealers and printers and solved the pecuniary problems, which must have been enormous. It seems that, save for the last ten or twelve years of his life, Redon was never well off financially. The artist was fifty-eight when he had to write to his mother that he was unable to support her: "I possess nothing. There are only a few francs in my wallet."

Of medium height and thin, Redon had an oblong face with a pointed reddish brown beard. His color was pale, his expression calm. His speech was slow, yet his words were well chosen. Just as he was a loyal husband and an affectionate father, so he was on the most cordial terms with a few men, chiefly poets, musicians and others not practicing his own art. The botanist Armand Clavaud acquainted him with Hindu poetry and the philosophy of Spinoza, lent him books by Flaubert, Poe and Baudelaire—all authors still dangerous at the time—and let him look through the microscope into a miraculous world that may have offered stimuli to his untrammeled imagination. Important, too, was Redon's friendship with the now forgotten critic Emile Hennequin, and with Joris-Karl Huysmans, whose novels are still widely appreciated. At a time when the public, if it came to Redon's exhibitions at all, angrily scoffed at the unusual charcoal drawings they saw on the walls, Hennequin wrote, astutely and brilliantly:

> He has managed to conquer a lonely region somewhere on the frontier between the real and the imaginary, populating it with frightful ghosts, monsters, monads, composite creatures made of every imaginable human perversity and animal baseness, and of all sorts of terrifying inert and baneful things. . . . His work is bizarre; it attains the grandiose, the delicate, the subtle, the perverse, the seraphic.

As for Huysmans, he called attention to Redon in a few lines appended to his review of the official Salon: "There is the nightmare transported into art. . . ."

He praised "the bizarre talent of this singular artist." Far more important for Redon was the lengthy reference in Huysmans' novel, *A Rebours*. When this story of a dandy and aesthete appeared in 1884, it "fell like a meteorite into the literary fairground," as its author was to recall. Since it was mainly through *A Rebours* that the public at large learned of the very existence of Redon, then already forty-four, and since the passages superbly characterize his macabre and elusive inner visions, they deserve quotation in full:

> . . . they [Redon's drawings, done with charcoal or lithographic crayon] contained productions of an inconceivable eccentricity,—a head in a Merovingian style, placed upon a cup; a bearded man, having something about him recalling at one and the same time a Buddhist priest and an orator at a public meeting, touching with the tip of his finger a colossal cannon-ball; a horrible spider, with a human face lodged in the middle of its body. Then there were crayons that went further yet in the horrors of a nightmare dream. Here it was an enormous die that winked a mournful eye; there, a series of landscapes,—barren, parched, burnt-up plains, riven by earthquakes, rising in volcanic heights wreathed with wild clouds under a livid, stagnant sky. Sometimes even the subjects seemed to be borrowed from the dreams of science, to go back to prehistoric times; a monstrous flora spread over the rocks; everywhere were erratic blocks, glacial mud streams, and amongst them human beings whose ape-like type,—the heavy jaws, the projecting arches of the brows, the receding forehead, the flattened top of the skull, recalled the ancestral head, the head of the earliest quaternary period, when man was still a fruit-eater and speechless, a contemporary of the mammoth, the woolly-haired rhinoceros and the giant bear. These drawings passed all bounds, transgressing in a thousand ways the established laws of pictorial art, utterly fantastic and revolutionary, the work of a mad and morbid genius.
>
> In fact, there were some of these faces, staring out with great, wild, insane eyes, some of these shapes exaggerated out of all measure or distorted as if seen refracted through water, that evoked in Des Esseintes' memory recollections of typhoid fever, remembrances that had stuck persistently in his head of hot nights of misery and horrid childish nightmares.

It was Huysmans who introduced the artist to Stéphane Mallarmé, leader of the Symbolists, and Redon often participated in the famous *mardis*, the Tuesday receptions given by the poet for the leading figures of the Parisian art world of the 1880's (the most contrasting personalities there were Paul Gauguin, noisy and garrulous, and the withdrawn and retiring Odilon Redon).

Though thousands now knew Redon's name from the best-selling novel, there was little change in the public's attitude to his work; it still ranged from apathy to hostility. The sequences of lithographs he produced between 1879 and 1899 were far from successful. He did not have a large one-man show before he was fifty-four. In the very year of that show, 1894, Gauguin—who rarely spoke about a colleague charitably—referred to Redon as "this extraordinary artist whom people stubbornly refuse to understand." Redon did, however, find a small consolation in the fact that some of the young progressive artists, tired of the Naturalism of which Impressionism was only the most refined fruit, were beginning to admire him. To them he represented Symbolism in the visual arts as Mallarmé stood for Symbolism in literature (although Redon did not cherish the idea of being put into a category). A painter of the "Nabi" group, Maurice Denis, enthusiastically wrote that Redon produced nothing that did not represent a state of soul, express some profound emotion or translate some interior vision. When Denis painted his large *Hommage à Cézanne*, shown at the Salon of 1901, Redon was among the artists and men of the art world portrayed around a still life by Cézanne. He is deliberately placed somewhat apart from the others, who include the painters Pierre Bonnard and Edouard Vuillard, as well as Denis himself, but also André Mellerio and the dealer Ambroise Vollard, whose client Redon had become. Thus, the picture can be read as being not only an homage to Cézanne, but also a gesture of respect for Redon.

Honors came to Redon only after he had turned sixty. In 1903 he received the rosette of the Légion d'Honneur. In the next year the Salon d'Automne at its first annual show devoted an entire room to him. In 1905 he could afford to move his family into a better apartment on the more elegant Avenue de Wagram. His financial worries were over, since the oils and pastels he now produced instead of the earlier black chalk drawings and lithographs fetched high prices, thanks largely to the efforts of Vollard and another important dealer, Paul Durand-Ruel. Redon's work was seen abroad: in Holland, England, Germany, Russia and the United States.

In *Odilon Redon: Peintre, Dessinateur et Graveur* (1923), Mellerio—who earlier had compiled the print catalogue *Odilon Redon* (1913)—remembered him as a healthy and happy old man, treated by everyone with respect and affection. Another admirer, the critic Claude Roger-Marx, was surprised to find, instead of a magician or sorcerer, "a little smiling old man . . . shyly doing the honors of the modest sitting room which served as his studio." He went on to write: "The sober light of Paris came in at the fifth floor window and caressed in all simplicity the most bourgeois furniture imaginable. Poppies, larkspur and daisies in an earthenware vase." Unfortunately, when World War I broke out, Redon's only son, Arï, was drafted. In 1916, news from the soldier Arï was too long delayed,

and the septuagenarian journeyed in bad weather to the house of a friend who he thought might have indirect word. A chill developed, and Redon passed away, on July 6.

An appreciation of Redon's glorious oils, watercolors and pastels would demand more space than we have here. We must confine ourselves to his lithographic work, comprising 172 items, all of which are reproduced in this volume,* chiefly in chronological order (28 etchings and engravings and 9 drawings mechanically reproduced are added). Lithography, or "stone printing," had been discovered accidentally by the German Senefelder at the close of the eighteenth century, decades before Redon began to experiment with the medium. The first major artist to explore it was the aged Goya, who, self-exiled in Redon's birthplace, Bordeaux, produced several exquisite lithographs of bullfights. Subsequently, Géricault and Delacroix made lithographs of great strength. An eminent master in this field was Daumier.

Lithography declined about the middle of the nineteenth century, when it was chiefly used for commercial purposes. But it gained a new lease on life when it was used by men of genius somewhat older than Redon, such as Pissarro, Manet and Degas. Redon at first did not look on lithography as a medium with its own intrinsic aesthetic possibilities, but resorted to it as a means of reproducing his charcoal drawings. He soon discovered it had qualities and laws of its own and that, far from being the insipid handmaiden of unimaginative, dry and cold illustrators, it was an art which obeyed "the subtlest breath of sensitivity."

Only twice did he try color lithography, then in its heyday in France. He felt that color "cheapened" the essential character of the medium. In his *Journals* and in his letters are many references to this art form, of which one will serve as example:

Black is the most essential of all colors. Above all, if I may say so, it draws its excitement and vitality from deep and secret sources of health. . . . One must admire black. Nothing can debauch it. It does not please the eye and awakens no sensuality. It is an agent of the spirit far more than the fine color of the palette or the prism. Thus a good lithograph is more likely to be appreciated in a serious country, where inclement nature compels man to remain confined to his home, cultivating his own thoughts, that is to say in the countries of the north rather than those of the south, where the sun draws us outside ourselves and delights us. Lithography enjoys little esteem in France, except when it has been cheapened by the addition of color, which produces a different result,

* A reproduction of portfolios published in The Hague in 1913 in an edition of 300 sets.

destroying its specific qualities so that it comes to resemble a cheap colored print. . . .

As a young man, Redon had been taught this technique by Bresdin. He returned to it in 1879. In the course of two decades, his work in this medium grew finer and bolder, the blacks richer and deeper, the whites more and more luminous. His *noirs* (drawings and lithographs) have had many admirers. Degas, for one, while admitting that he often did not quite understand what Redon wished to say, nevertheless exclaimed: "But his blacks! oh! his blacks . . . impossible to pull any of equal beauty." A critic once asked Vollard, who had published the album *L'Apocalypse de Saint-Jean,* where "that devil of a Redon" had gotten those blacks. The artist, who had an impish sense of humor, urged Vollard to tell this puzzled man that he had obtained them through eating beefsteak and drinking good wine. In our own day, Harold Joachim, Curator of the Print Room of the Art Institute of Chicago (which owns the most complete collection of prints by Redon anywhere in the United States, a collection purchased from the artist's widow in 1920) has written that in the *Apocalypse* Redon achieved a wider range of contrasts than ever before: "Some plates are conceived in terms of deep, sonorous blacks, others are done in purest outlines and still others in delicate gradations of grey." Joachim sums up: "If nothing remained of Redon's work except the lithographs, his whole range of thought and emotion, the mysterious and visionary strength and delicacy of his art would still be clearly evident" ("Notes on Redon's Prints," in the catalogue of the Redon-Moreau-Bresdin show, Museum of Modern Art, New York, 1961).

Particularly evident is Redon's ability, unexcelled by any of his contemporaries, to explore the most fantastic reaches of a boundless imagination, but with the aid of an eye that had long trained itself to study nature with great exactitude. This "Prince of Shadows" appears as a great liberator who—as his friend Gauguin had done in painting—demonstrated that plain Realism did not offer the ultimate solution, and that there was a world beneath and beyond that of everyday vision. Baudelaire, whom Redon greatly admired, had spoken of a good picture as "a faithful equivalent of the dream which had begotten it," and had defined art as "the creation of an evocative magic." The poet had little sympathy for Courbet, arch-exponent of *réalisme,* who had once challengingly declared that he would paint an angel only if he were shown one. Redon, in an essay, criticized the Impressionist school largely because its adherents were too submissive before nature, because they wanted man to be obliterated at the expense of the model that must shine; in short, because they had "too low a ceiling" for him. Indeed, in the last analysis the Impressionists were the final heirs of the Renaissance tradition which conceived art as a faithful copy of the external appearance of things. In

contradiction to this Redon pleaded for "a right that has been lost and which we must reconquer: the right to fantasy. . . ." (Nevertheless, he was to participate in an Impressionist group show, the last one, in 1886.)

Anticipating to a degree what, in the twentieth century, Paul Klee, Marc Chagall and the Surrealists endeavored to accomplish, Redon expressed his aims with his usual literary finesse when he asserted that he wished to place "the logic of the visible in the service of the invisible." Like Hamlet, he knew of a world that most of his fellow men do not care or dare to envision, and his art helped him to conquer his obsessions, or at least to tame them by giving them definite shapes. He did not hesitate to enter the world of dreams, and made the most of his gift by looking far beyond trivial reality. As he put it in a pivotal statement:

> I suffered the torments of imagination and the surprises which it presen-
> ted to me under the pencil; but I guided and controlled these surprises
> according to the laws of artistic organization which I know, which I feel,
> with the sole purpose that they should exercise upon the spectator,
> through a process of attraction, all the evocative power, all the charm of
> the vague that lies at the extreme limits of thought.

It is therefore not surprising that Redon has been claimed as a precursor by the Surrealists of our age, who have asserted that "nothing but the astonishing" is beautiful, and who have described their pictures as "hand-painted dream photographs."

Art lovers, looking at Redon's enigmatic prints, will do well to surrender without mental reservations to what he called the "charm of the vague," as they would to chords of music, rather than search for a meaning, a "message" in the pedestrian sense of the term. A good many of his drawings and prints are inspired by literature—Poe, Flaubert, Baudelaire, Verhaeren and the anonymous author of the Revelation of Saint John the Divine, and also by *belles-lettres* of contemporaries who are now completely forgotten. Yet in no case are these mere translations from one medium into another, from the word to the print. Instead, we have here, to use the artist's own term, *correspondances*. A word or a phrase dropped into his mind has started a train of images which have a life of their own, with only the most tenuous connection with the tale, dramatic scene or poem the title refers to. Indeed, many of the titles are the artist's own, and even those for the series *A Edgar Poë* were actually worded by Redon in what he considered to be Poe's manner.

Except in the etching of Cain slaying Abel, violent dramatic action is lacking in this collection. There are no masses of people, there is no clutter of things. There is usually one figure, or one object. There are eight delicate portraits, all done after 1900, when the artist became preoccupied with painting, almost to the exclusion

of everything else. More faces appear—of the suffering Christ, of sad, even depressed, nameless men or women. Winged creatures abound—decades before Chagall was to give us his renderings of flying beggars and flying animals of all kinds. There are spiders and serpents, skulls and skeletons. The frequently occurring monsters are drawn with a conviction which makes them appear so plausible that, having once viewed them, we would not be surprised to encounter one as we turn a corner. The great scientist Louis Pasteur paid Redon this compliment: "Your monsters have life in them!" The surprising thing is that Redon managed to reach these hitherto unknown shores of vision without resorting to drugs, without any extraordinary cerebral efforts—solely, as he put it, by submitting to "the uprush of the unconscious."

The most widely reproduced of these prints is, in all likelihood, the first plate from the sequence *A Edgar Poë*. It is entitled "The eye, like a strange balloon, moves toward Infinity." Is there an explanation for the sphere, shaped like an eye, which rises into the sky, or for the human head on a tray, lifted upward by this strange balloon? There is none. But there is mystery, anguish, delirium, fright. Redon exorcised them, bringing them up from the abyss of the unconscious mind, to make us look at a world which exists, but which we rarely dare to face. Sigmund Freud, whose *Theory of Dreams* was published in the same year that Redon's *Apocalypse* was issued, once wrote that the artist in general is a man who has turned away from reality because he cannot make peace with it. Freud added: "He finds, however, the way back to reality; thanks to special talents, he molds his phantasies into new kinds of realities, which are accepted by people as valuable likenesses of reality."

It is quite possible that, had Redon not found release in his work, he might have gone mad. Yet his delirium, his fever, was broken by the creation of grotesques as startling as some of the pictures by Bosch, Goya, Fuseli or Blake. Art enabled him to channel the demoniacal forces from the depths of his self into well-integrated, well-designed images that, despite their astounding aspects, console and comfort with an amazingly soothing lucidity.

Since prints—unlike paintings, which remain on museum walls—are usually kept locked up in the graphics departments of public collections, and are shown only upon special application under circumstances not conducive to the long, intense contemplation which they would require, it is a pleasure to be able to enjoy Redon's major works through these convenient reproductions. (Redon's prints, incidentally, are now very rare, and some command as much as $2,000.) They want more than a fleeting glance. One must return to these symbols and metaphors time and again, as one comes back to old legends, myths, religious lore. For they are timeless, bound to no civilization, no era. Like the eye in the first plate of the series inspired by Poe, they move toward Infinity. From a drab reality in metro-

politan Paris, Redon managed to soar into a chiaroscuro universe on the wings of that very imagination, his "guardian angel," which tortured him, but also set him free.

ALFRED WERNER

New York City
January 1969

LIST OF PLATES

The 1913 catalogue of Redon's graphics by André Mellerio, along with its 1923 supplement, has been used here as the standard source for the titles of the prints and the size of the editions. Thus, any impressions of Redon's prints pulled later than 1923 are not taken into account. A few indications concerning engravings unknown to Mellerio are based on the 1961 catalogue of the Museum of Modern Art (N.Y.)/Art Institute of Chicago exhibition of works by Redon, Moreau and Bresdin. Throughout the list, dimensions are given in millimeters (100 mm = 3.937 inches), height before width. The "M" numbers (M.26, M.27, etc.) are the catalogue numbers of the works assigned by Mellerio.

LITHOGRAPHS

1–11 *Dans le Rêve* (In the Dream); 1879; album of 10 plates and cover; edition of 25 sets

 1 Cover; 302 × 223; M.26
 2 No. 1: Blossoming (*Eclosion*); 328 × 257; M.27
 3 No. 2: Germination (*Germination*); 273 × 194; M.28
 4 No. 3: The Wheel (*La Roue*); 232 × 196; M.29
 5 No. 4: Limbo (*Limbes*); 307 × 223; M.30
 6 No. 5: The Gambler (*Le Joueur*); 270 × 193; M.31
 7 No. 6: Gnome (*Gnome*); 272 × 220; M.32
 8 No. 7: Feline Scene (*Félinerie*) OR Mephisto (*Méphisto*); 268 × 203; M.33
 9 No. 8: Vision (*Vision*); 274 × 198; M.34
 10 No. 9: Sad Ascent (*Triste montée*); 267 × 200; M.35
 11 No. 10: On the Dish (*Sur la coupe*); 244 × 160; M.36

12–18 *A Edgar Poë* (To Edgar Allan Poe); 1882; album of 6 plates and inside front cover illustration; edition of 50 sets

 12 Inside front cover; 165 × 115; M.37
 13 No. 1: The eye, like a strange balloon, moves toward Infinity (*L'œil, comme un ballon bizarre se dirige vers l'Infini*); 262 × 198; M.38
 14 No. 2: Before the black sun of Melancholy, Lenore appears (*Devant le noir soleil de la Mélancolie, Lénor apparaît*); 168 × 127; M.39
 15 No. 3: A mask sounds the funeral knell (*Un masque sonne le glas funèbre*); 158 × 192; M.40

32 No. 4: There were also embryonic beings (*Il y eut aussi des êtres embryon-naires*); 238 × 197; M.57

33 No. 5: A Strange Juggler (*Un étrange jongleur*); 199 × 190; M.58

34 No. 6: Upon awakening I saw the Goddess of the Intelligible with her severe and hard profile (*Au réveil j'aperçus la Déesse de l'Intelligible au profil sévère et dur*); 276 × 217; M.59

35 The Egg (*L'Œuf*); 1885; trial proof, not published; 290 × 225; M.60

36 Profile of Light (*Profil de lumière*); 1886; edition of 50 copies; 340 × 242; M.61

37–42 *La Nuit* (The Night); 1886; album of 6 plates; edition of 50 sets

37 No. 1: To Old Age (*A la Vieillesse*); 245 × 183; M.62

38 No. 2: The man was alone in a night landscape (*L'homme fut solitaire dans un paysage de nuit*); 293 × 220; M.63

39 No. 3: The lost angel then opened black wings (*L'ange perdu ouvrit alors des ailes noires*); 258 × 215; M.64

40 No. 4: The chimera gazed at all things with fear (*La chimère regarda avec effroi toutes choses*); 250 × 185; M.65

41 No. 5: The priestesses were waiting (*Les prêtresses furent en attente*); 287 × 212; M.66

42 No. 6: And the searcher was engaged in an infinite search (*Et le chercheur était à la recherche infinie*); 276 × 181; M.67

43 Brünnhilde (*Brunnhilde*); published in the *Revue wagnérienne* of August 8, 1886; edition of 300 copies; 118 × 100; M.68

44 Dark Peak (*Cime noire*); published in the *Revue indépendante* of April 1887; edition of 500 copies; 170 × 90; M.69

45 Girl (*Jeune fille*); 1887; edition of 25 copies; 300 × 224; M.70

46 Christ (*Christ*); 1887; edition of 25 copies; 330 × 270; M.71

47 Spider (*Araignée*); 1887; edition of 25 copies; 260 × 215; M.72

48 Menu of a dinner for French lithographers, April 1, 1887; about 50 copies were distributed; 50 × 118; M.73

49 The Idol (*L'Idole*); 1887; frontispiece for *Les Soirs* (The Evenings) by Emile Verhaeren; in 56 copies of the book; 162 × 94; M.74

50–56 Illustrations for *Le Juré* (The Juror) by Edmond Picard; 1887; edition of 100 copies in the book and 20 copies separately*

 * The order of illustrations for *Le Juré* given in this List of Plates (and adopted in the plate section of this volume) is that of the complete book publication. When Redon's lithographs were issued in a separate album (also in 1887), their order (using

the plate numbers given above) was 52, 54, 53, 50, 55, 51, 56, and their captions (in the order last given) read:

A man of the people, a savage (*Un homme du peuple, un sauvage*)

In the maze of branches the pale figure appeared (*Dans le dédale des branches la blême figure apparaissait*)

A bell was sounding in the tower (*Une cloche battait dans la tour*)

Through the crack in the wall a death's-head was projected (*Par la fente du mur, une tête de mort fut projetée*)

Is there not an invisible world (*N'y a-t-il pas un monde invisible*)

Dramatic and grandiose with her face like that of a Druid priestess (*Dramatique et grandiose avec sa figure de prêtresse druidique*)

The dream ends in death (*Le rêve s'achève par la mort*)

d'eau, ensuite une prostituée, le coin d'un temple, une figure de soldat, un char avec deux chevaux blancs qui se cabrent); 291 × 208; M.84

60 No. 2: It is the devil, bearing beneath his two wings the seven deadly sins (*C'est le diable, portant sous ses deux ailes les sept péchés capitaux*); 254 × 200; M.85

61 No. 3: And a large bird, descending from the sky, hurls itself against the topmost point of her hair (*Et un grand oiseau qui descend du ciel vient s'abattre sur le sommet de sa chevelure*); 190 × 160; M.86

62 No. 4: He raises the bronze urn (*Il hausse le vase d'airain*); 274 × 196; M.87

63 No. 5: Then there appears a singular being, having the head of a man on the body of a fish (*Ensuite paraît un être singulier, ayant une tête d'homme sur un corps de poisson*); 275 × 170; M.88

64 No. 6: It is a skull wreathed with roses. It dominates a woman's torso of pearly whiteness (*C'est une tête de mort, avec une couronne de roses. Elle domine un torse de femme d'une blancheur nacrée*); 296 × 213; M.89

65 No. 7: The chimera with green eyes turns, bays (*La chimère aux yeux verts tournoie, aboie*); 275 × 160; M.90

66 No. 8: And all manner of frightful creatures arise (*Et toutes sortes de bêtes effroyables surgissent*); 312 × 224; M.91

67 No. 9: Everywhere eyeballs are aflame (*Partout des prunelles flamboient*); 204 × 158; M.92

68 No. 10: And in the very disk of the sun shines the face of Jesus Christ (*Et dans le disque même du soleil rayonne la face de Jésus-Christ*); 282 × 230; M.93

69–75 *A Gustave Flaubert* (To Gustave Flaubert; 2nd series of *The Temptation of Saint Anthony*); 1889; album of 6 plates and title plate; edition of 60 sets

69 Title plate; 258 × 203; M.94

70 No. 1: Saint Anthony: "Beneath her long hair, which covered her face, I thought I recognized Ammonaria" (*Saint-Antoine: . . . A travers ses longs cheveux qui lui couvraient la figure, j'ai cru reconnaître Ammonaria*); 287 × 232; M.95

71 No. 2: A long chrysalis, the color of blood (*Une longue chrysalide couleur de sang*); 220 × 185; M.96

72 No. 3: Death: "My irony surpasses all others!" (*La Mort: Mon ironie dépasse toutes les autres!*); 262 × 197; M.97

73 No. 4: Saint Anthony: "Somewhere there must be primordial shapes whose bodies are only images" (*Saint-Antoine: Il doit y avoir quelque part des figures primordiales dont les corps ne sont que les images*); 170 × 124; M.98

74 No. 5: The Sphinx: "My gaze, which nothing can deflect, passes through the things and remains fixed on an inaccessible horizon." The Chimera: "*I* am weightless and joyful" (*Le Sphynx: . . . Mon regard que rien ne peut*

dévier, demeure tendu à travers les choses sur un horizon inaccessible. La Chimère: Moi, je suis légère et joyeuse); 282 × 202; M.99

75 The Skiapods: "The head as low as possible, that is the secret of happiness!" (*Les Sciapodes: La tête le plus bas possible, c'est le secret du bonheur!*); 277 × 210; M.100

76 Frontispiece for *Les Débâcles* by Emile Verhaeren; 1889; in 52 copies of the book; 142 × 97; M.101*

77 Frontispiece for *El Moghreb al Aksa* by Edmond Picard; 1889; edition of 205 copies; 243 × 185; M.103

78 Frontispiece for *La Damnation de l'artiste* (The Damnation of the Artist) by Iwan Gilkin; 1889; edition of 152 copies; 190 × 125; M.104

79 Frontispiece for *Les Chimères* (The Chimeras) by Jules Destrée; 1889; edition of 120 copies; 140 × 97; M.105

80 Captive Pegasus (*Pégase captif*); 1889 (first state); about 25 copies printed (a second state was published some years later in less than 100 copies); 340 × 293; M.102

81 Frontispiece for *Les Flambeaux noirs* (The Black Torches) by Emile Verhaeren; 1890; in 52 copies of the book; 173 × 121; M.106

82 Closed Eyes (*Yeux clos*); 1890; two editions of 50 copies each; 312 × 242; M.107

83 Serpent-Halo (*Serpent-Auréole*); 1890; edition of 50 copies; 302 × 226; M.108

84 Female Saint and Thistle (*Sainte et chardon*); 1891; edition of 50 copies; 285 × 207; M.109

85–90 *Songes* (Dreams); 1891; album of 6 plates; edition of 80 sets

85 No. 1: It was a veil, an imprint (*C'était un voile, une empreinte*); 188 × 133; M.110

86 No. 2: And beyond, the astral idol, the apotheosis (*Et là-bas l'idole astrale, l'apothéose*); 277 × 192; M.111

87 No. 3: Precarious glimmering, a head suspended from infinity (*Lueur précaire, une tête à l'infini suspendue*); 208 × 275; M.112

88 No. 4: Beneath the wing of shadow the black creature was biting energetically (*Sous l'aile d'ombre, l'être noir appliquait une active morsure*); 225 × 172; M.113

89 No. 5: Pilgrim of the sublunary world (*Pèlerin du monde sublunaire*); 275 × 205; M.114

90 No. 6: Day (*Le Jour*); 210 × 158; M.115

* This lithograph illustrates the verses *Mes doigts, touchez mon front et cherchez là / Les vers qui mangeront un jour de leur morsure* . . . (My fingers, touch my brow and seek there / The worms which will one day devour with their bite . . .).

* This lithograph illustrates Flaubert's line *Buddha: On m'a mené dans les écoles. J'en savais plus que les docteurs* (I was entered in the schools. I knew more than the teachers).

It is empty, perhaps!" (*La Vieille: Que crains-tu? Un large trou noir! Il est vide peut-être?*); 162 × 108; M.152

128 No. 20: Death: "It is I who make you serious; let us embrace each other" (*La Mort: C'est moi qui te rends sérieuse; enlaçons-nous*); 303 × 211; M.153

129 No. 21: I have sometimes seen in the sky what seemed like forms of spirits (*J'ai quelquefois aperçu dans le ciel comme des formes d'esprits*); 261 × 182; M.154

130 No. 22: The beasts of the sea, round like leather bottles (*Les bêtes de la mer rondes comme des outres*); 222 × 190; M.155

131 No. 23: Different peoples inhabit the countries of the Ocean (*Des peuples divers habitent les pays de l'Océan*); 310 × 230; M.156

132 No. 24: Day appears at last, . . . and in the very disk of the sun shines the face of Jesus Christ (*Le jour enfin paraît, . . . et dans le disque même du soleil, rayonne le face de Jésus-Christ*); 270 × 263; M.157

133 Old Knight (*Vieux chevalier*); 1896; published by Vollard in the *Album des Peintres-Graveurs*; edition of 100 copies; 298 × 239; M.158

134 Frontispiece for *Le Mouvement idéaliste en peinture* (The Idealistic Movement in Painting) by André Mellerio; 1896; edition of 350 copies; 90 × 80; M.159

135–141 *La Maison hantée*; 1896; illustrations for René Philipon's translation of Edward Bulwer-Lytton's short story *The Haunted and the Haunters; or, The House and the Brain*; album of 6 plates and title plate; edition of 60 sets; the English captions as given here are direct quotations from the original Bulwer-Lytton text

135 Title plate; 320 × 200; M.160

136 No. 1: I continued to gaze on the chair, and fancied I saw on it a pale blue misty outline of a human figure (*Je vis dessus le contour vaporeux d'une forme humaine*); 253 × 181; M.161

137 No. 2: We both saw a large pale light (*Je vis une lueur large et pâle*); 230 × 170; M.162

138 No. 3: He [the narrator's dog] kept his eyes fixed on me with a look so strange (*Il tenait ses yeux fixés sur moi avec une expression si étrange*); 228 × 153; M.163

139 No. 4: It was a hand, seemingly as much of flesh and blood as my own (*Selon toute apparence, c'était une main de chair et de sang comme la mienne*); 245 × 178; M.164

140 No. 5: Larvæ so bloodless and so hideous (*Des larves si hideuses*); 179 × 170; M.165

141 No. 6: The width and flatness of [the] frontal [bone] (*La largeur de l'aplatissement de l'os frontal*); 140 × 90; M.166

142 The Shulamite (*La Sulamite*); 1897; color lithograph; edition of 50 copies; 245 × 190; M.167

143 Beatrice (*Béatrice*); 1897; color lithograph; published by Vollard in the *Album des Peintres-Graveurs*; 335 × 295; M.168

144 Child's Head with Flowers (*Tête d'enfant avec fleurs*); 1897; edition of 50 copies; 251 × 213; M.169

145 Arï [the artist's son]; 1898; total number printed 22 or 23; 208 × 125; M.170

146 Man on Pegasus (*Homme sur Pégase*) OR The Poet and Pegasus (*Le Poète et le Pégase*); 1898; 10 copies printed not for sale; 137 × 93; M.171

147 Sleep (*Le Sommeil*); offered as a bonus by *L'Estampe et l'Affiche* in its issue of February 15, 1898; edition of 510 copies; 130 × 125; M.172

148–160 *Apocalypse de Saint-Jean* (The Revelation of St. John the Divine); 1899; album of 12 plates and cover, published by Vollard; edition of 100 sets; the English captions as given here are from the King James Version of the Bible

148 Cover; 202 × 233; M.173

149 No. 1: And he had in his right hand seven stars; and out of his mouth went a sharp two-edged sword (*Et il avait dans sa main droite sept étoiles, et de sa bouche sortait une épée aiguë à deux tranchants*); 292 × 209; M.174

150 No. 2: And I saw in the right hand of him that sat on the throne a book written within and on the backside, sealed with seven seals (*Puis je vis, dans la main droite de celui qui était assis sur le trône, un livre écrit dedans et dehors, scellé de sept sceaux*); 322 × 243; M.175

151 No. 3: And his name that sat on him was Death (*Et celui qui était monté dessus se nommait la Mort*); 310 × 225; M.176

152 No. 4: And the angel took the censer (*Puis l'ange prit l'encensoir*); 310 × 215; M.177

153 No. 5: And there fell a great star from heaven, burning as it were a lamp (*Et il tombe du ciel une grande étoile ardente*); 303 × 233; M.178

154 No. 6: A woman clothed with the sun (*Une femme revêtue du soleil*); 230 × 286; M.179

155 No. 7: And another angel came out of the temple which is in heaven, and he also having a sharp sickle (*Et un autre ange sortit du temple qui est au ciel, ayant lui aussi une faucille tranchante*); 313 × 212; M.180

156 No. 8: And I saw an angel come down from heaven, having the key of the bottomless pit and a great chain in his hand (*Après cela je vis descendre du ciel un ange qui avait la clef de l'abîme, et une grande chaîne en sa main*); 304 × 232; M.181

157 No. 9: And bound him a thousand years (*Et le lia pour mille ans*); 298 × 210; M.182

158 No. 10: And the devil that deceived them was cast into the lake of fire and brimstone, where the beast and the false prophet are (*Et le diable qui les*

séduisait, fut jeté dans l'étang de feu et de soufre, où est la bête et le faux prophète); 274 × 238; M.183

159 No. 11: And I John saw the holy city, new Jerusalem, coming down from God out of heaven (*Et moi, Jean, je vis la sainte cité, la nouvelle Jérusalem, qui descendait du ciel, d'auprès de Dieu*); 300 × 237; M.184

160 No. 12: And I John saw these things, and heard them (*C'est moi, Jean, qui ai vu et qui ai ouï ces choses*); 158 × 190; M.185

161 Head of Woman with Corsage of Flowers (*Tête de femme avec fleurs au corsage*); 1900; only 4 proofs extant; 225 × 195; M.189

162 Untitled trial lithograph: 1900; 120 × 70; M.187

163 Untitled trial lithograph; 1900; 260 × 240; M.188

164 Untitled trial lithograph; 1900; 300 × 240; M.186

165 Portrait of the "Nabi" painter Edouard Vuillard (1868–1940); 1900; edition of 12 copies; 200 × 152; M.190

166 Portrait of the painter Pierre Bonnard (1867–1947); 1902; edition of 12 copies; 145 × 123; M.191

167 Portrait of the "Nabi" painter Paul Sérusier (1865–1927); 1903; edition of 12 copies; 160 × 135; M.192

168 Portrait of the painter Maurice Denis (1870–1943); 1903; edition of 25 copies; 153 × 135; M.193

169 Portrait of the pianist Ricardo Viñes (1875–1943); 1903; edition of 25 copies; 135 × 114; M.194

170 Portrait of Juliette Dodu (1850–1909), heroine of the Franco-Prussian War and half-sister of Redon's wife; 1904; edition of 40 copies; 146 × 90; M.195

171 Portrait of the art critic Roger Marx (1859–1913), father of the present-day critic Claude Roger-Marx (born 1888); 1904; edition of 20 copies; 250 × 145; M.196

172 Portrait of the guitarist Miguel Llobet (1875–1938); 1908; edition of 15 copies; 95 × 95; M.197

ETCHINGS AND ENGRAVINGS

173 The Ford, with Small Horsemen (*Le Gué, avec petits cavaliers*); etching; 1865; 15 or 20 copies printed, plate lost; 135 × 180; M.2

174 Fear (*La Peur*); etching; 1865; edition of 30 copies; 112 × 200; M.6

175 Battle (*Bataille*); etching; 1865; edition of 25 copies; 58 × 132; M.5

176 The Two Small Horsemen (*Les deux petits cavaliers*) OR Combat of Horsemen (*Lutte de cavaliers*); etching; 1865; small printing; 100 × 80; M.3

177 Combat of Horsemen (*Lutte de cavaliers*); etching; 1865; edition of 30 copies; 83 × 180; M.4

178 Two Trees; etching; 1865; not in Mellerio

179 Chapel in the Pyrenees (*Chapelle des Pyrénées*); etching; 1866; unique proof, plate lost; 60 × 140; M.1

180 Horseman Waiting (*Cavalier dans l'attente*); etching; 1866; trial run of 3 proofs; 85 × 110; M.7

181 Horseman in the Mountains (*Cavalier dans les montagnes*); etching; 1866; trial run of 3 proofs; 85 × 113; M.8

182 Horseman under a Stormy Sky (*Cavalier sous un ciel d'orage*); etching; 1866; trial run of 3 proofs; 56 × 140; M.9

183 Horseman Galloping (*Cavalier galopant*); etching; c. 1866; trial run of 3 proofs; 65 × 135; M.10

184 Apparition OR Female Nude; etching and drypoint; reworking of Plate 182; not in Mellerio

185 Mountainous Landscape (*Paysage de montagnes*); etching; c. 1866; trial run of 3 proofs; 40 × 105; M.11

186 Saint-Jean-Pied-de-Port; etching; 1866; 4 proofs extant; 110 × 200; M.12

187 Sketch of Heads and Leaves (*Croquis*); etching; before 1870; unique proof; 120 × 95; M.13

188 David; etching; c. 1880; 3 proofs extant; 95 × 55; M.14

189 Tobias (*Tobie*); etching; c. 1880; 3 proofs extant, each a different state; 155 × 120; M.15

190 Dream Vision (*Vision de rêve*); etching; c. 1880; 2 or 3 proofs extant; 90 × 105; M.16

191 Evil Glory (*Mauvaise gloire*); etching; 1886; edition of 20 copies; 93 × 50; M.17

192 Cain and Abel (*Caïn et Abel*); etching; 1886; edition of 20 copies; 175 × 119; M.18

193 Little Prelate (*Petit prélat*); drypoint; 1888; edition of 30 copies; 85 × 46; M.19

194 Passage of a Soul (*Passage d'une âme*); etching; 1891; frontispiece for the novel *La Passante* by Adrien Remacle; edition of 420 copies; 84 × 53; M.21

195 Perversity (*Perversité*); etching; 1891; edition of 30 copies; 160 × 126; M.20

DRAWINGS REPRODUCED BY THE EVELY PROCESS

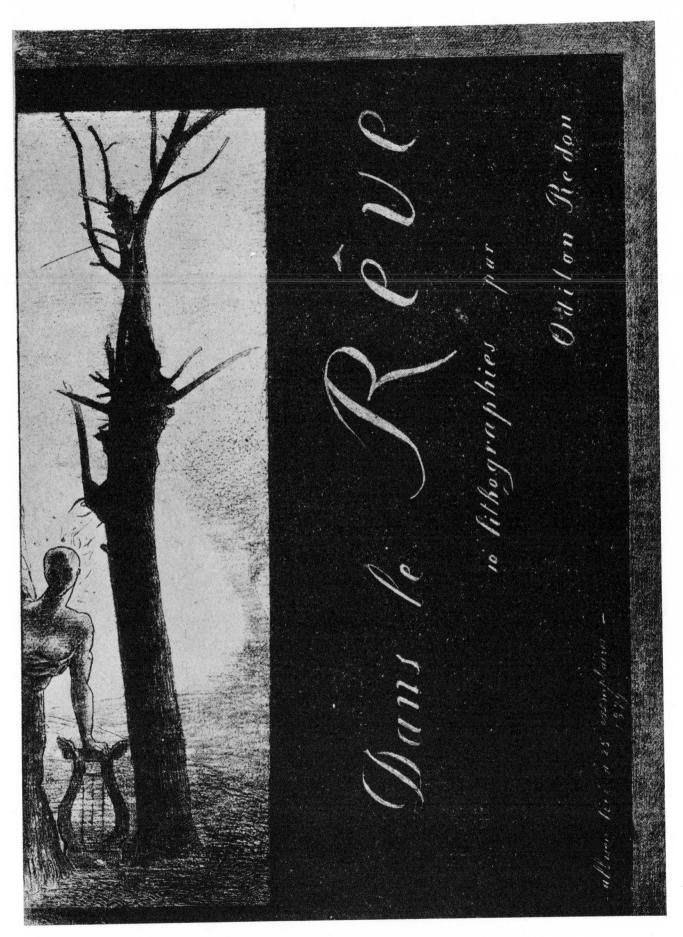

1 Cover of *Dans le Rêve*

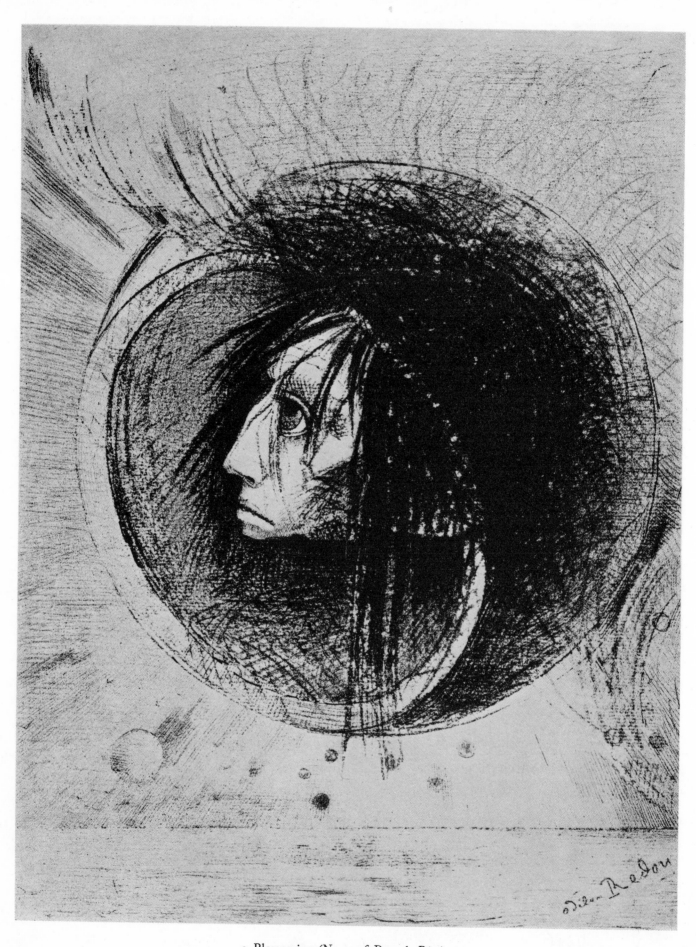

2 Blossoming (No. 1 of *Dans le Rêve*)

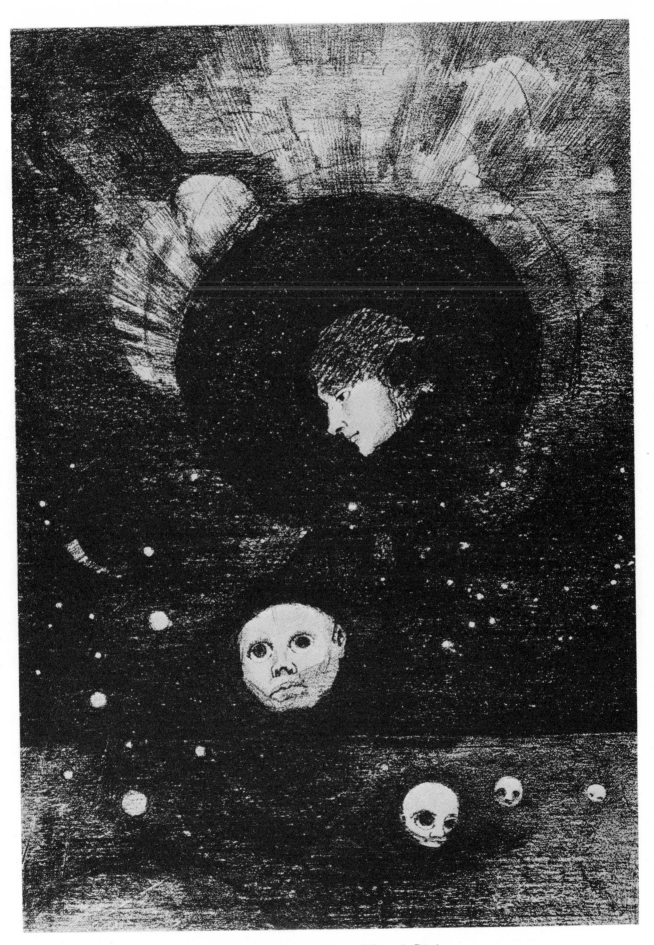

3 Germination (No. 2 of *Dans le Rêve*)

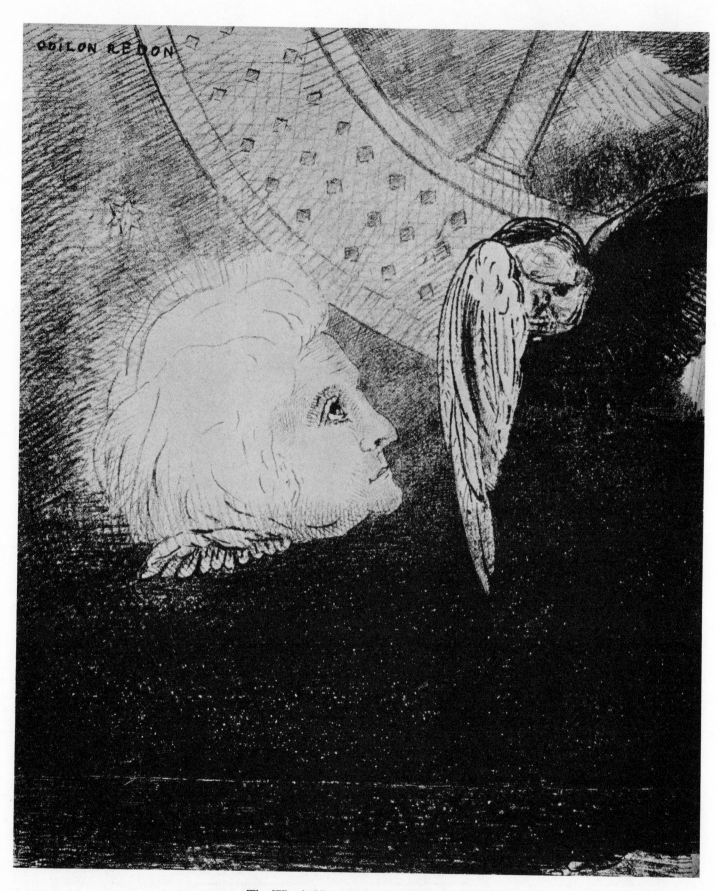

4 The Wheel (No. 3 of *Dans le Rêve*)

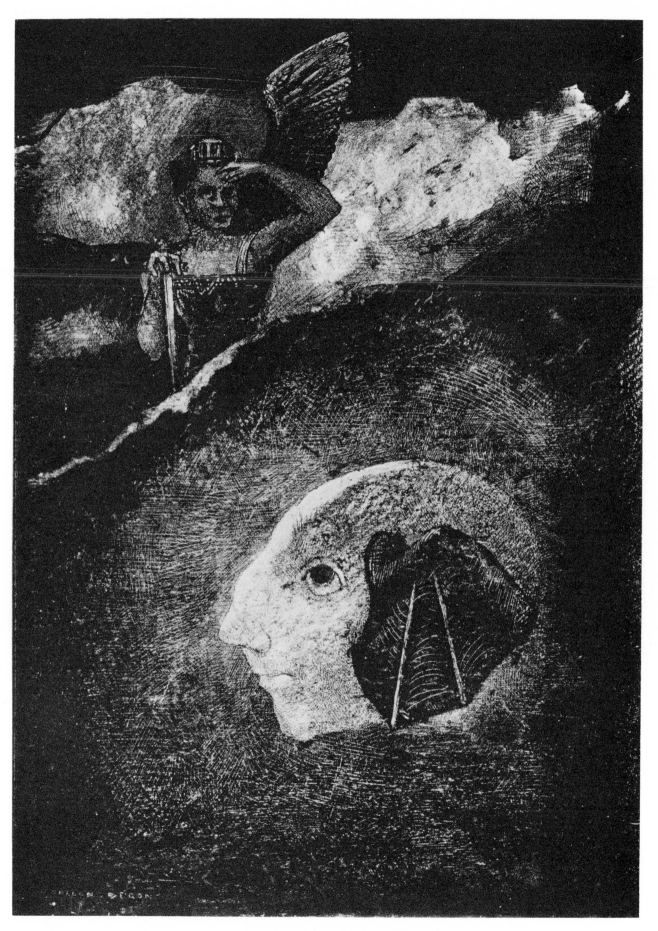

5 Limbo (No. 4 of *Dans le Rêve*)

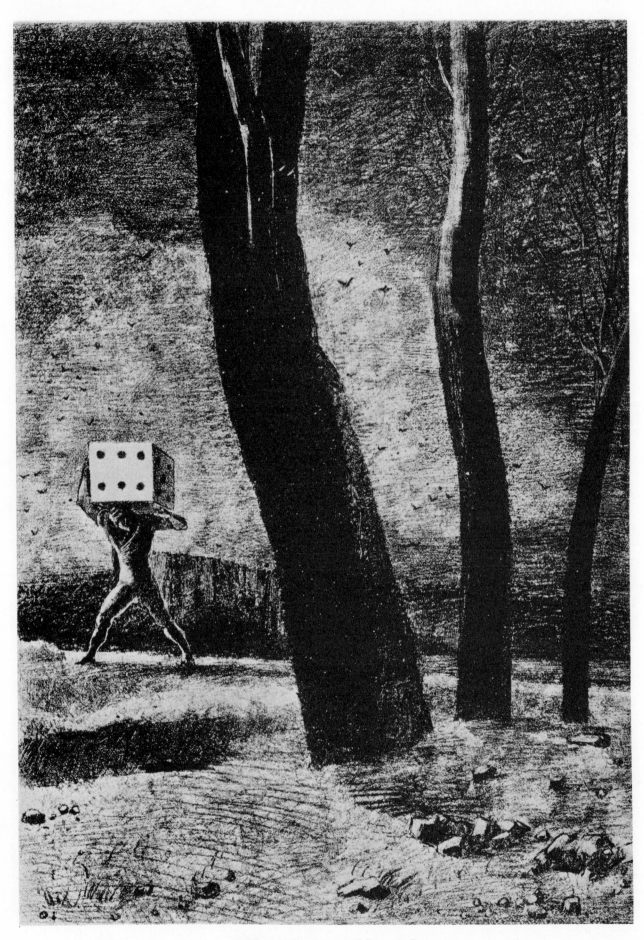

6 The Gambler (No. 5 of *Dans le Rêve*)

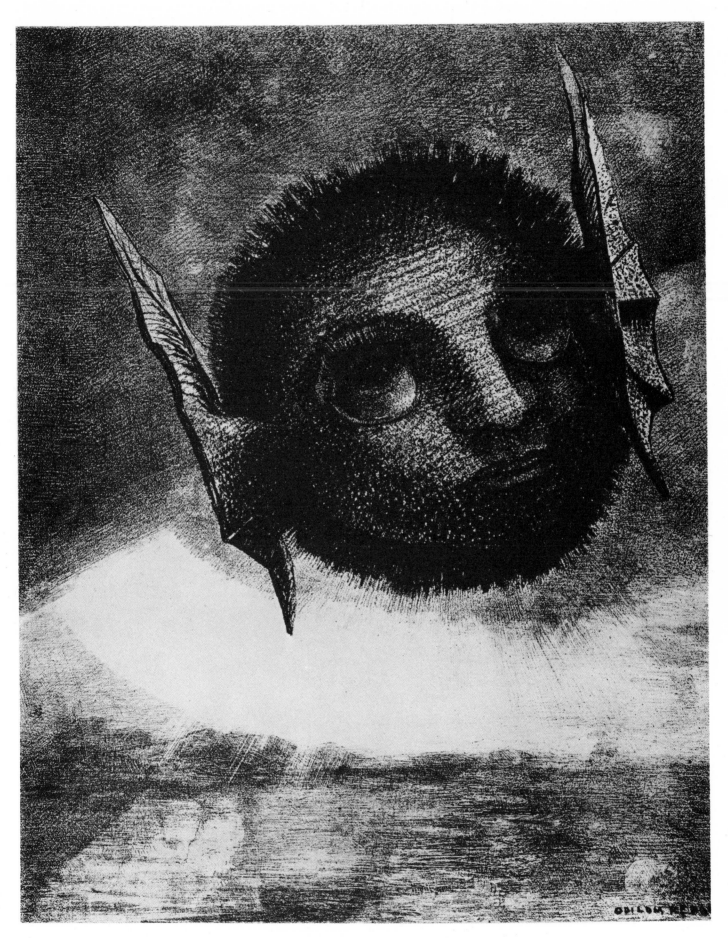

7 Gnome (No. 6 of *Dans le Rêve*)

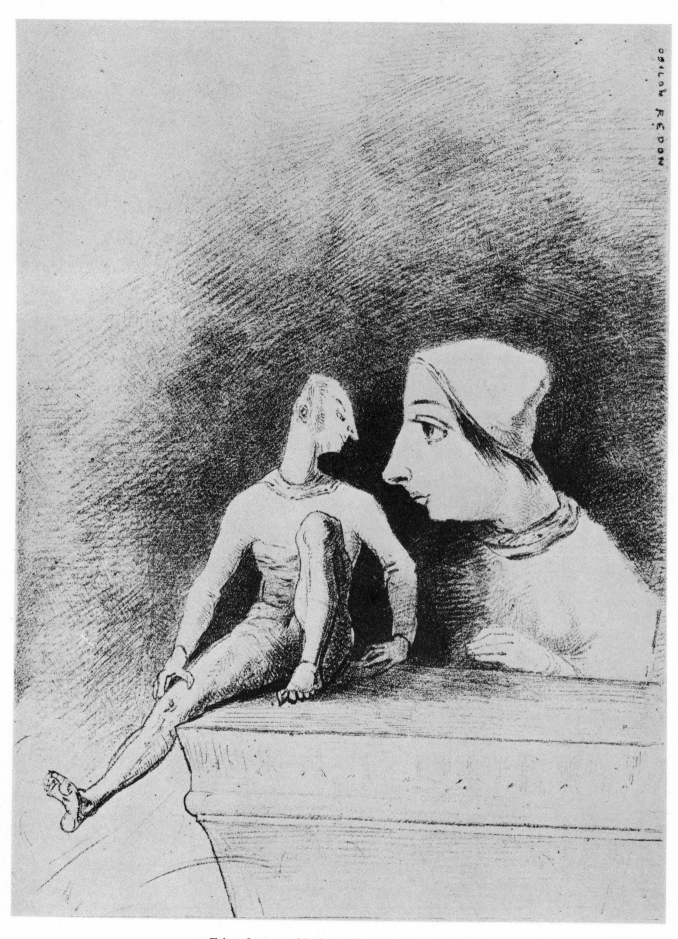

8 Feline Scene OR Mephisto (No. 7 of *Dans le Rêve*)

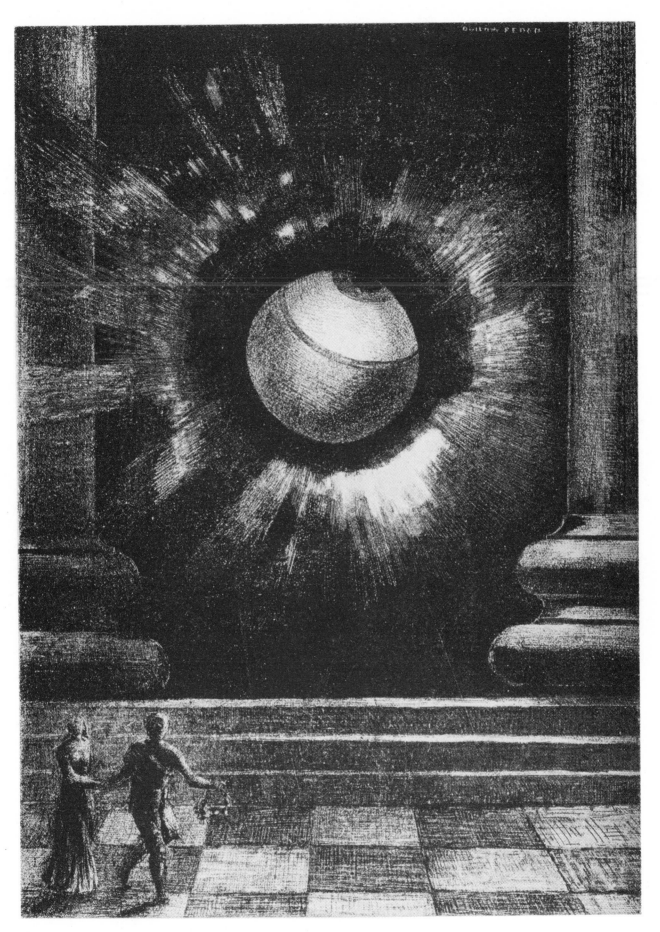

9 Vision (No. 8 of *Dans le Rêve*)

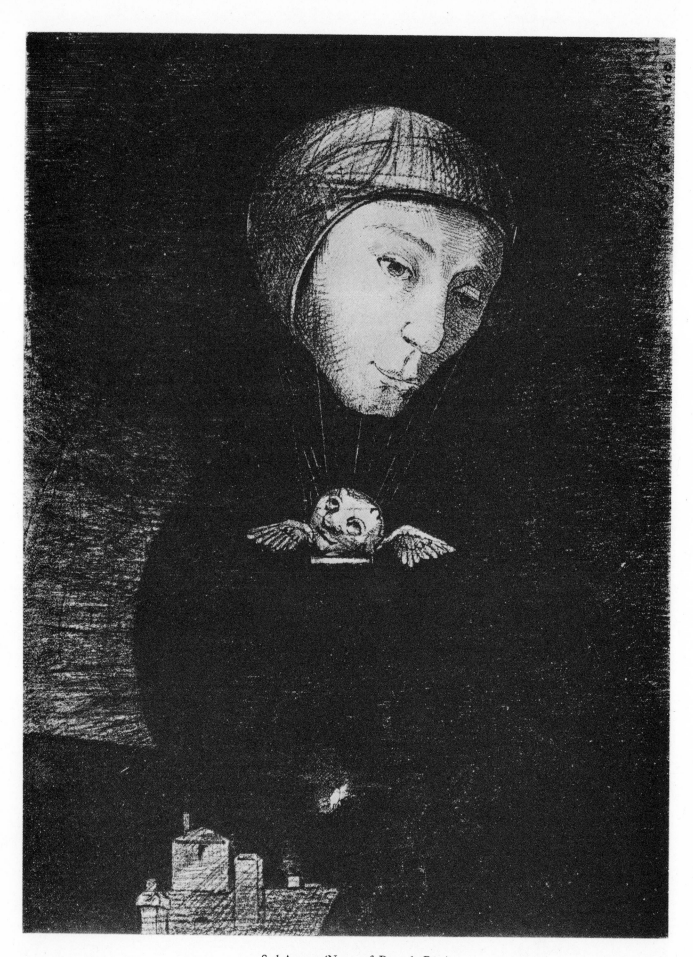

10 Sad Ascent (No. 9 of *Dans le Rêve*)

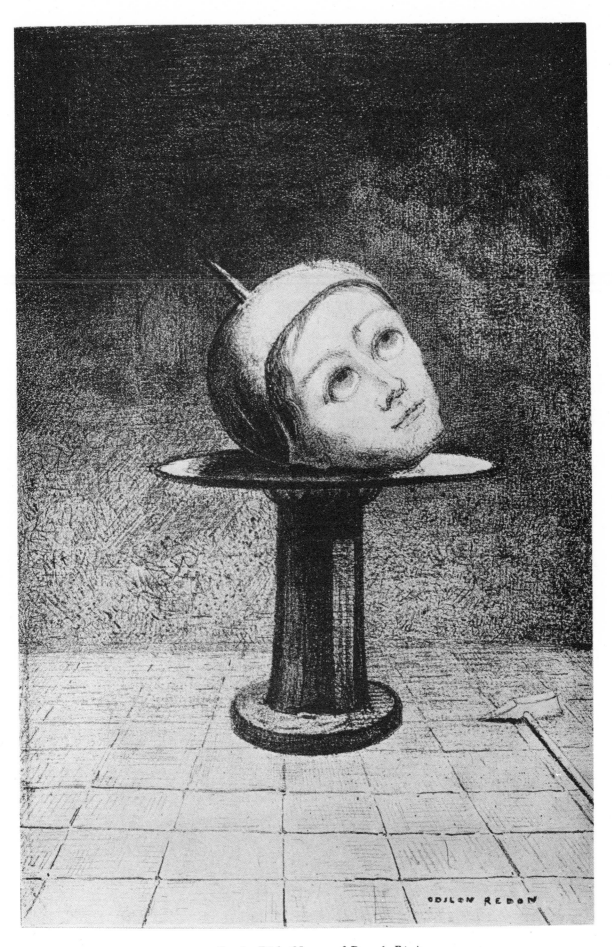

11 On the Dish (No. 10 of *Dans le Rêve*)

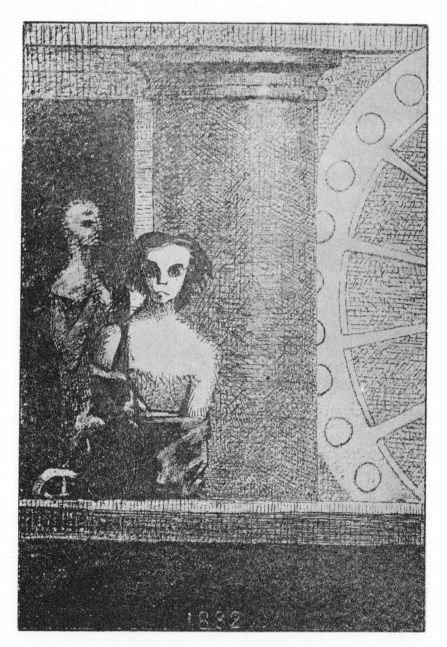

12 Inside front cover of *A Edgar Poë*

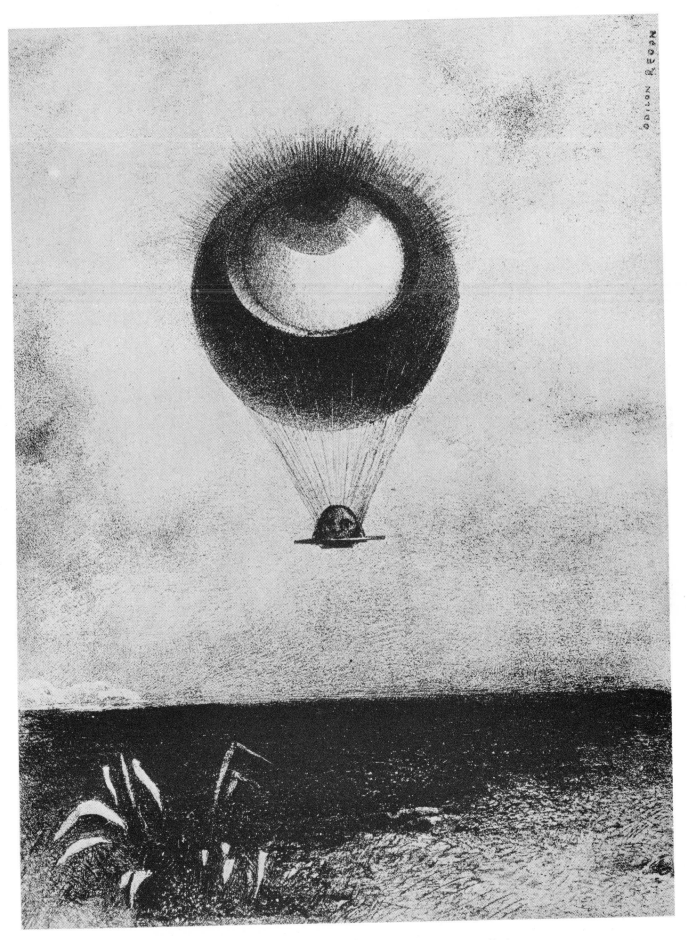

13 The eye, like a strange balloon (No. 1 of *A Edgar Poë*)

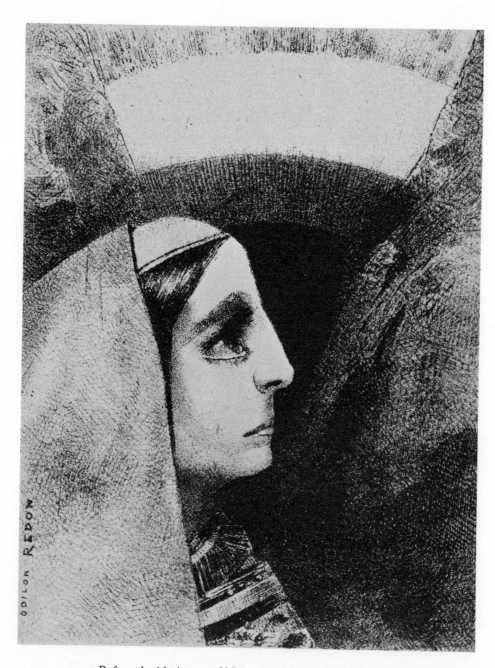

14 Before the black sun of Melancholy (No. 2 of *A Edgar Poë*)

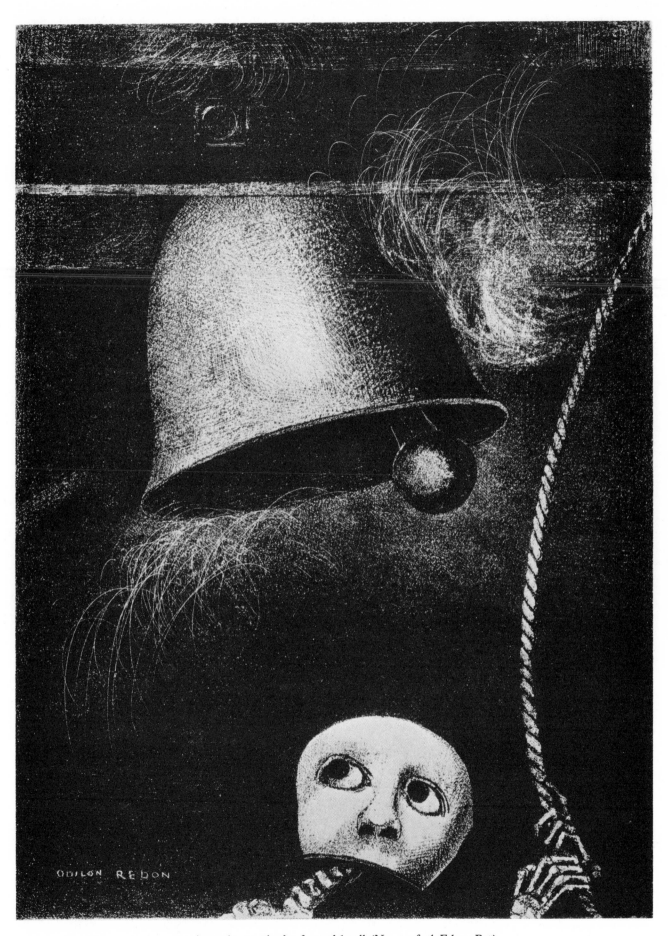

15 A mask sounds the funeral knell (No. 3 of *A Edgar Poë*)

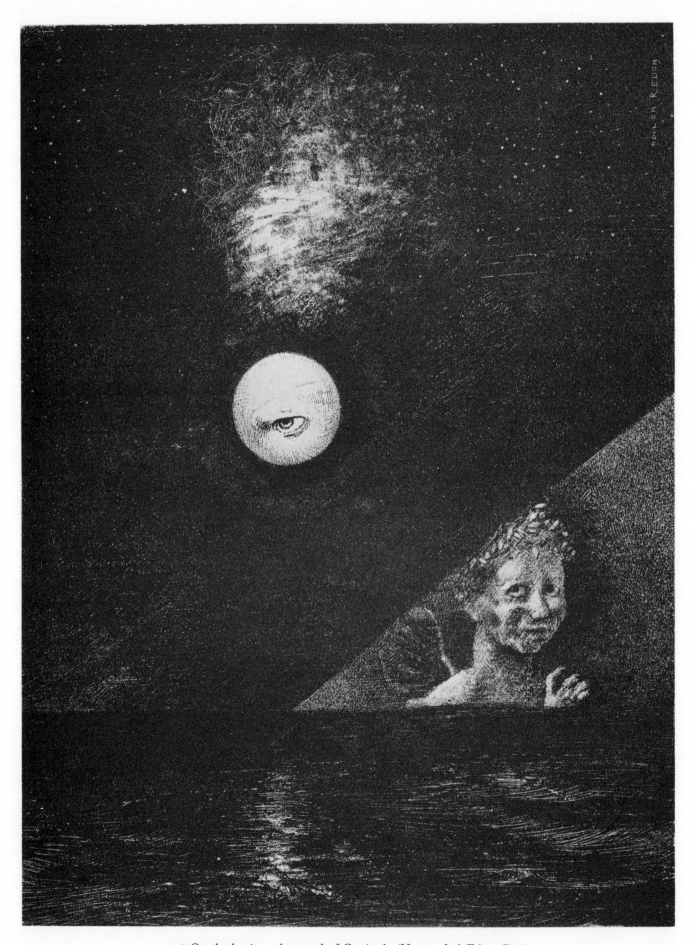

16 On the horizon the angel of Certitude (No. 4 of *A Edgar Poë*)

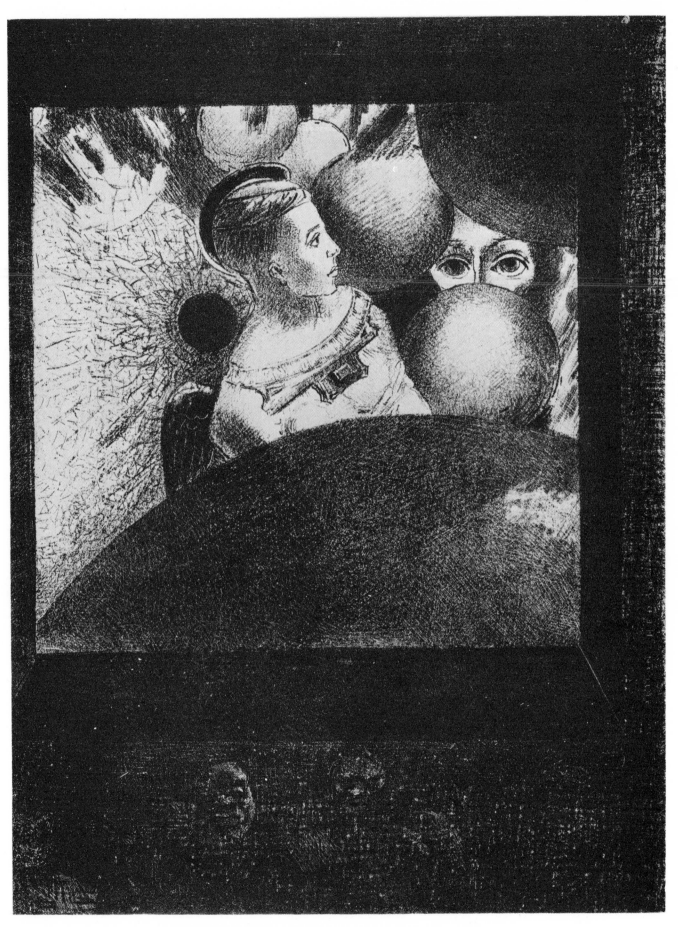

17 The breath which leads living creatures (No. 5 of *A Edgar Poë*)

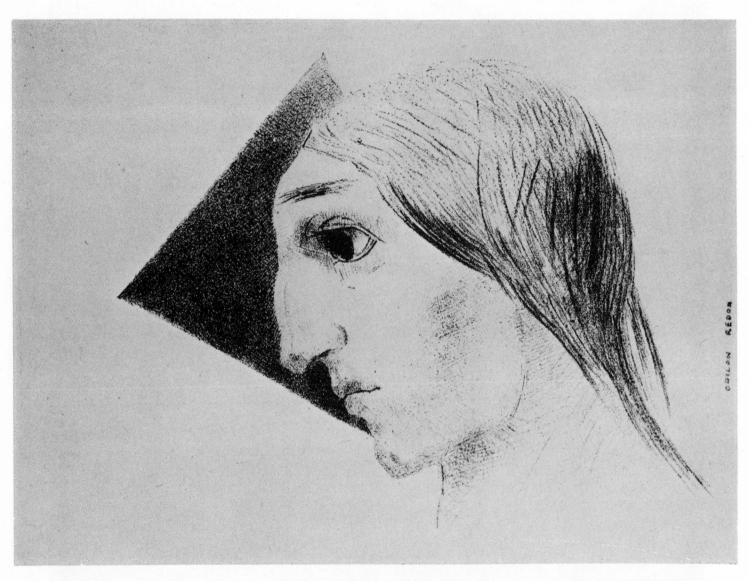

18 Madness (No. 6 of *A Edgar Poë*)

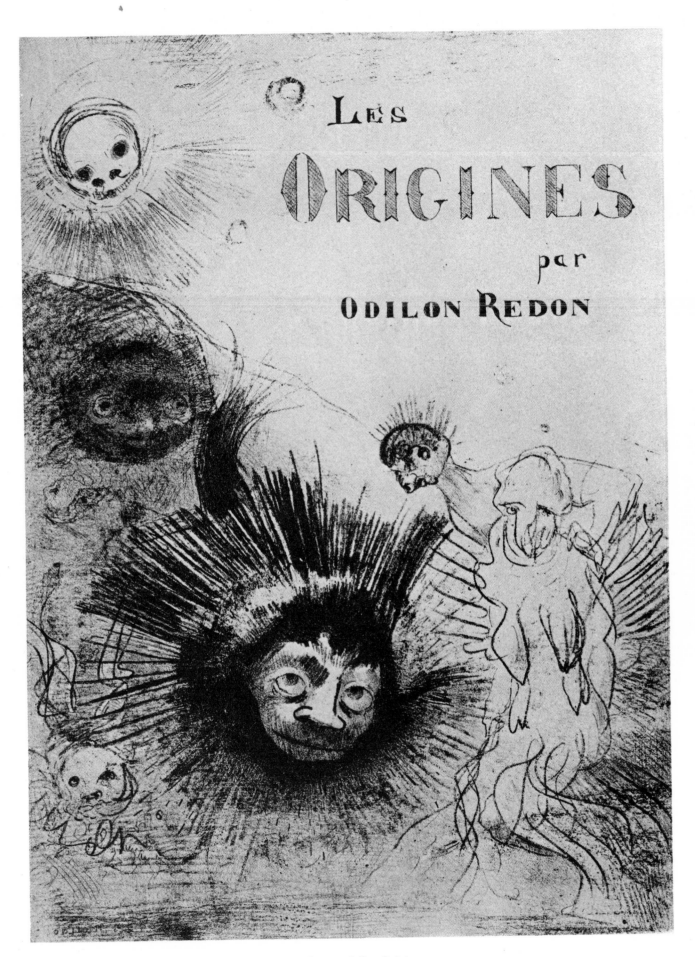

19 Cover of *Les Origines*

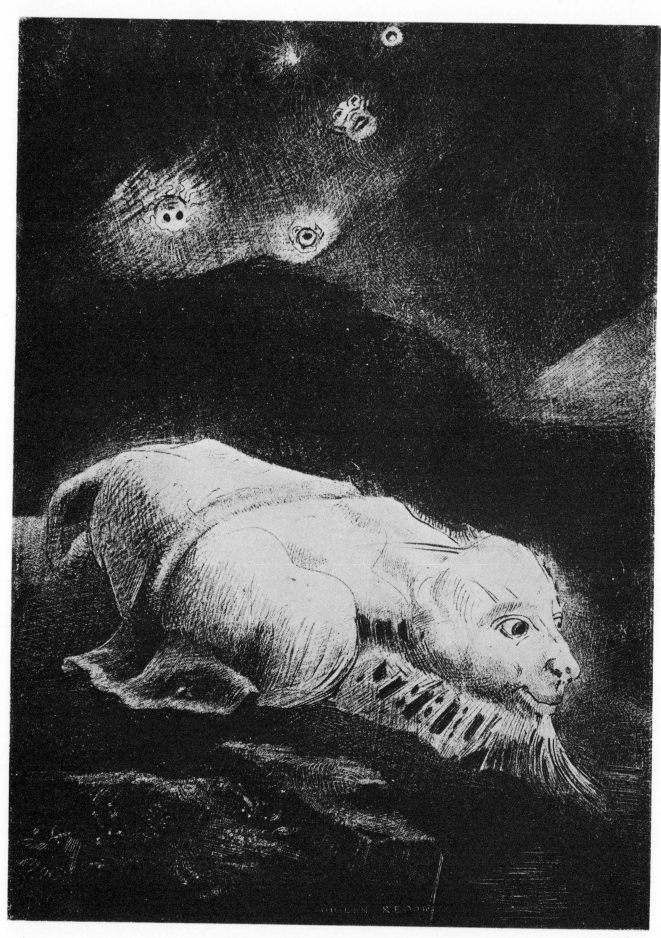

20 When life was awakening (No. 1 of *Les Origines*)

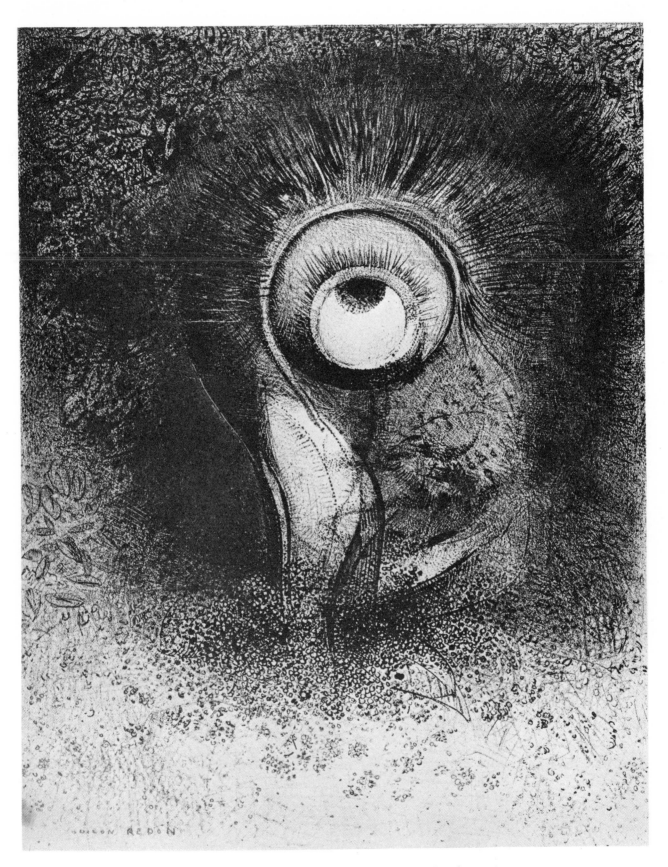

21 There was perhaps a first vision (No. 2 of *Les Origines*)

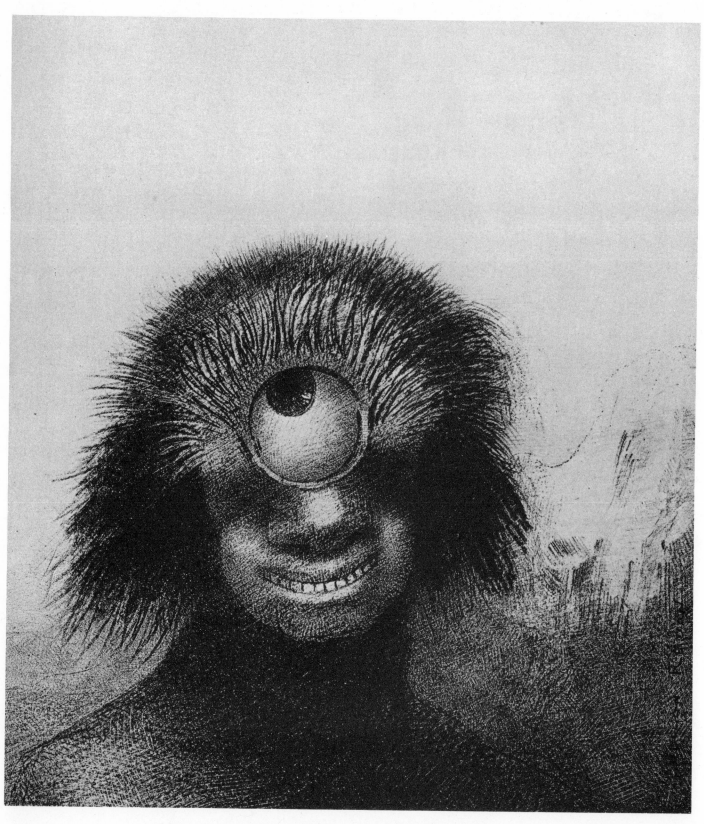

22 The misshapen polyp (No. 3 of *Les Origines*)

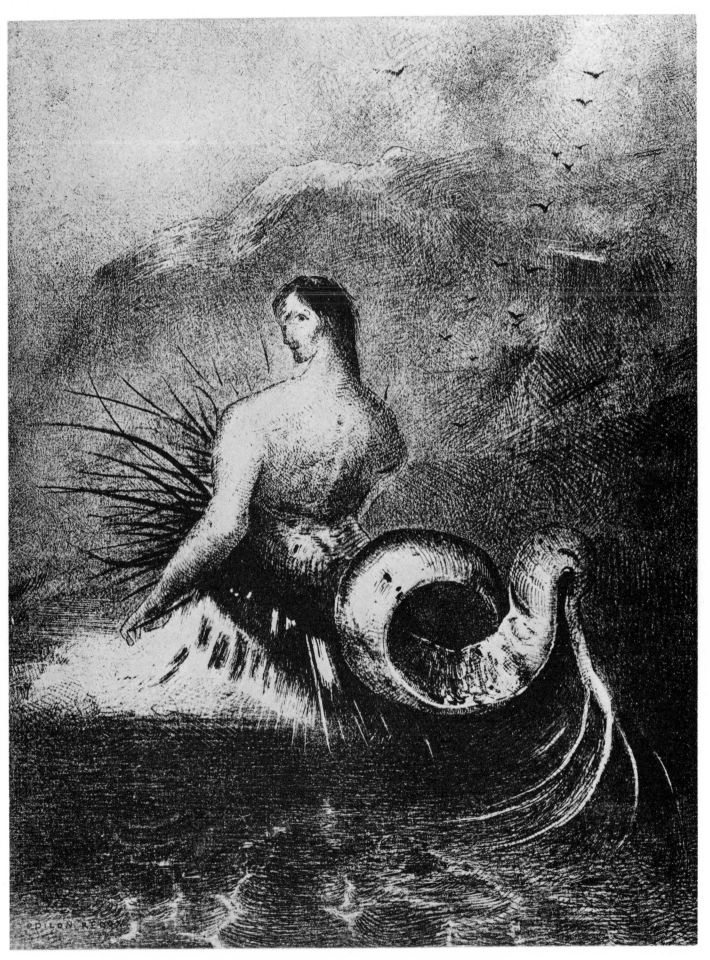

23 The Siren, clothed in barbs (No. 4 of *Les Origines*)

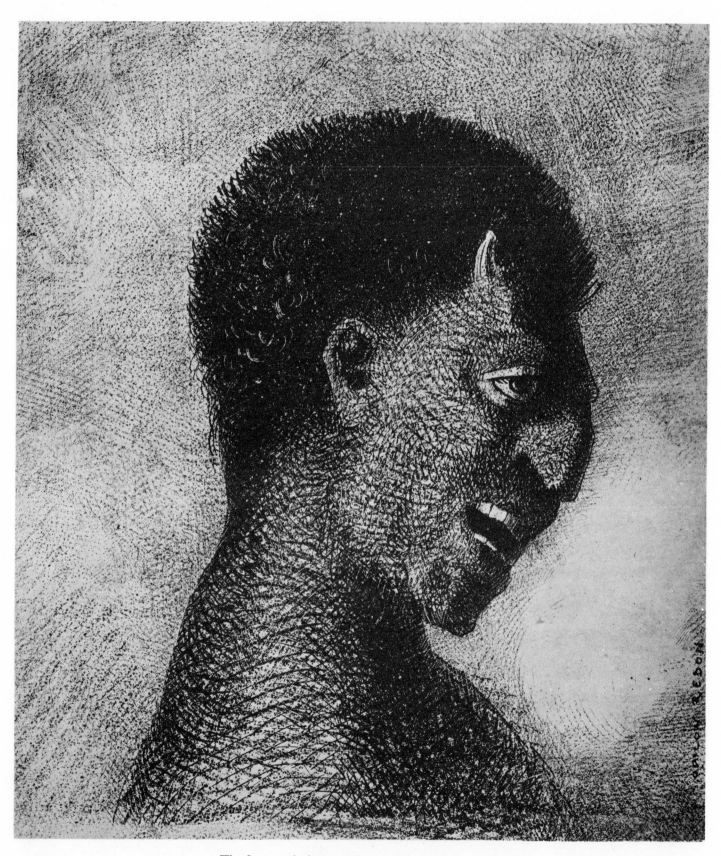

24 The Satyr with the cynical smile (No. 5 of *Les Origines*)

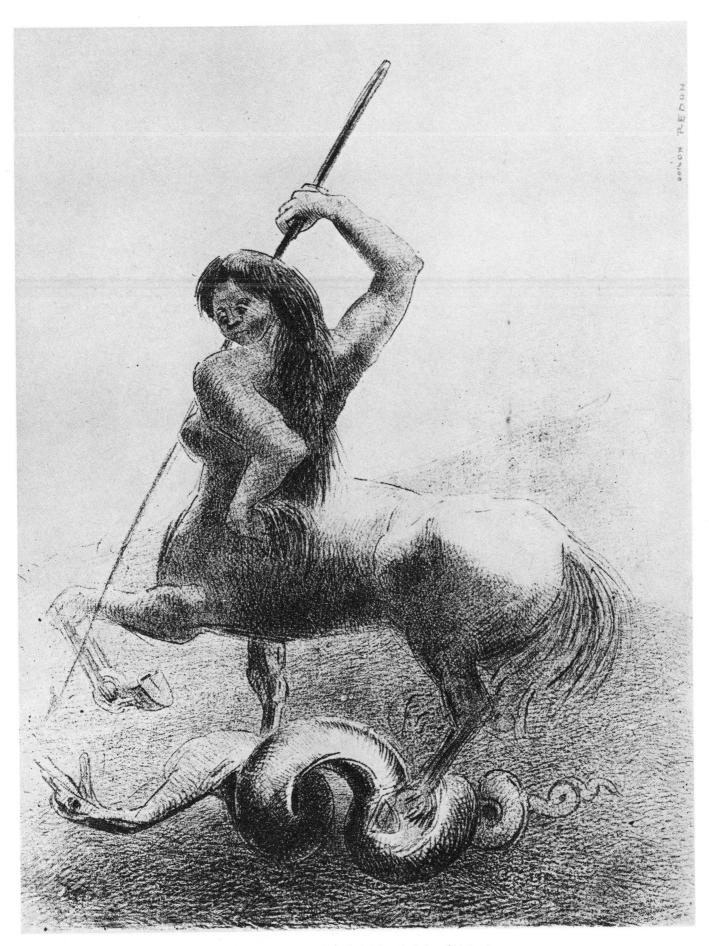

25 There were struggles (No. 6 of *Les Origines*)

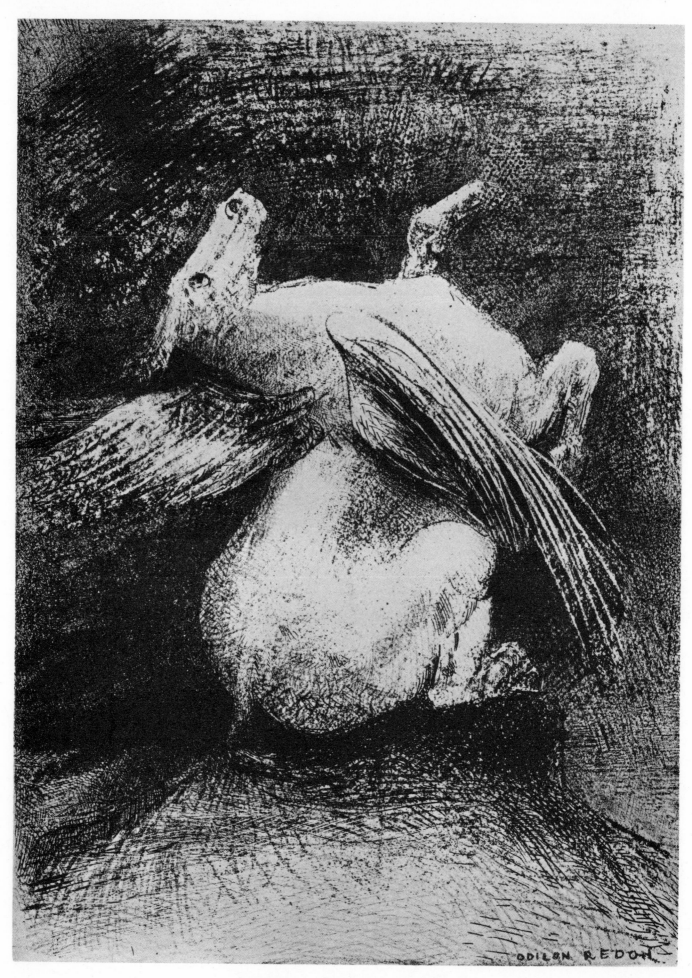

26 The impotent wing (No. 7 of *Les Origines*)

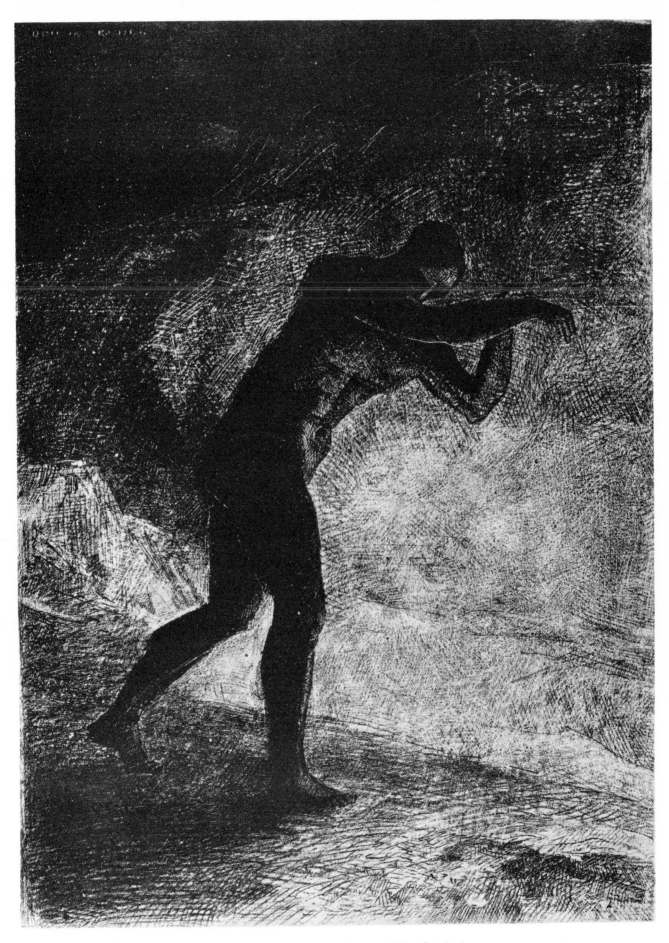

27 And Man appeared (No. 8 of *Les Origines*)

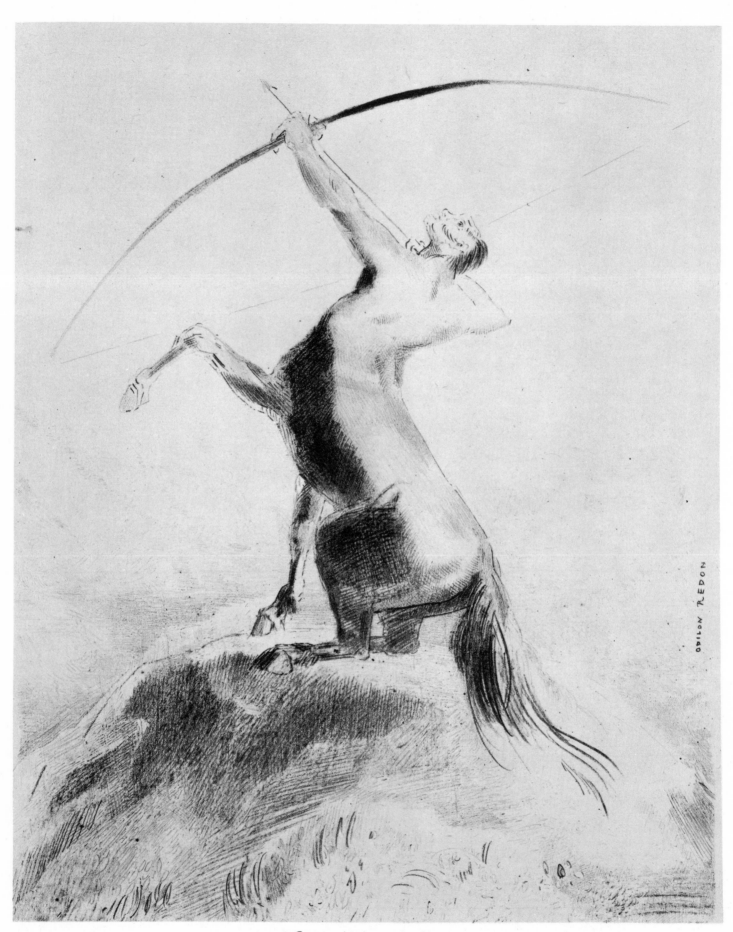

28 Centaur Aiming at the Clouds

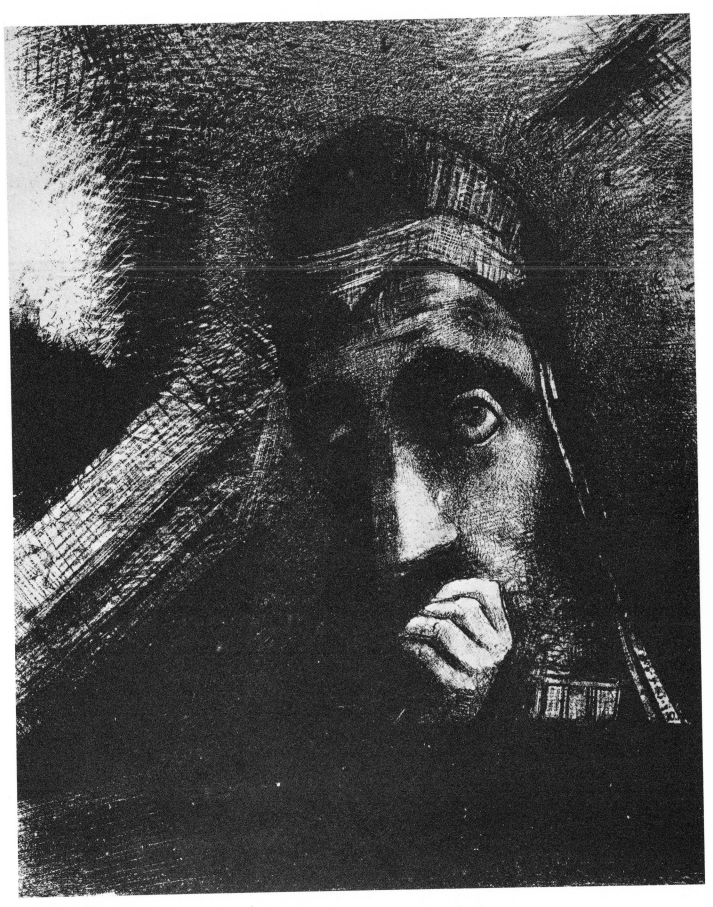

29 In my dream (No. 1 of *Hommage à Goya*)

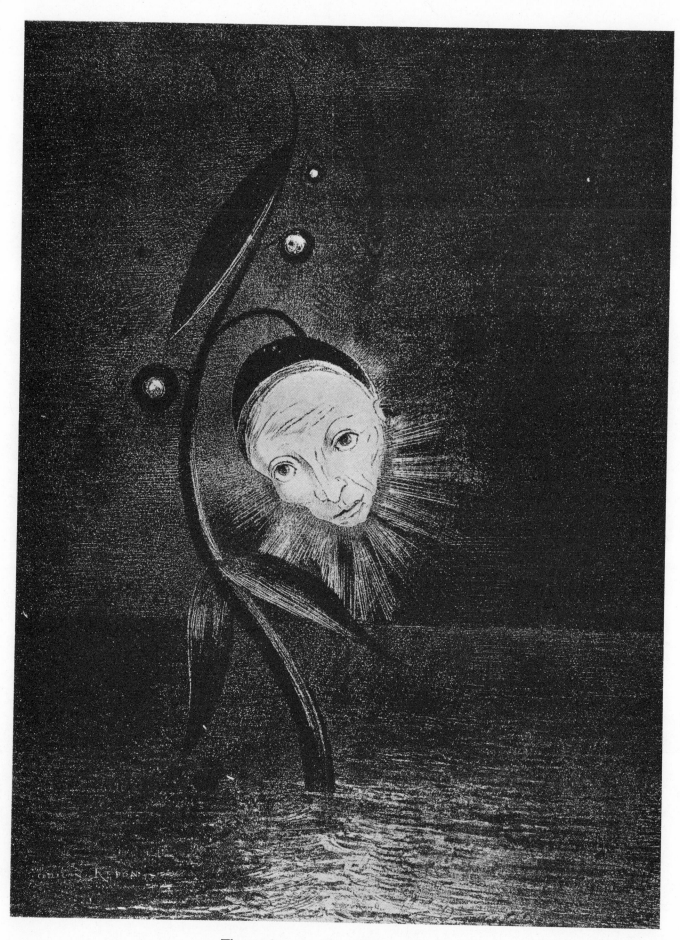

30 The marsh flower (No. 2 of *Hommage à Goya*)

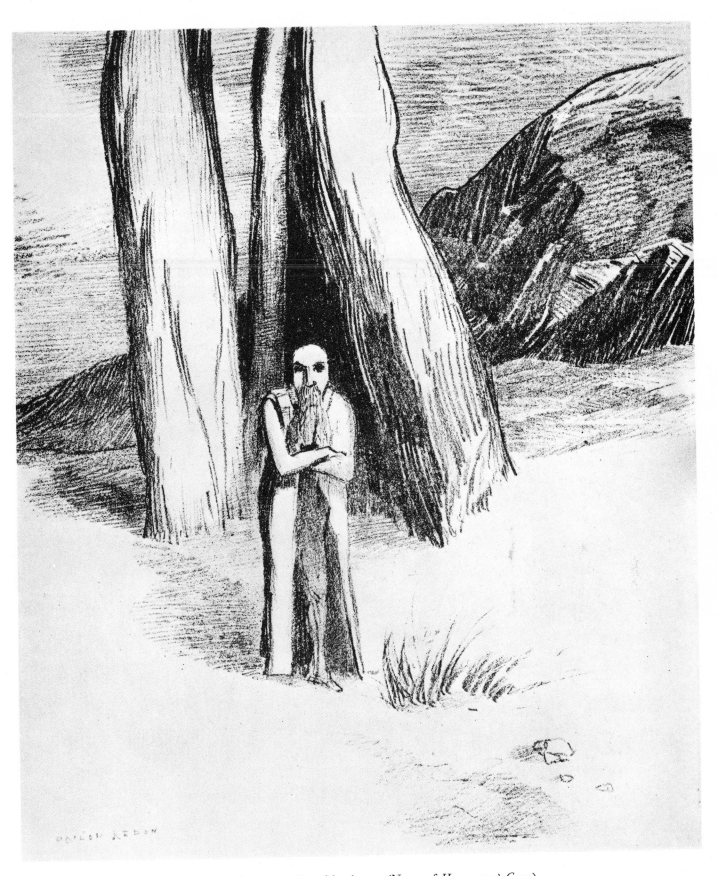

31 A madman in a dismal landscape (No. 3 of *Hommage à Goya*)

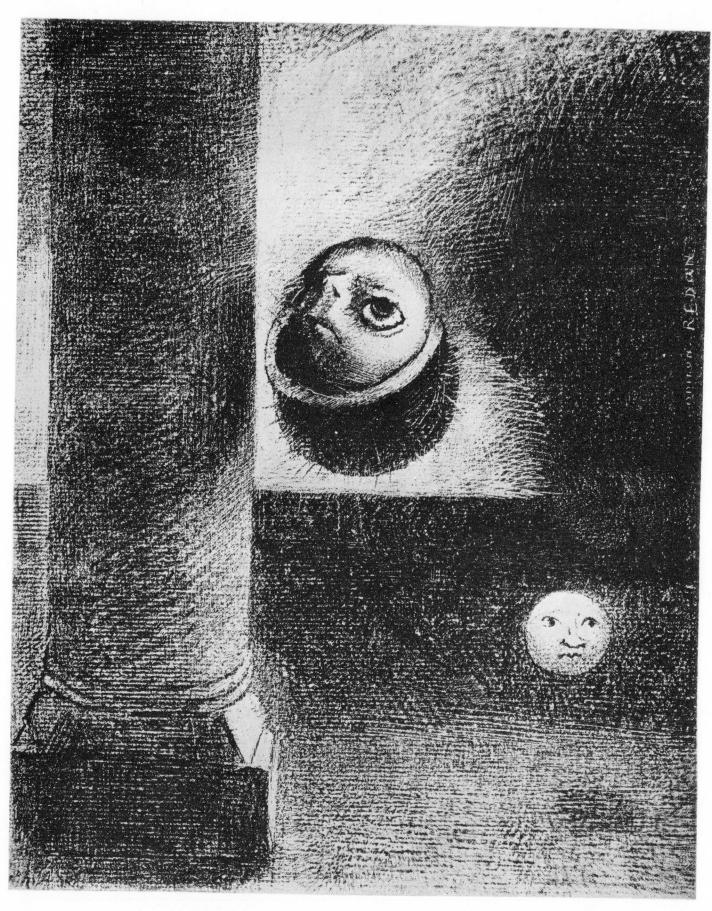

32 There were also embryonic beings (No. 4 of *Hommage à Goya*)

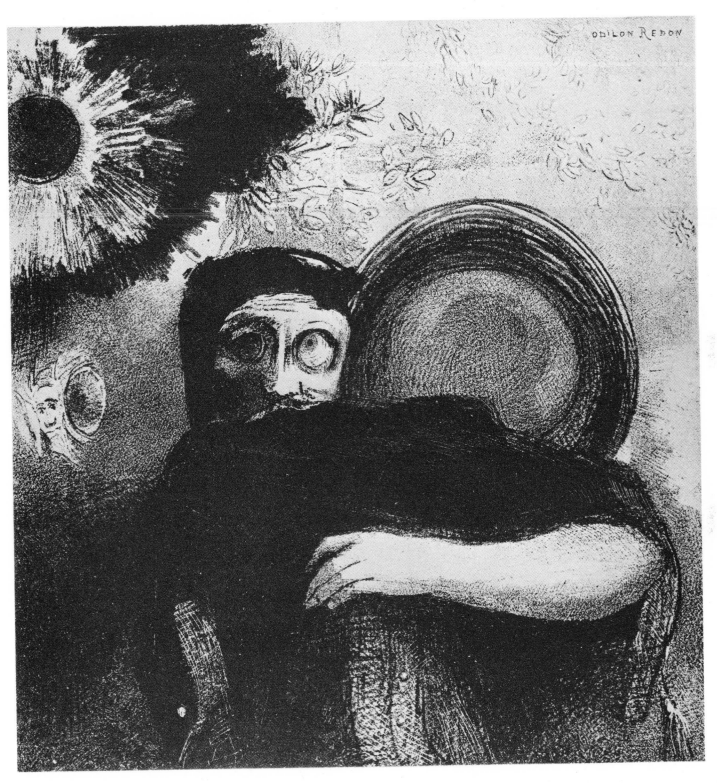

33 A Strange Juggler (No. 5 of *Hommage à Goya*)

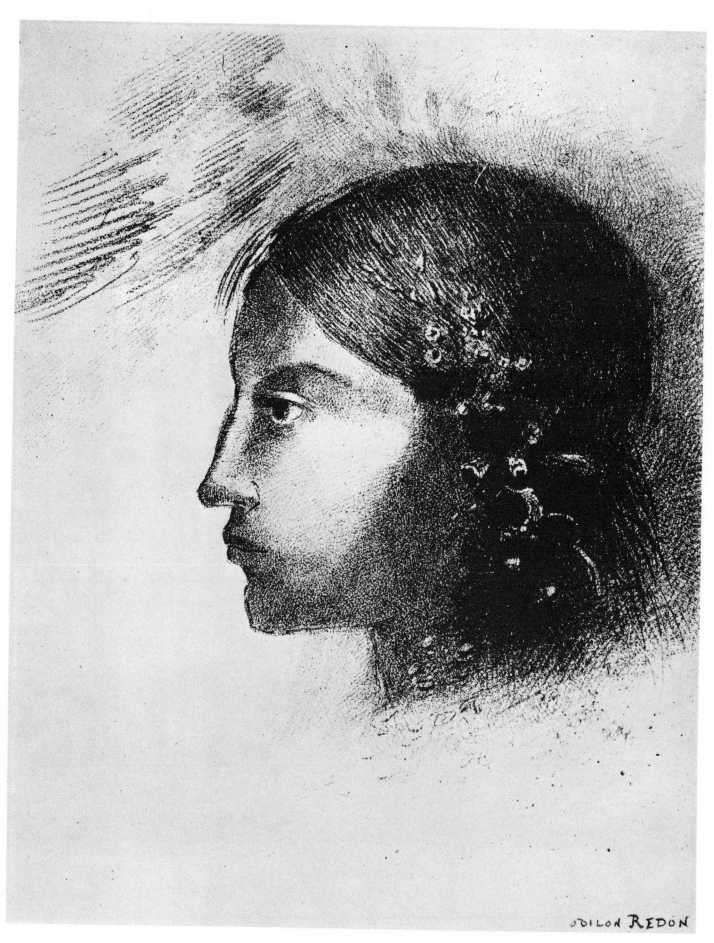

ODILON REDON

34 Upon awakening (No. 6 of *Hommage à Goya*)

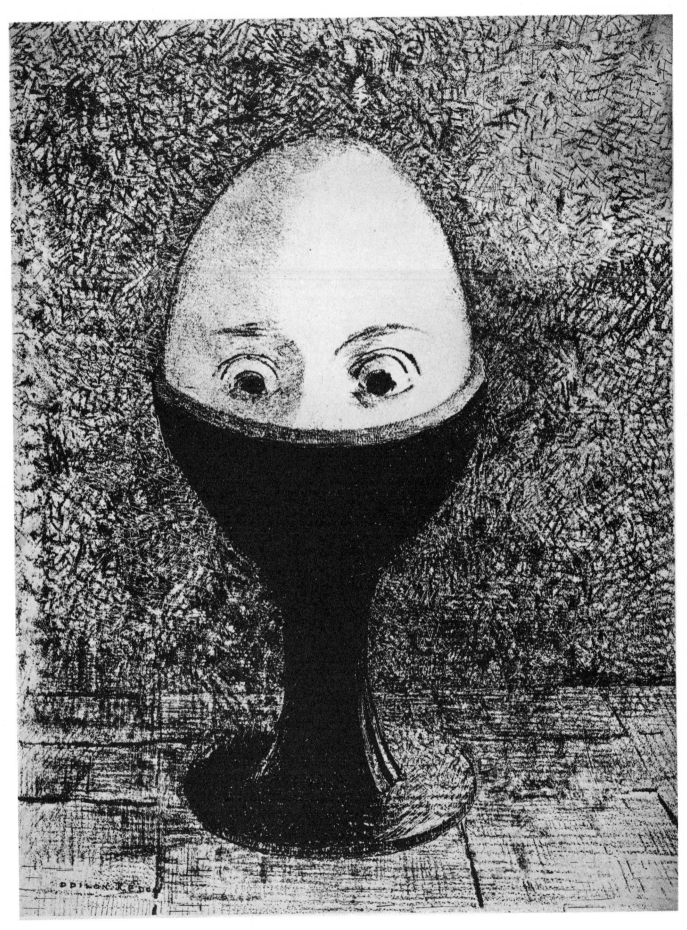

35 The Egg

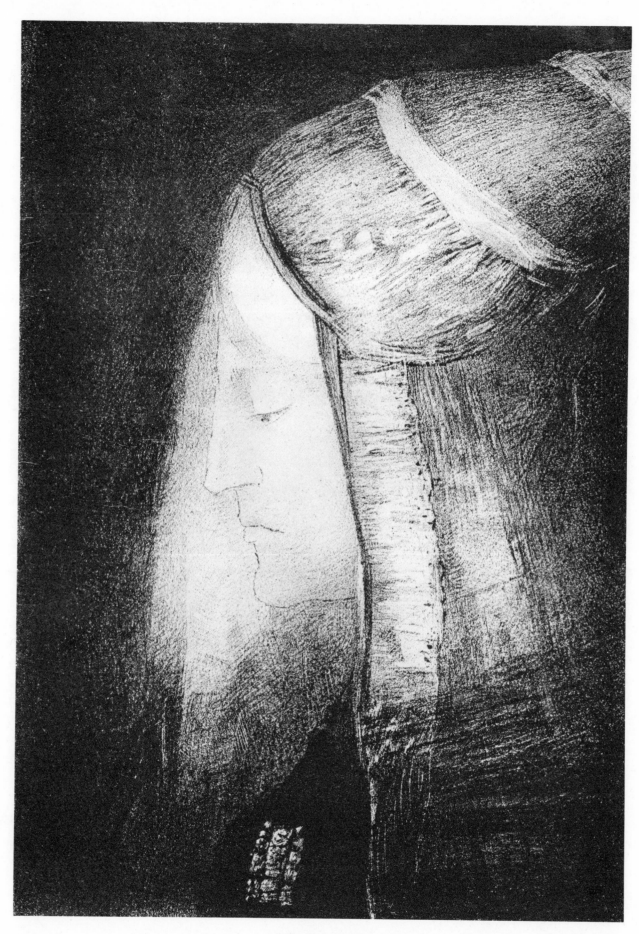

36 Profile of Light

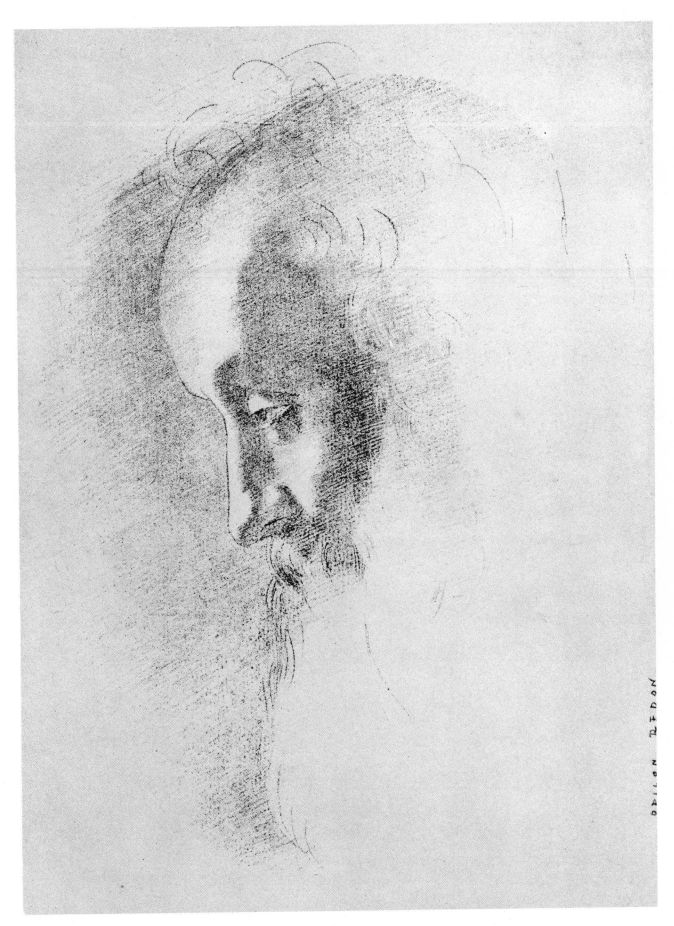

37 To Old Age (No. 1 of *La Nuit*)

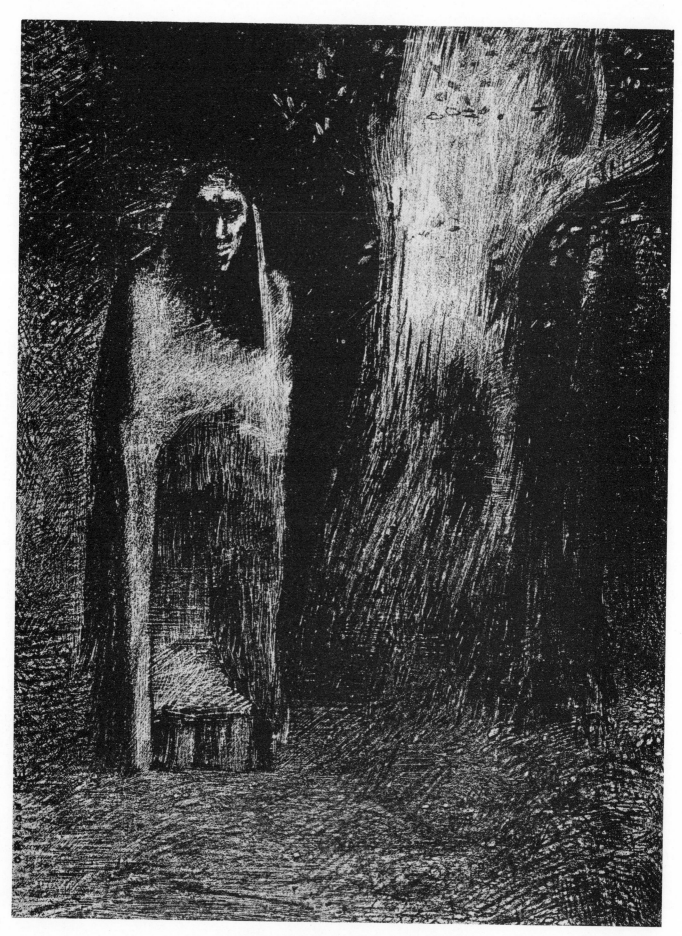

38 The man was alone (No. 2 of *La Nuit*)

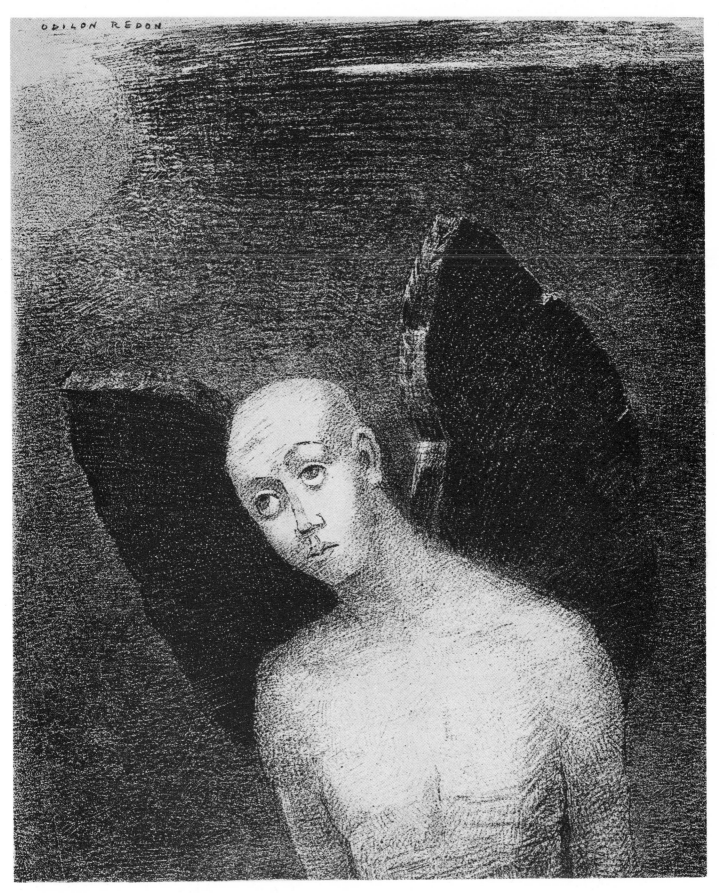

39 The lost angel (No. 3 of *La Nuit*)

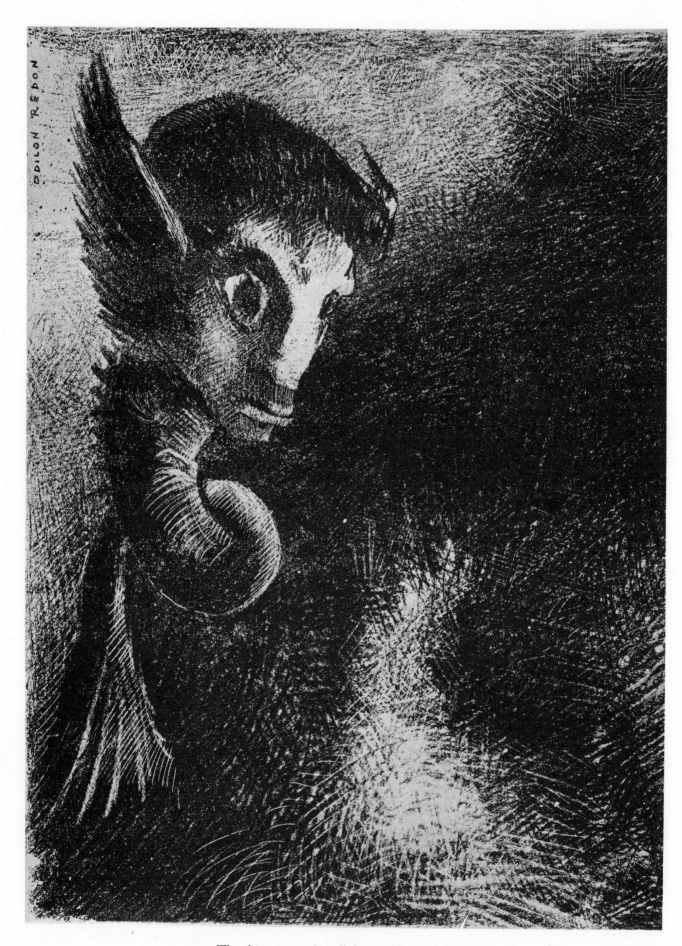

40 The chimera gazed at all things (No. 4 of *La Nuit*)

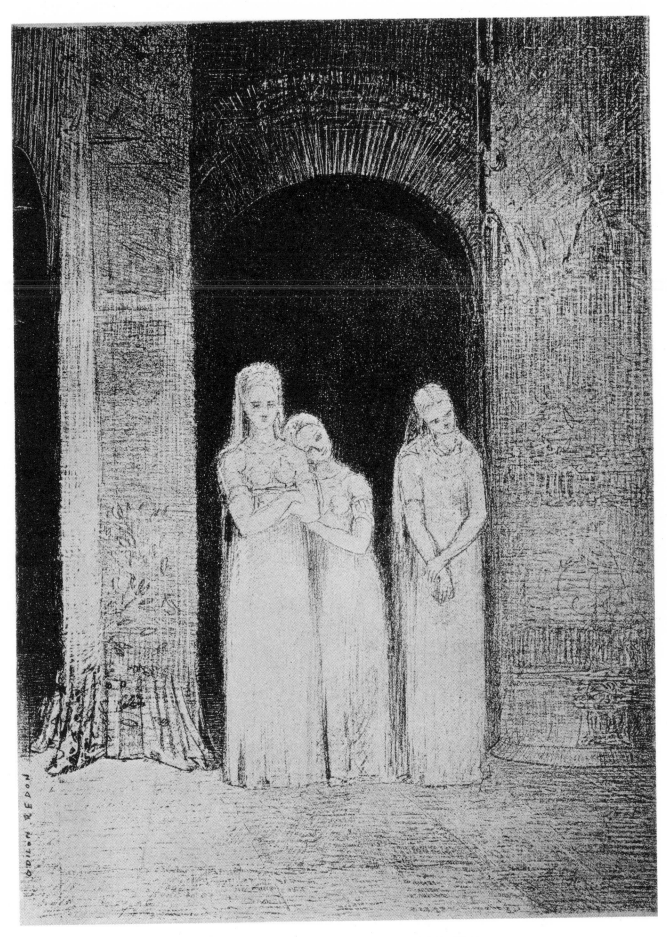

41 The priestesses were waiting (No. 5 of *La Nuit*)

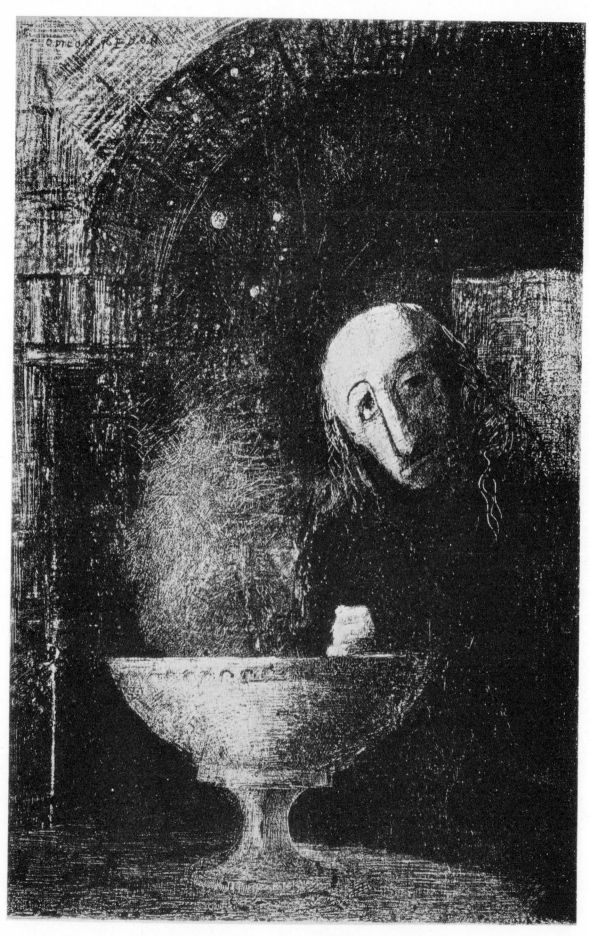

42 And the searcher was engaged (No. 6 of *La Nuit*)

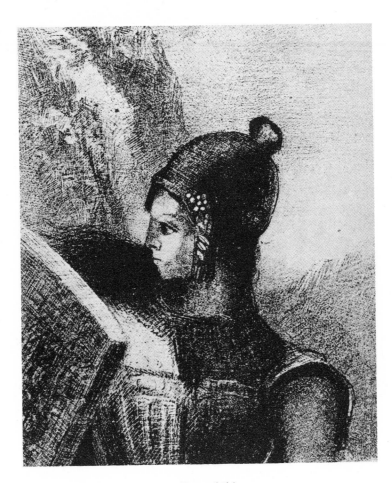

43 Brünnhilde

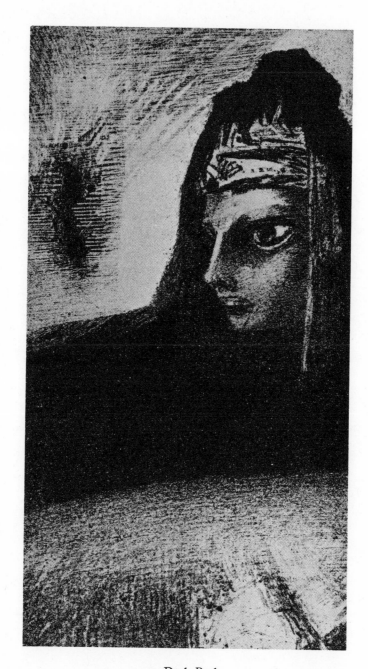

44 Dark Peak

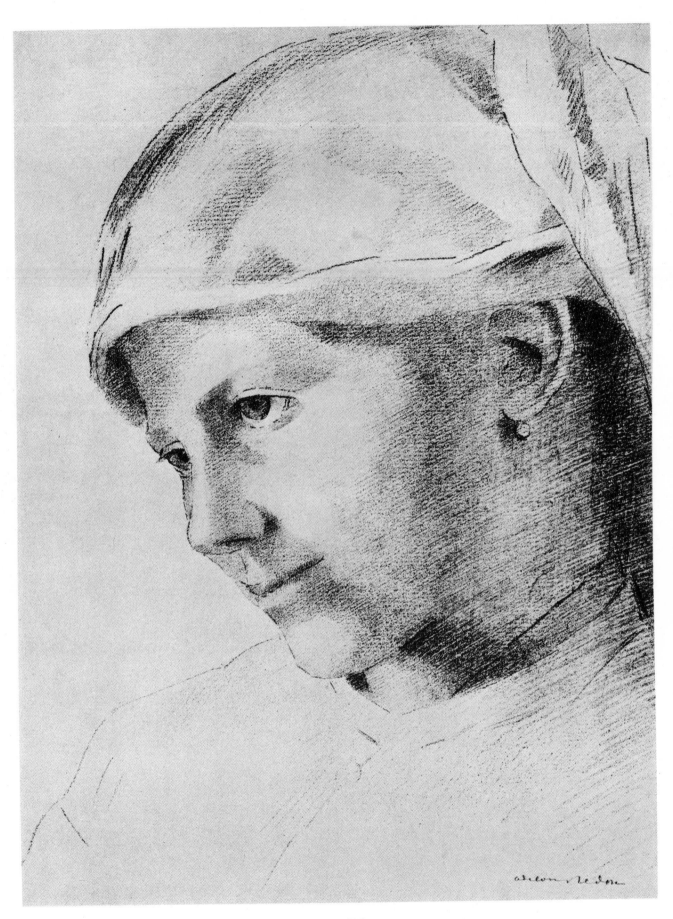

45 Girl

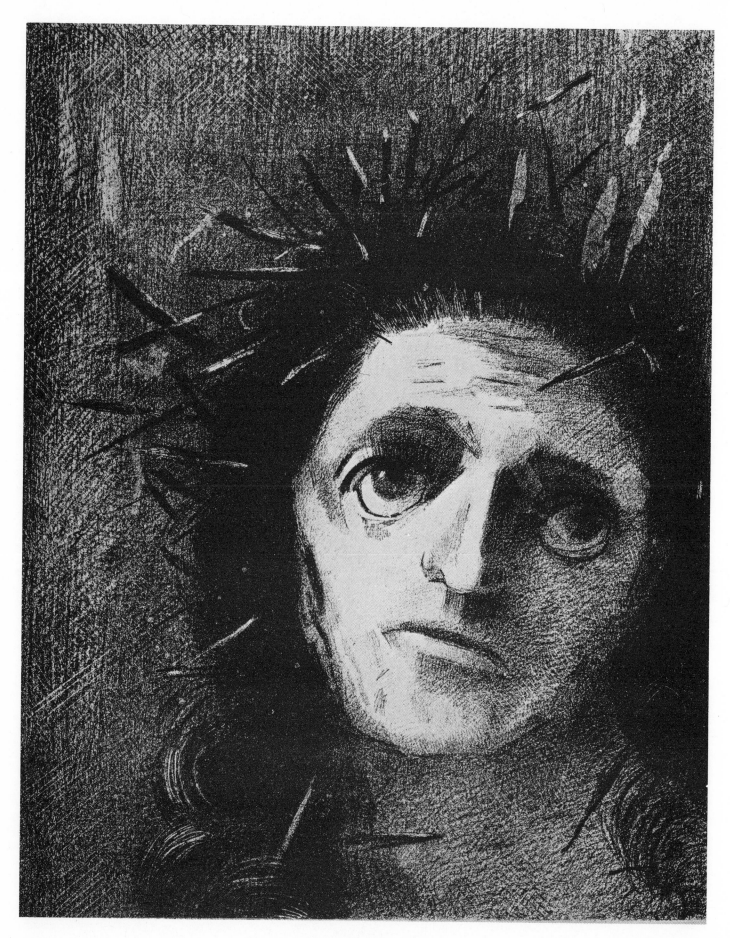

46 Christ

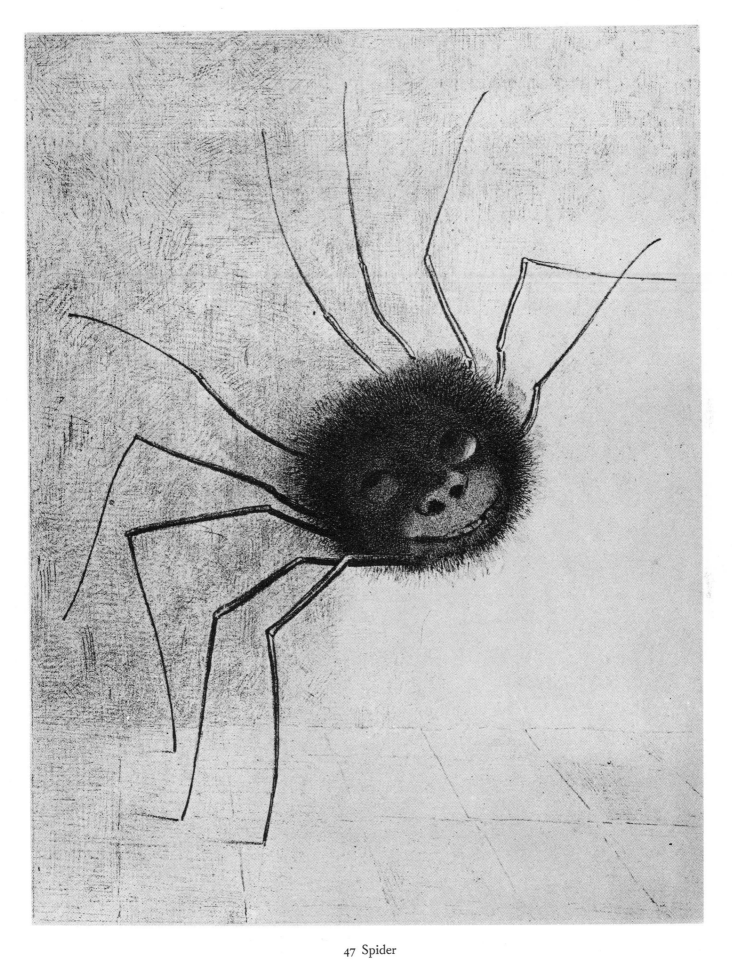

47 Spider

48 Design for a menu

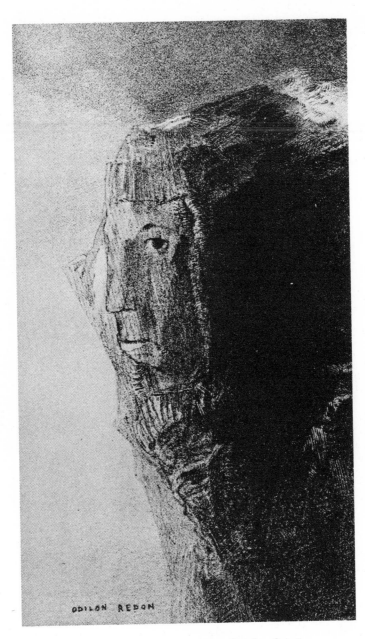

49 The Idol (frontispiece for *Les Soirs*)

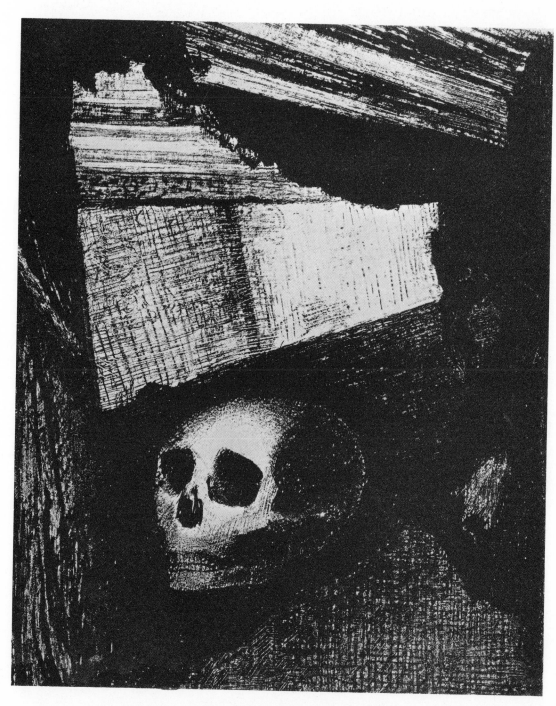

50 The wall of his room was opening up (from *Le Juré*)

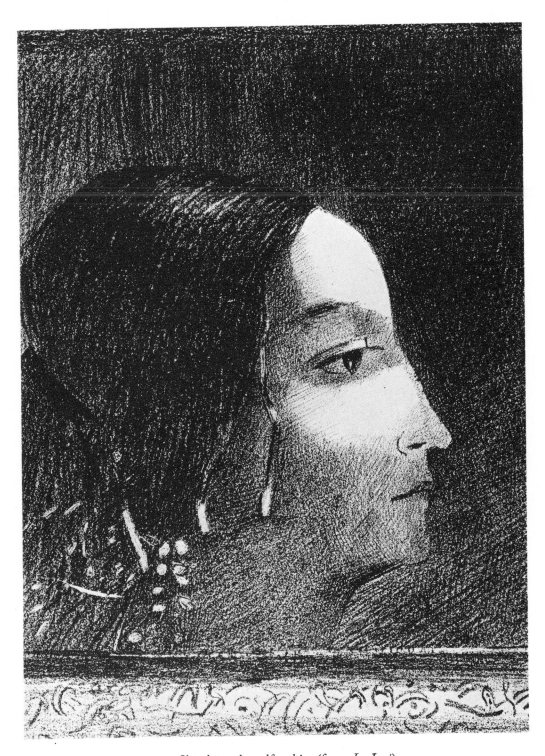

51 She shows herself to him (from *Le Juré*)

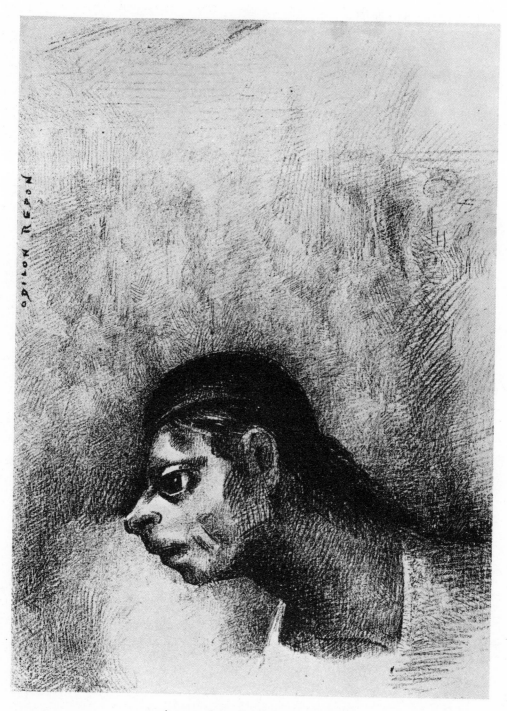

52 A man of the people (from *Le Juré*)

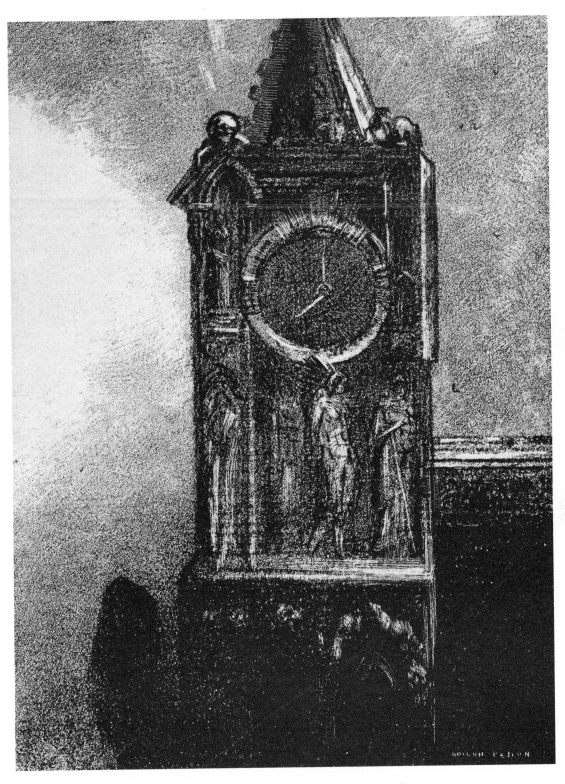

53 The deep bell of Sainte-Gudule (from *Le Juré*)

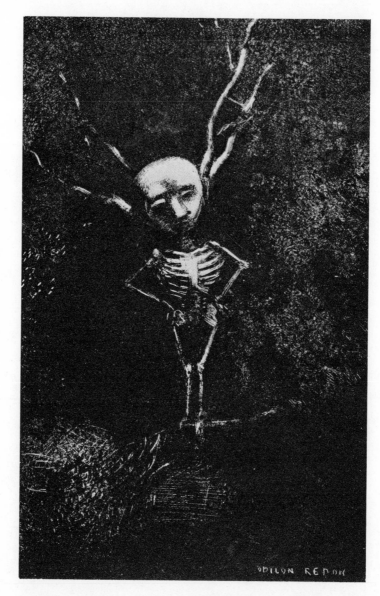

54 At the entrance of the walks (from *Le Juré*)

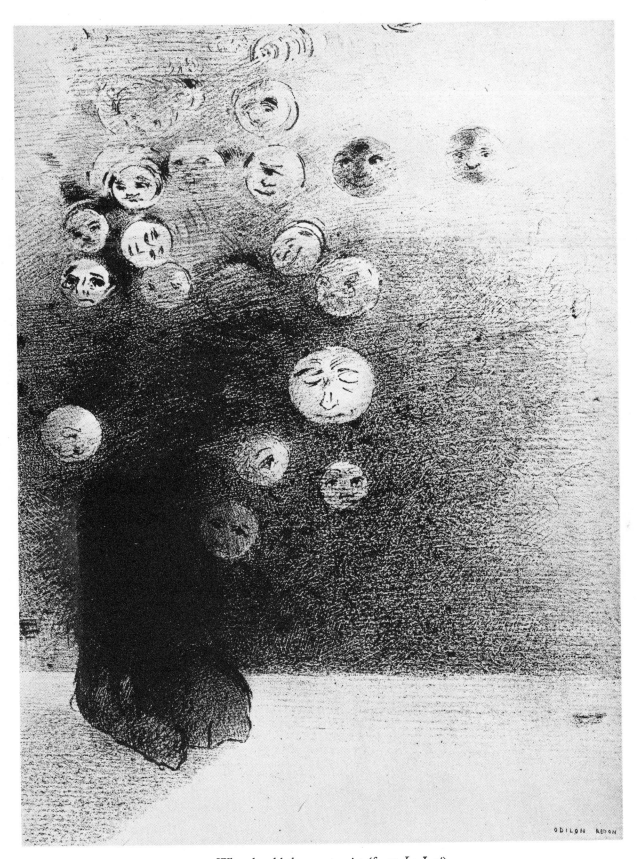

55 Why should there not exist (from *Le Juré*)

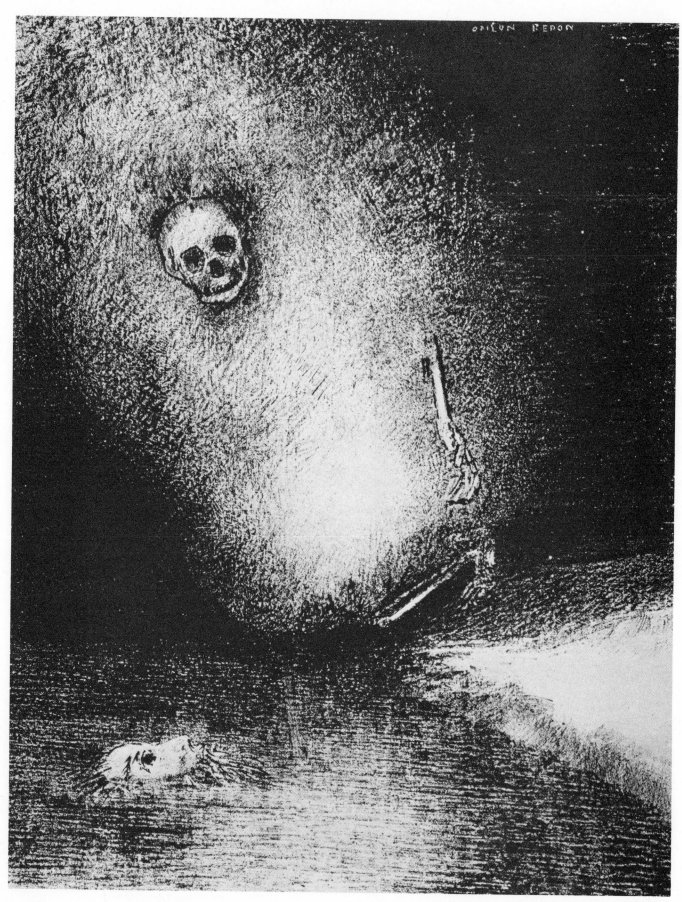

56 The sinister command of the specter (from *Le Juré*)

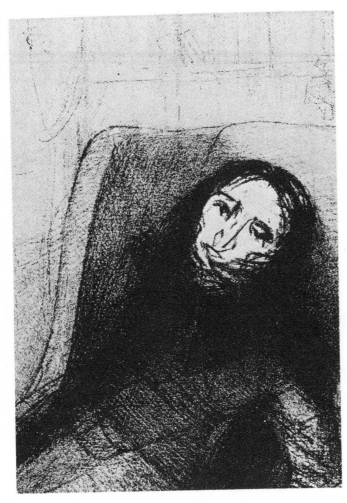

57 Des Esseintes (frontispiece for *A Rebours*)

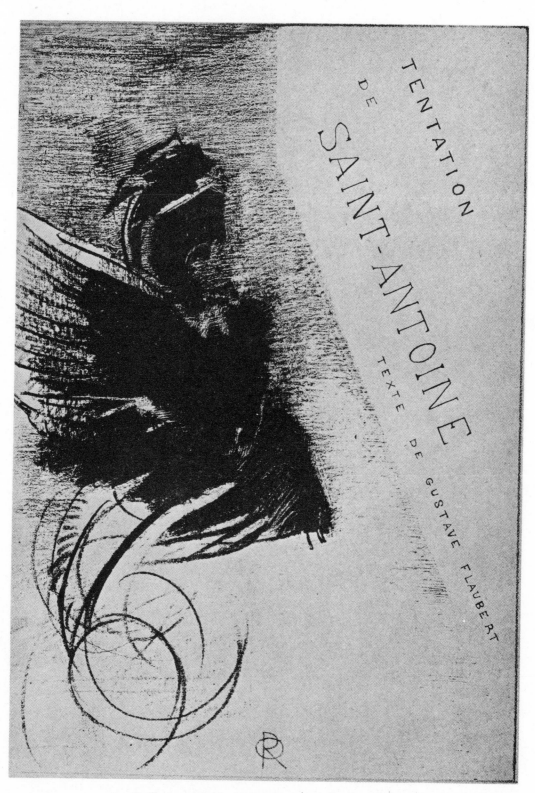

TENTATION
DE
SAINT-ANTOINE
TEXTE
DE GUSTAVE FLAUBERT

58 Cover of *Tentation de Saint-Antoine*, 1st series

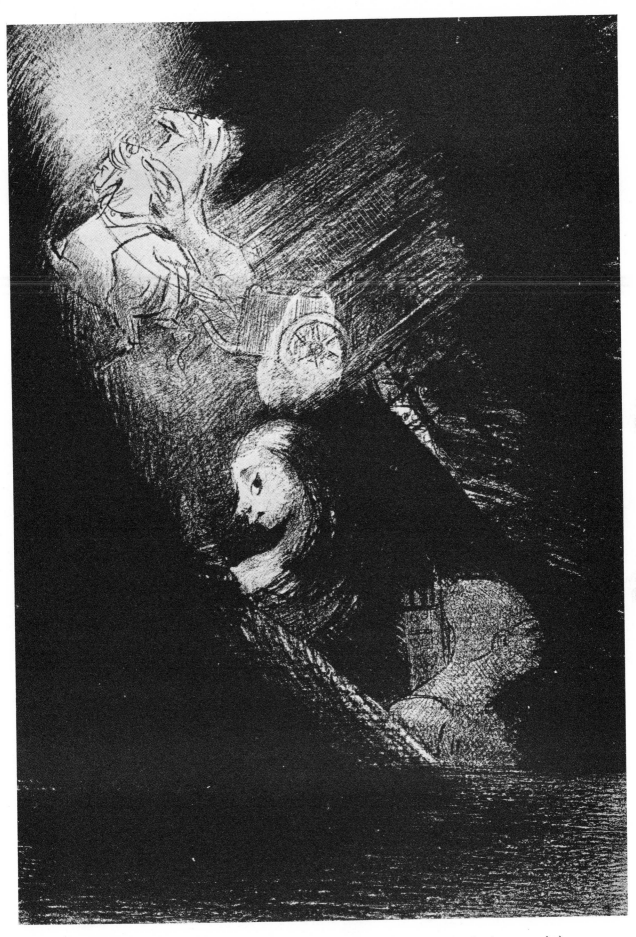

59 First a pool of water, then a prostitute (No. 1 of *Tentation de Saint-Antoine*, 1st series)

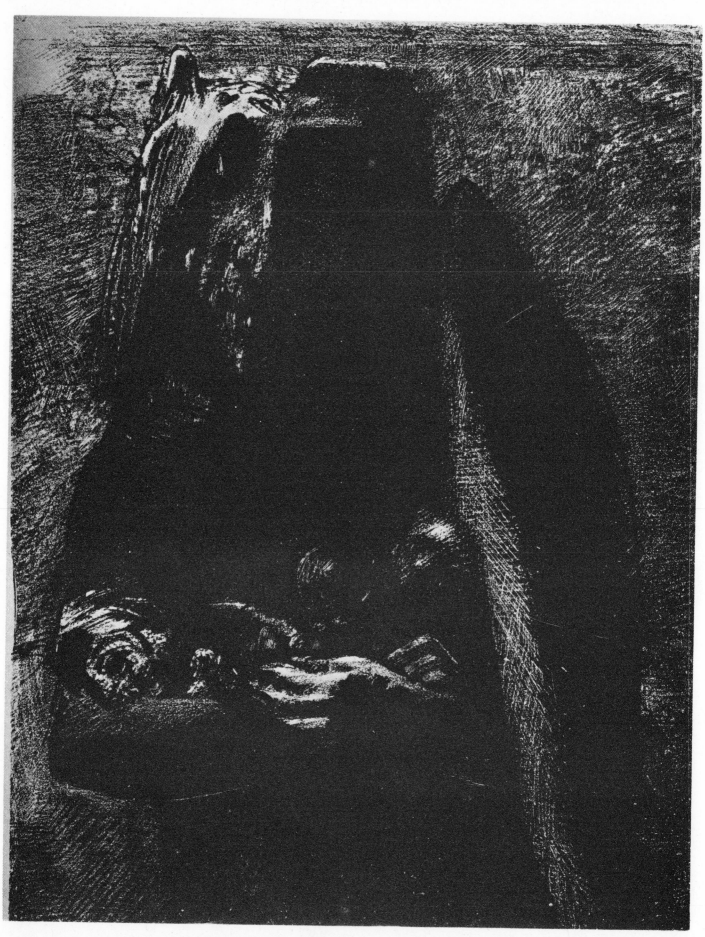

60 It is the devil (No. 2 of *Tentation de Saint-Antoine*, 1st series)

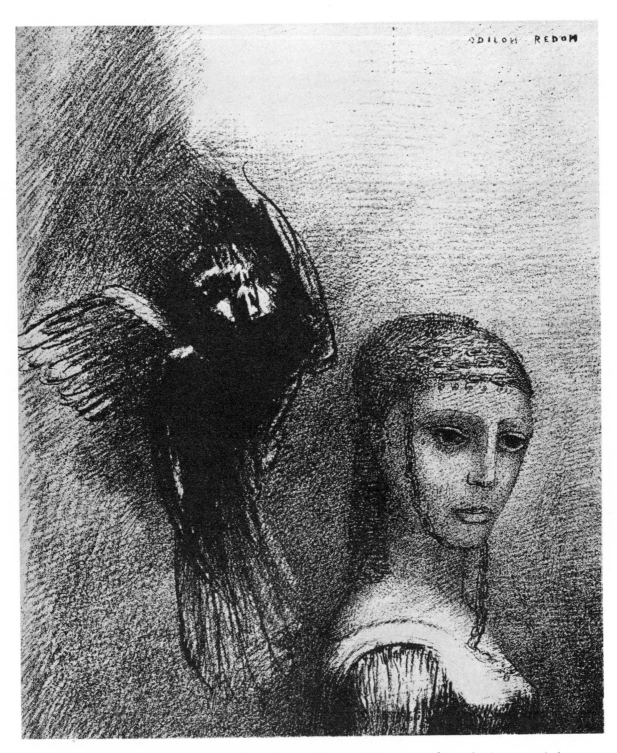

61 And a large bird, descending from the sky (No. 3 of *Tentation de Saint-Antoine*, 1st series)

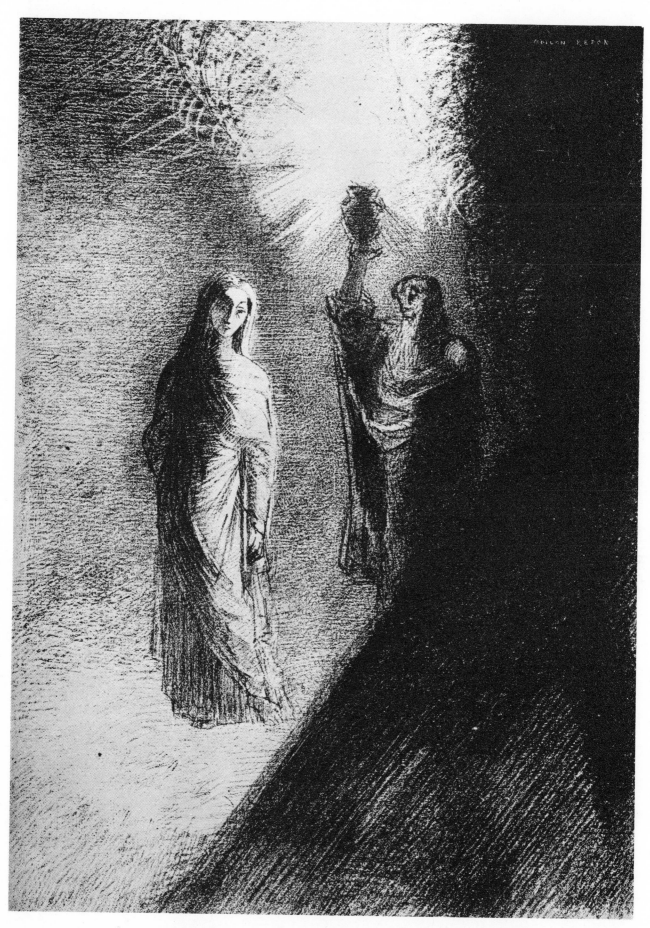

62 He raises the bronze urn (No. 4 of *Tentation de Saint-Antoine*, 1st series)

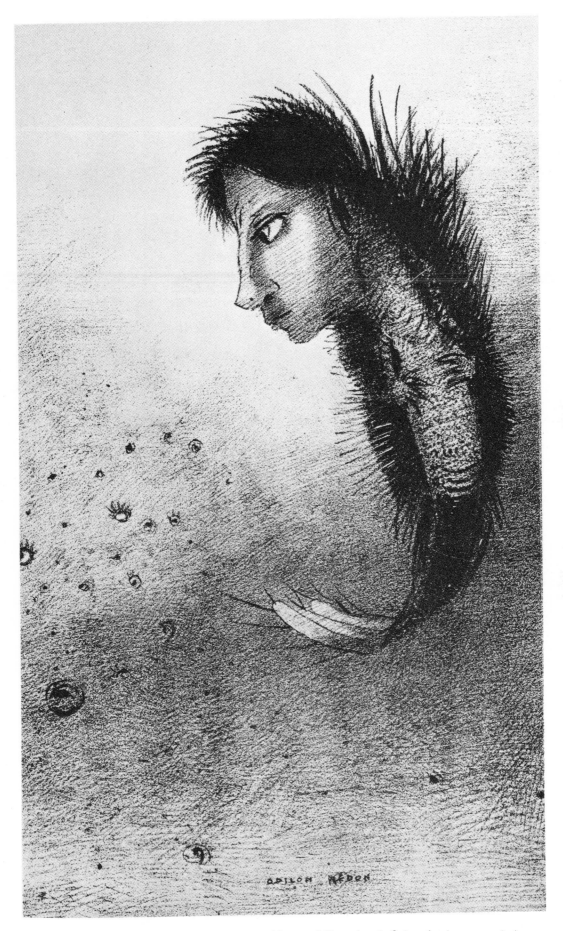

63 Then there appears a singular being (No. 5 of *Tentation de Saint-Antoine*, 1st series)

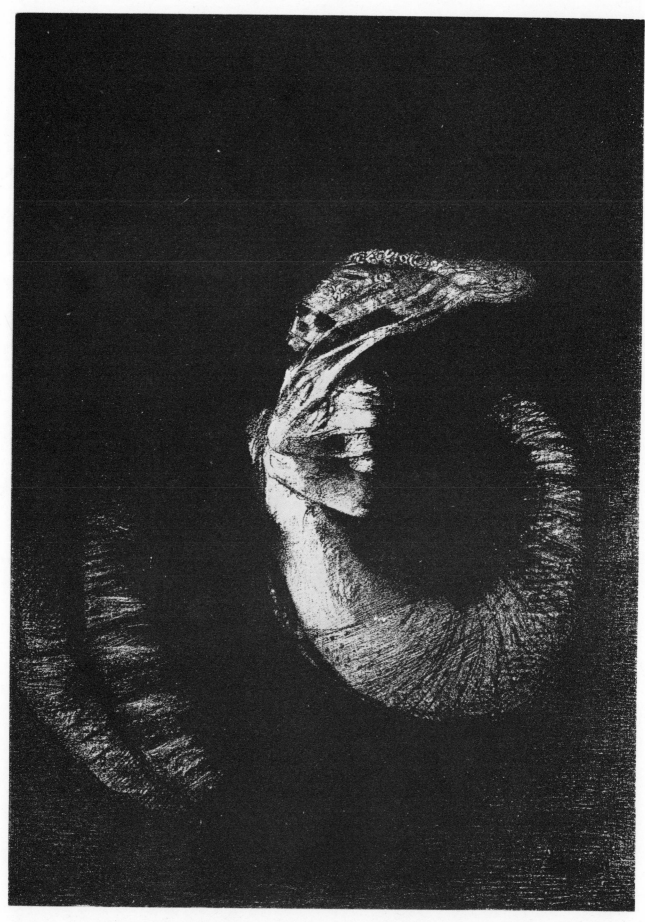

64 It is a skull wreathed with roses (No. 6 of *Tentation de Saint-Antoine*, 1st series)

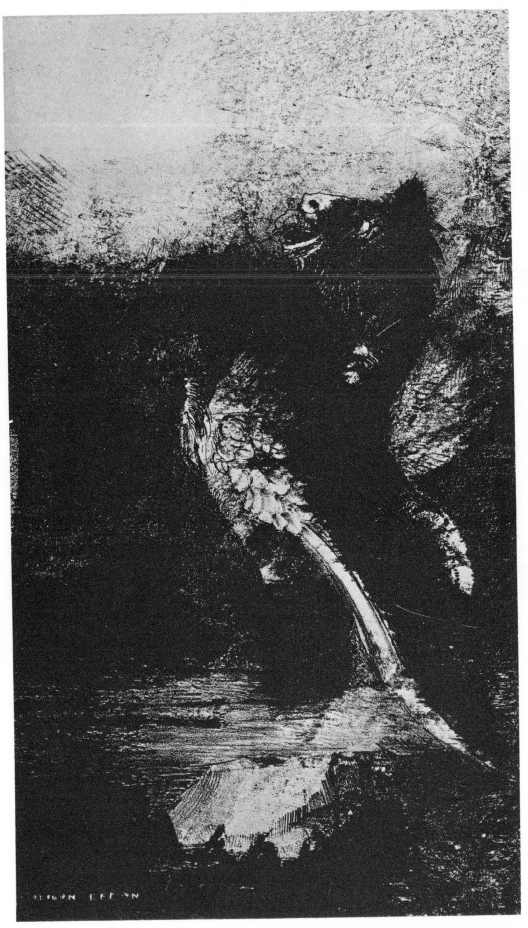

65 The chimera with green eyes turns, bays (No. 7 of *Tentation de Saint Antoine*, 1st series)

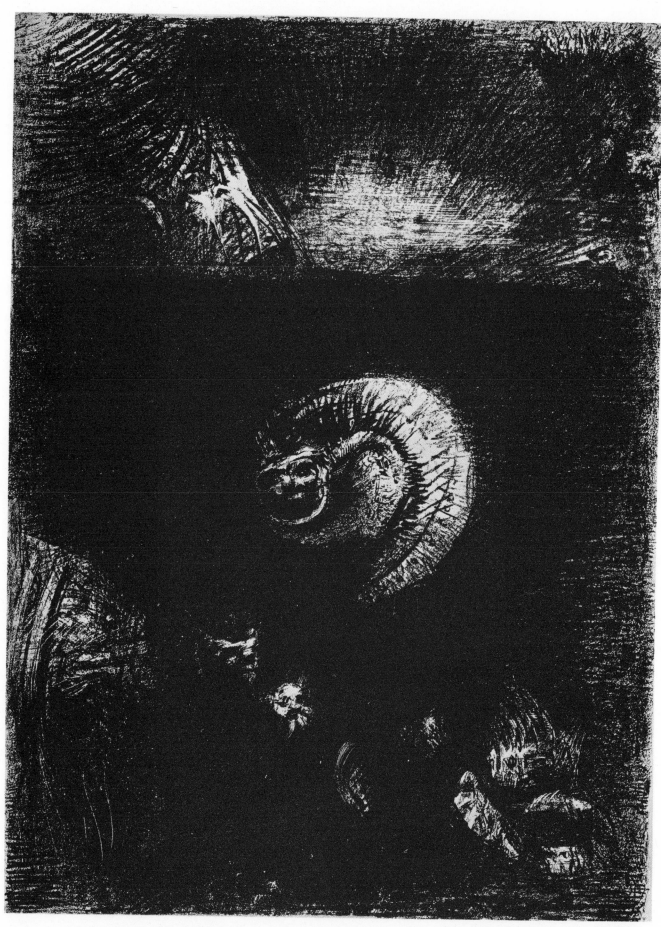

66 And all manner of frightful creatures arise (No. 8 of *Tentation de Saint Antoine*, 1st series)

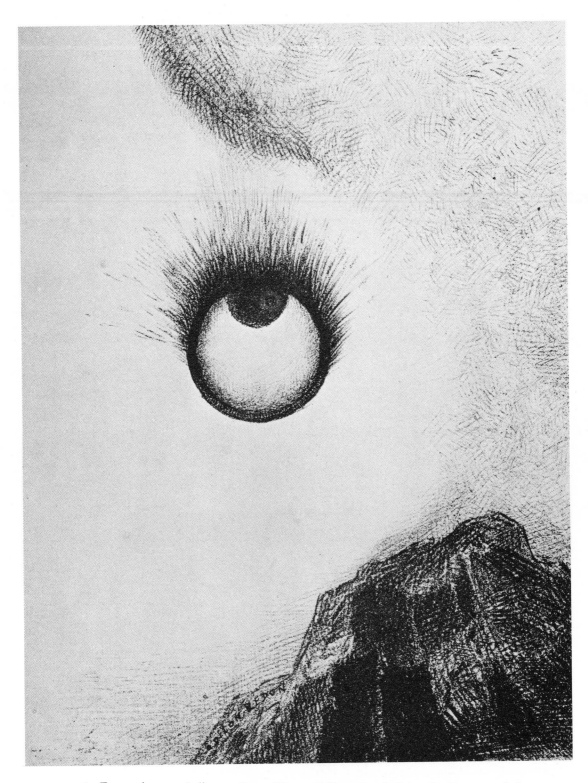

67 Everywhere eyeballs are aflame (No. 9 of *Tentation de Saint Antoine*, 1st series)

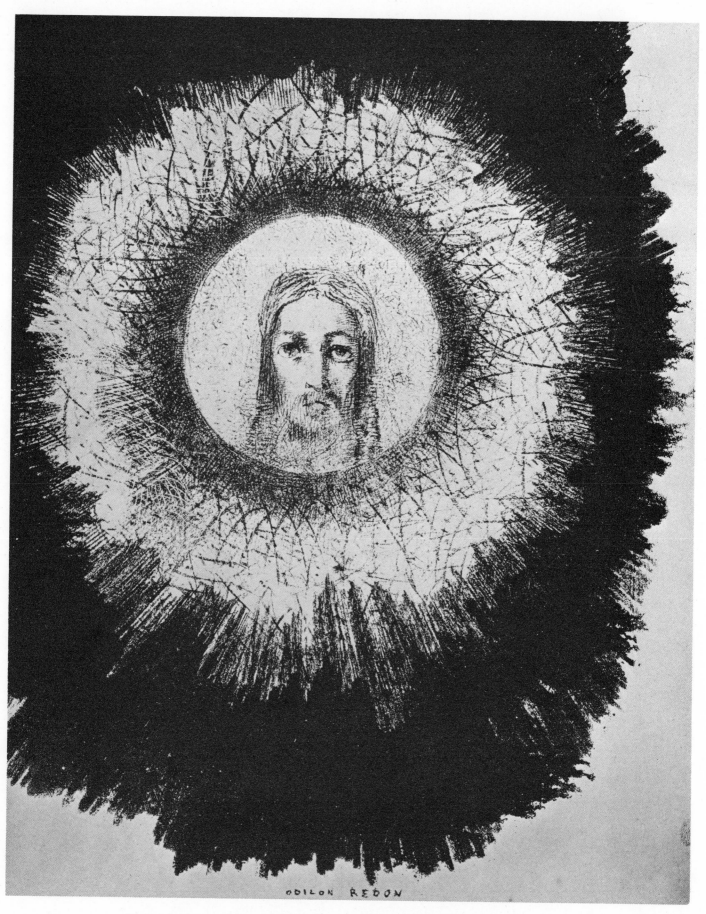

ODILON REDON

68 And in the very disk of the sun (No. 10 of *Tentation de Saint-Antoine*, 1st series)

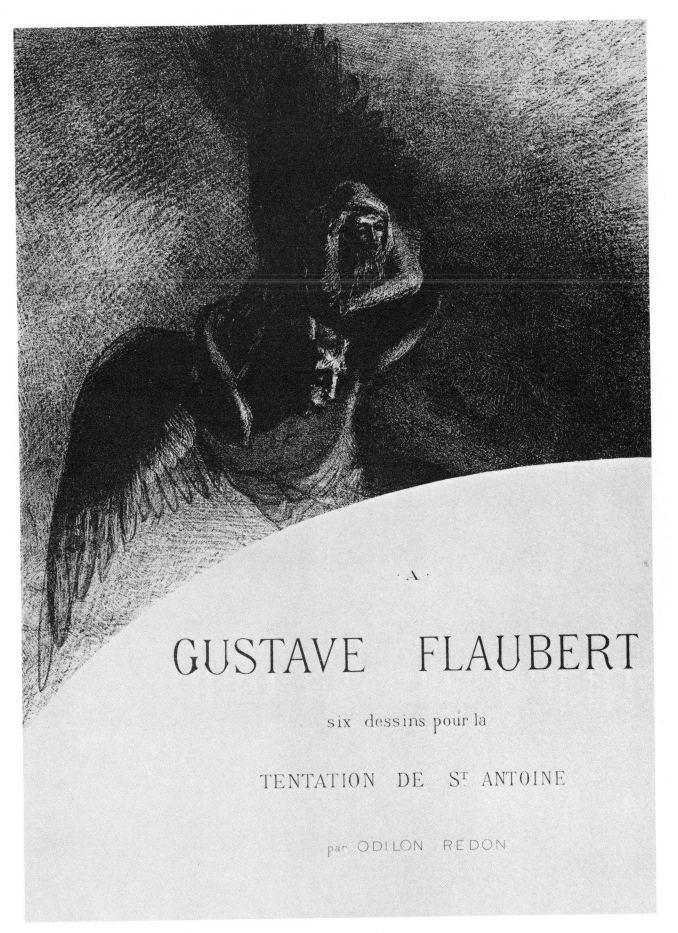

69 Title plate of *A Gustave Flaubert* (2nd *Tentation* series)

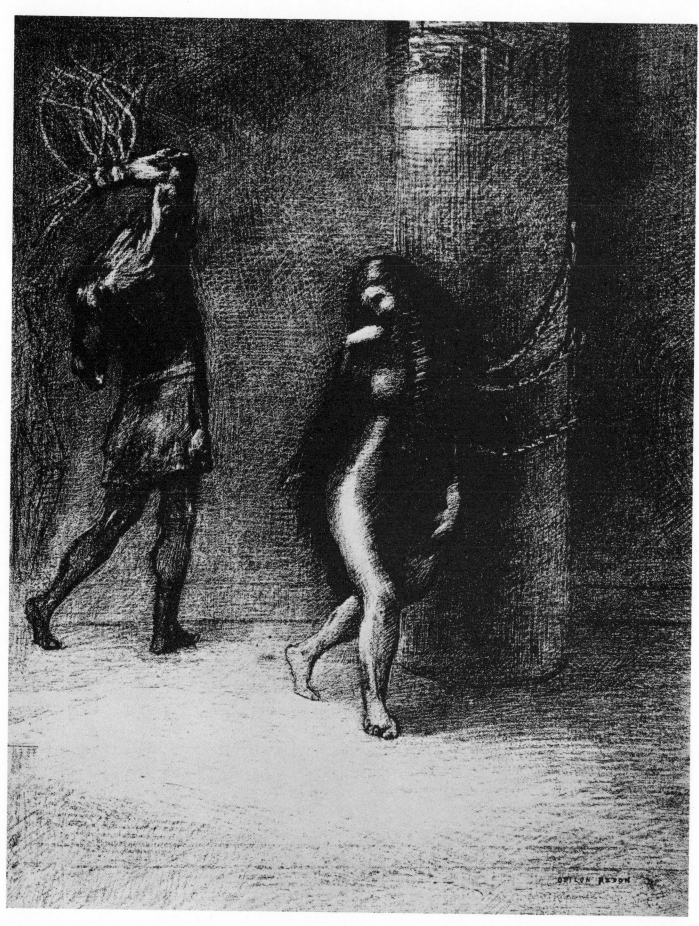

70 Saint Anthony: "Beneath her long hair . . ." (No. 1 of *A Gustave Flaubert*)

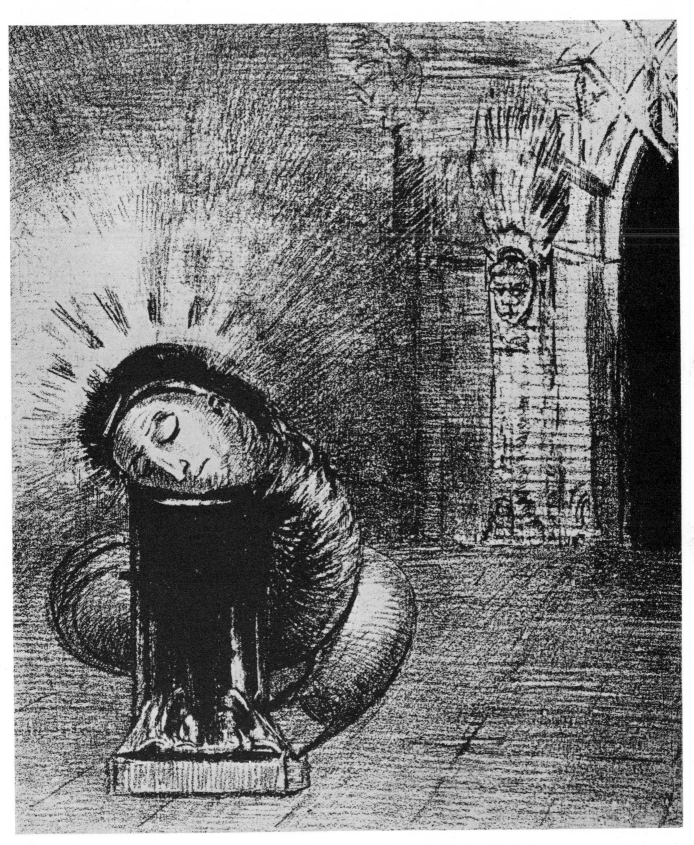

71 A long chrysalis, the color of blood (No. 2 of *A Gustave Flaubert*)

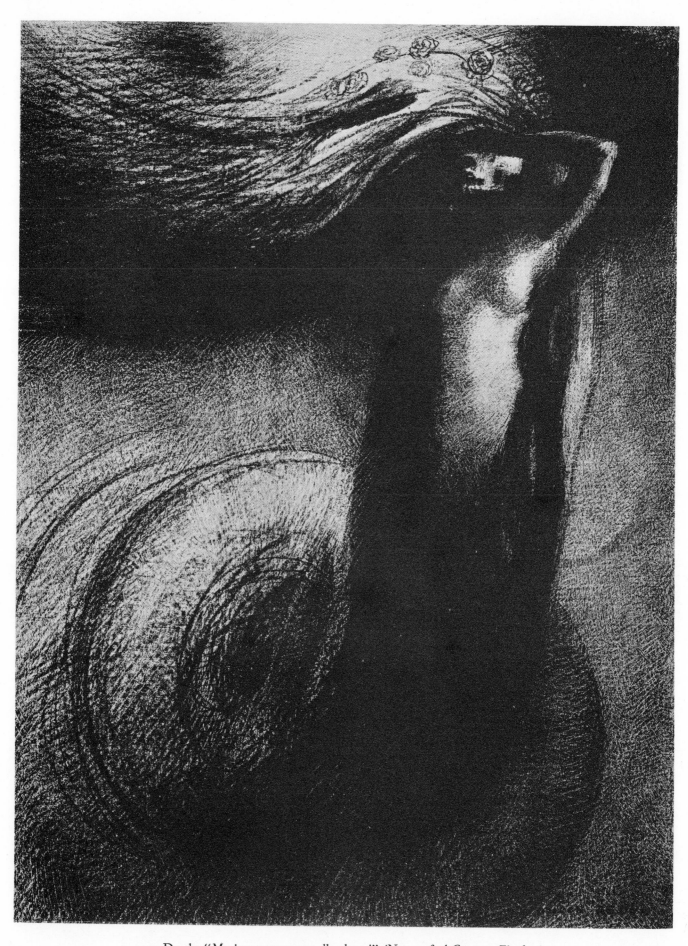

72 Death: "My irony surpasses all others!" (No. 3 of *A Gustave Flaubert*)

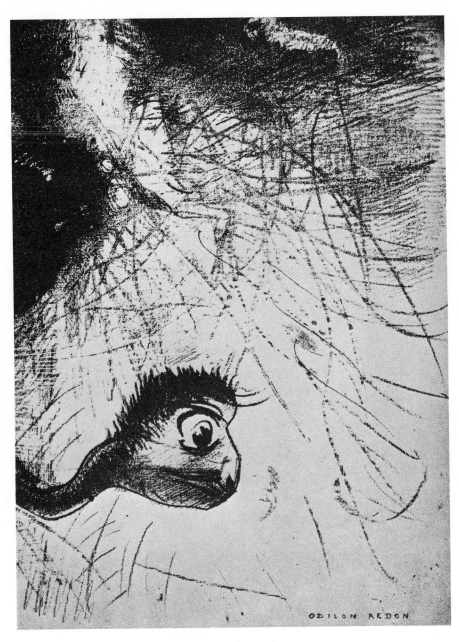

73 Saint Anthony: "Somewhere there must be primordial shapes . . ."
(No. 4 of *A Gustave Flaubert*)

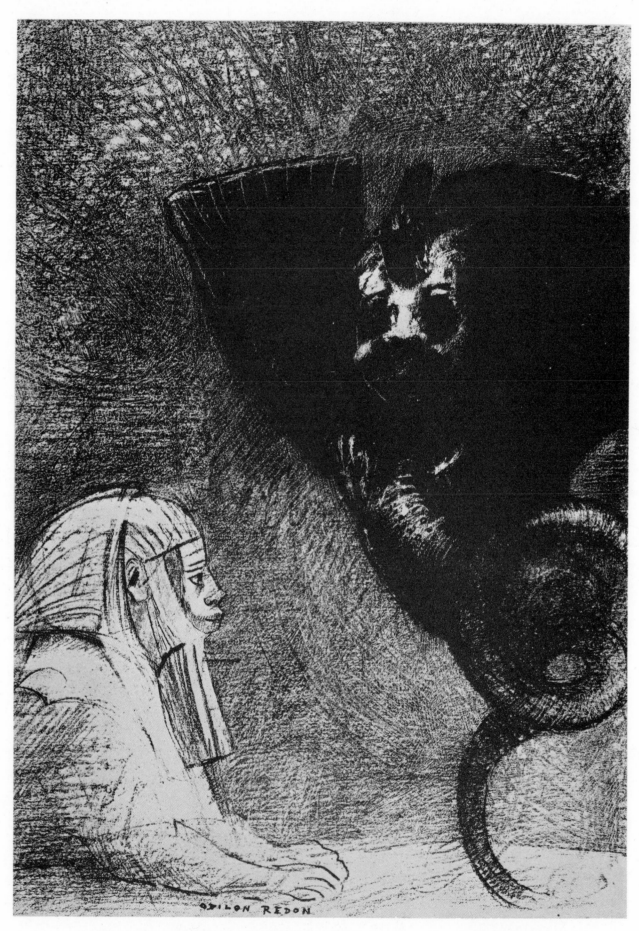

74 The Sphinx: "My gaze, which nothing can deflect . . ." (No. 5 of *A Gustave Flaubert*)

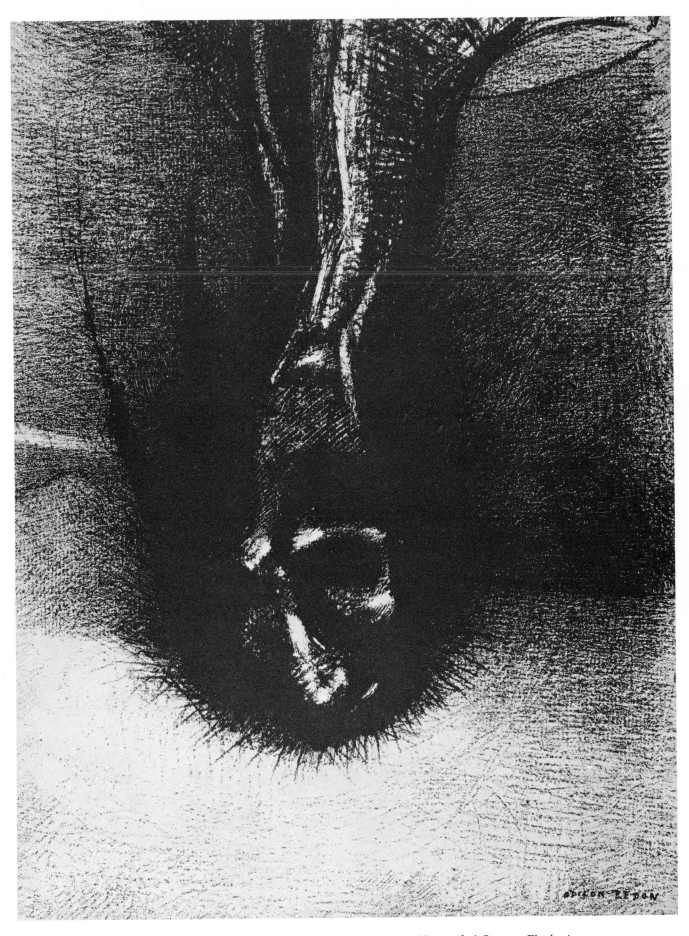

75 The Skiapods: "The head as low as possible . . ." (No. 6 of *A Gustave Flaubert*)

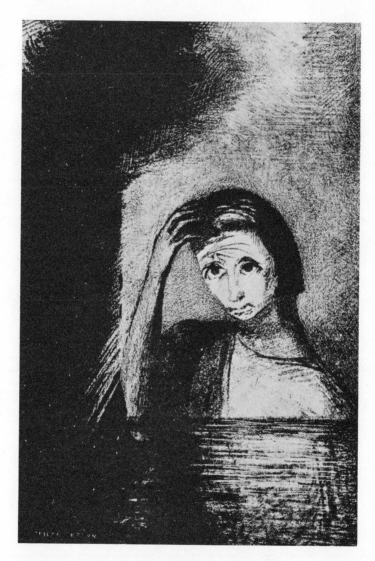

76 Frontispiece for *Les Débâcles*

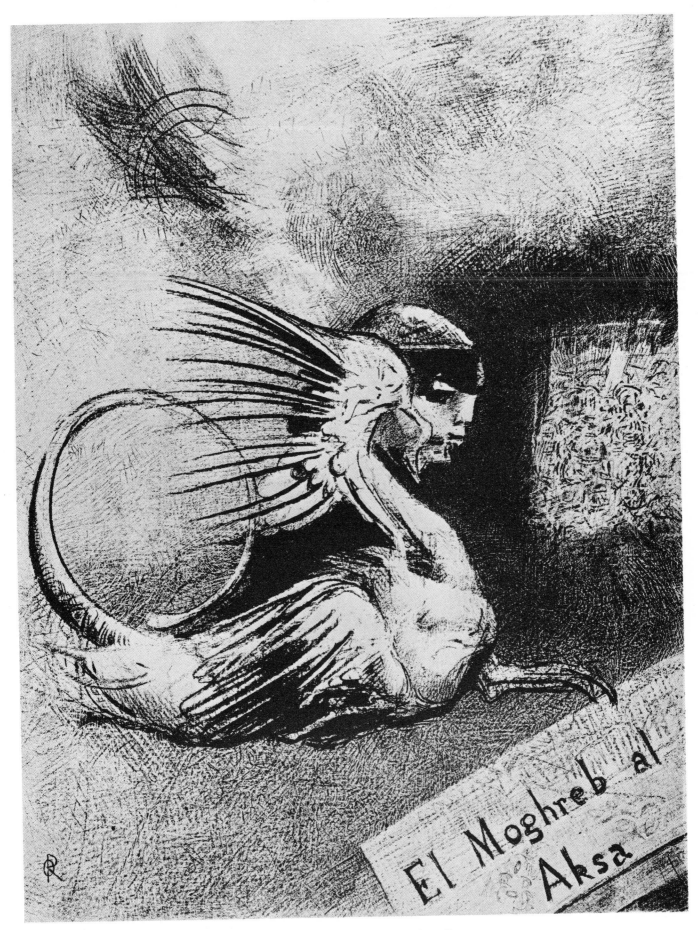

77 Frontispiece for *El Moghreb al Aksa*

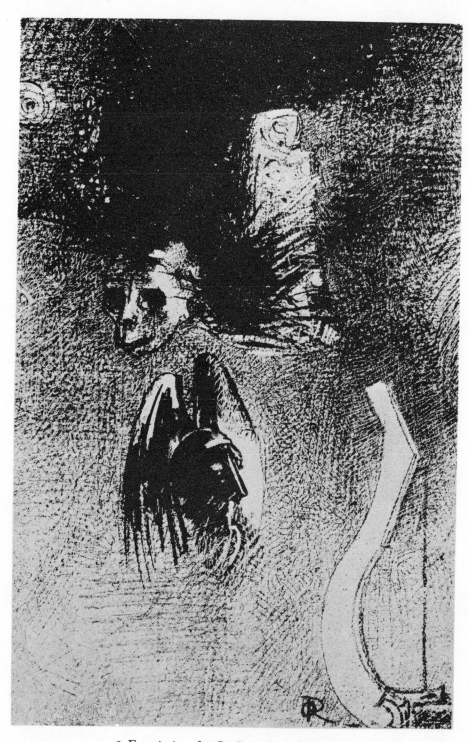

78 Frontispiece for *La Damnation de l'artiste*

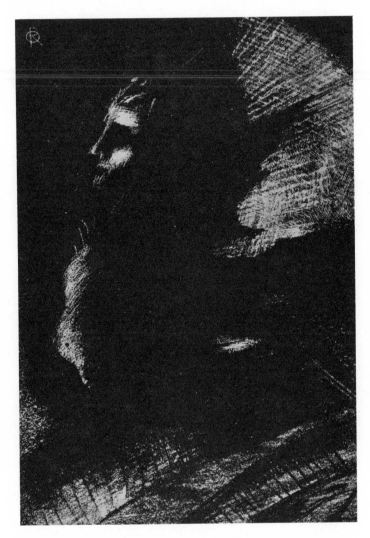

79 Frontispiece for *Les Chimères*

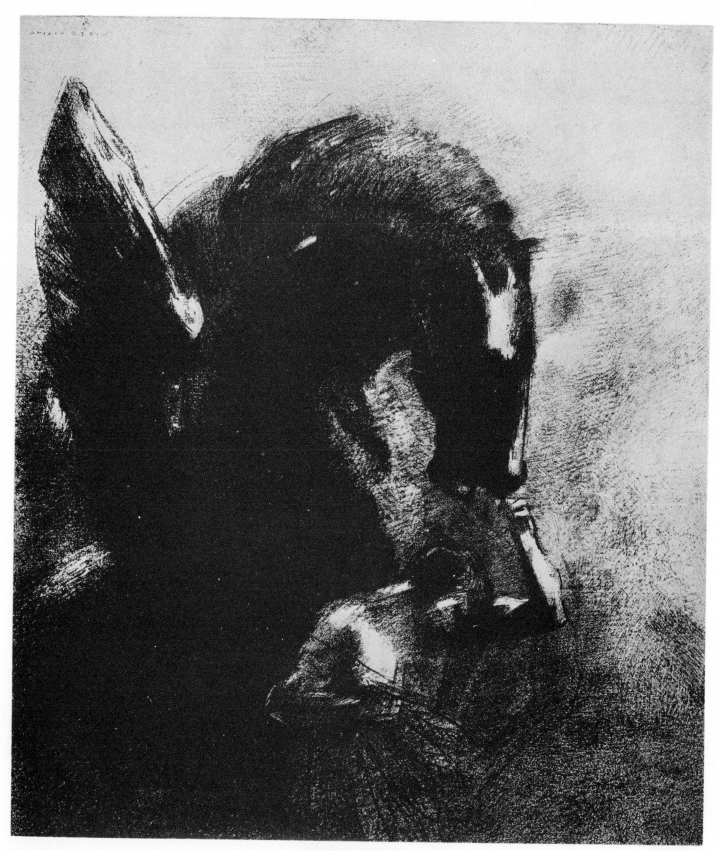

80 Captive Pegasus

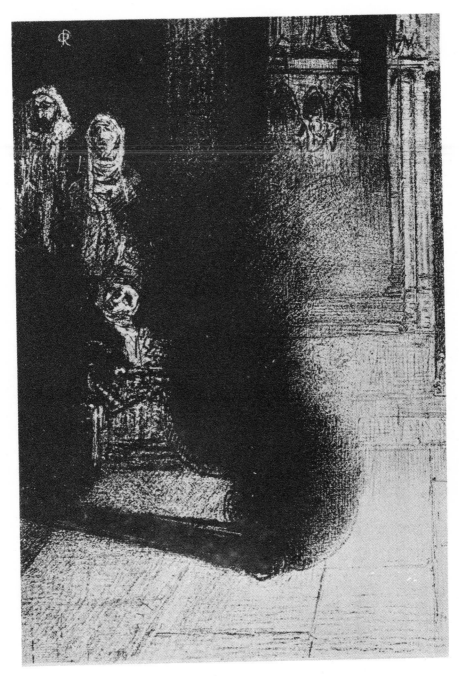

81 Frontispiece for *Les Flambeaux noirs*

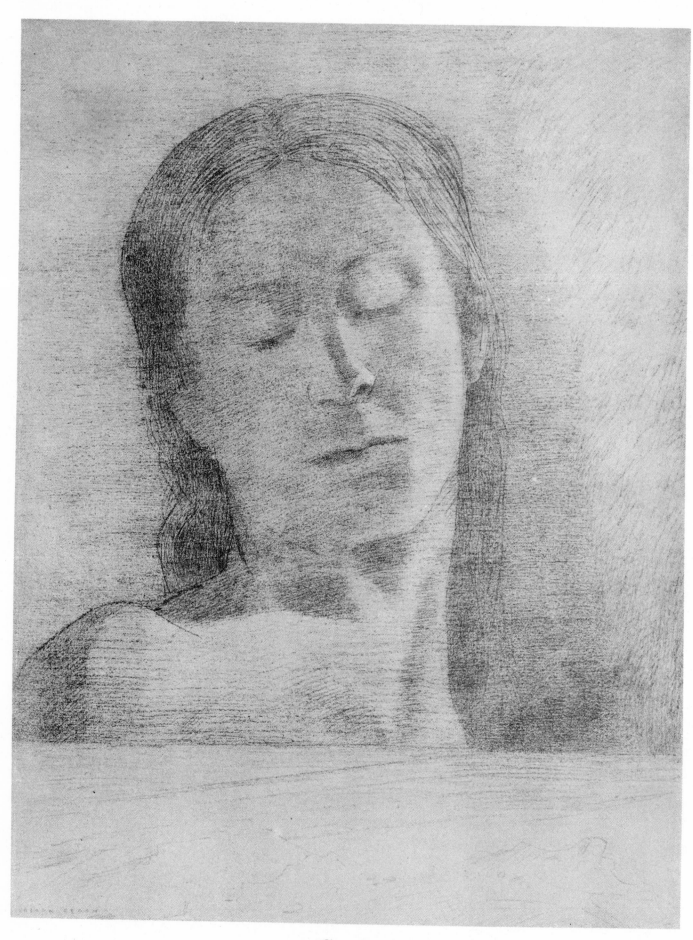

82 Closed Eyes

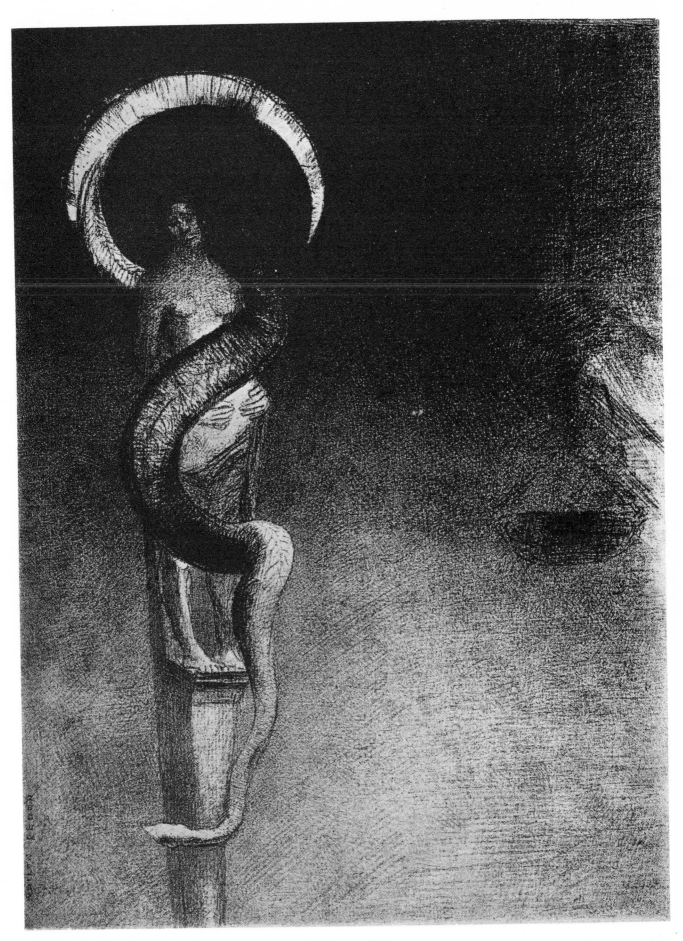

83 Serpent-Halo

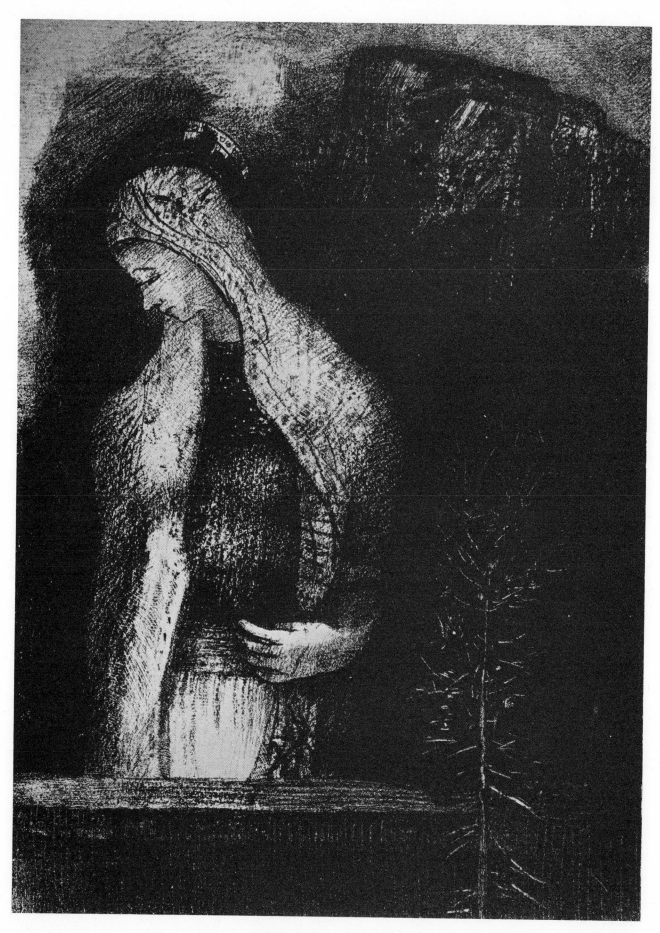

84 Female Saint and Thistle

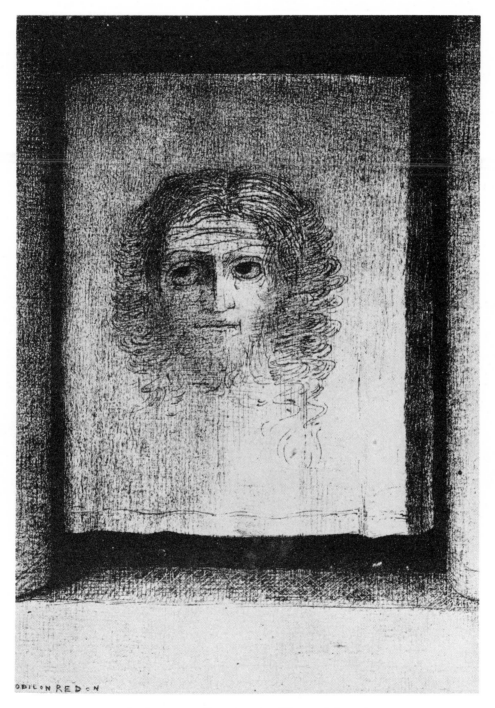

85 It was a veil, an imprint (No. 1 of *Songes*)

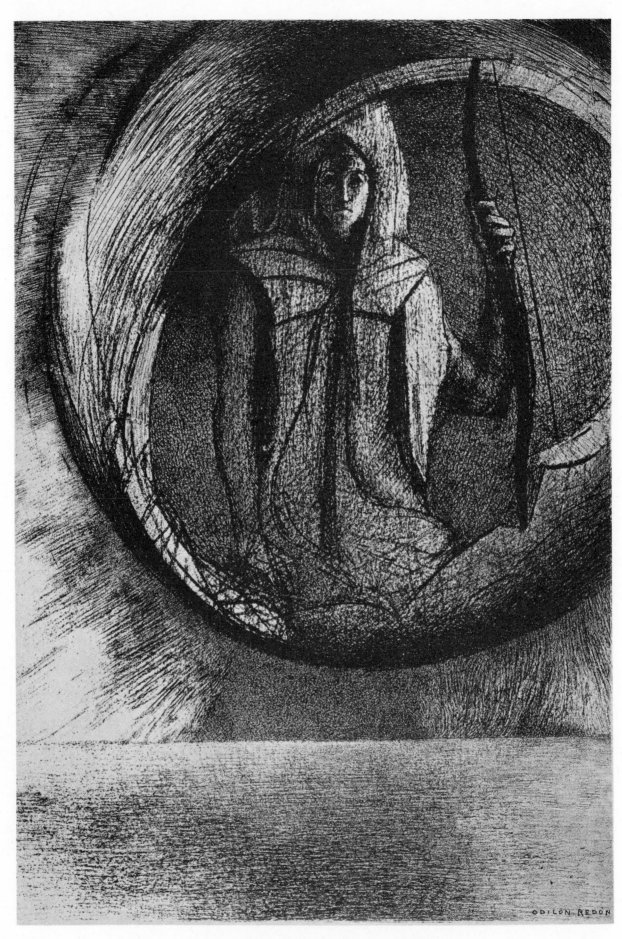

86 And beyond, the astral idol (No. 2 of *Songes*)

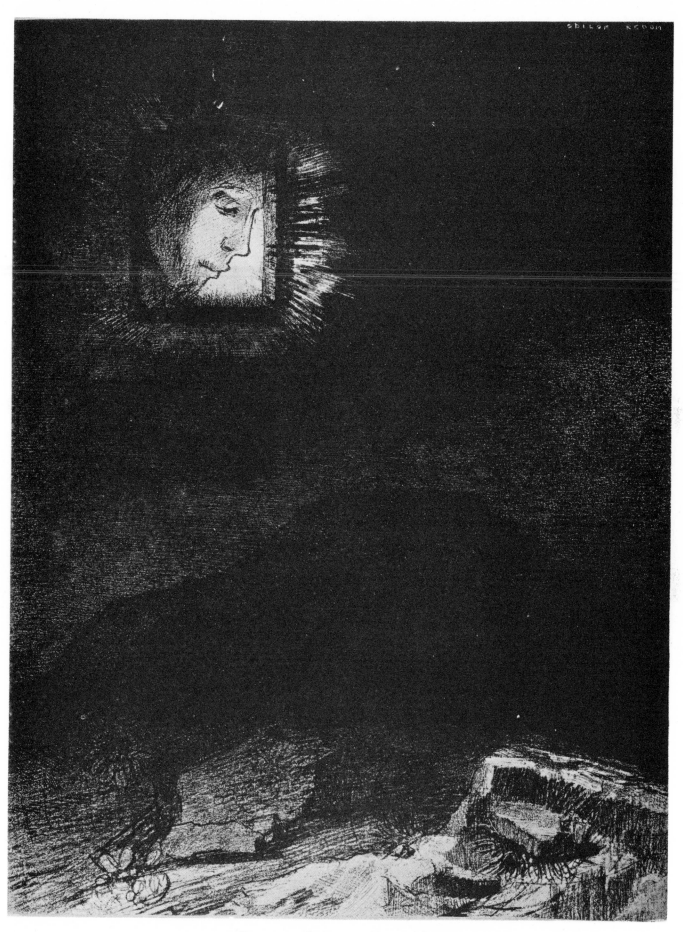

87 Precarious glimmering (No. 3 of *Songes*)

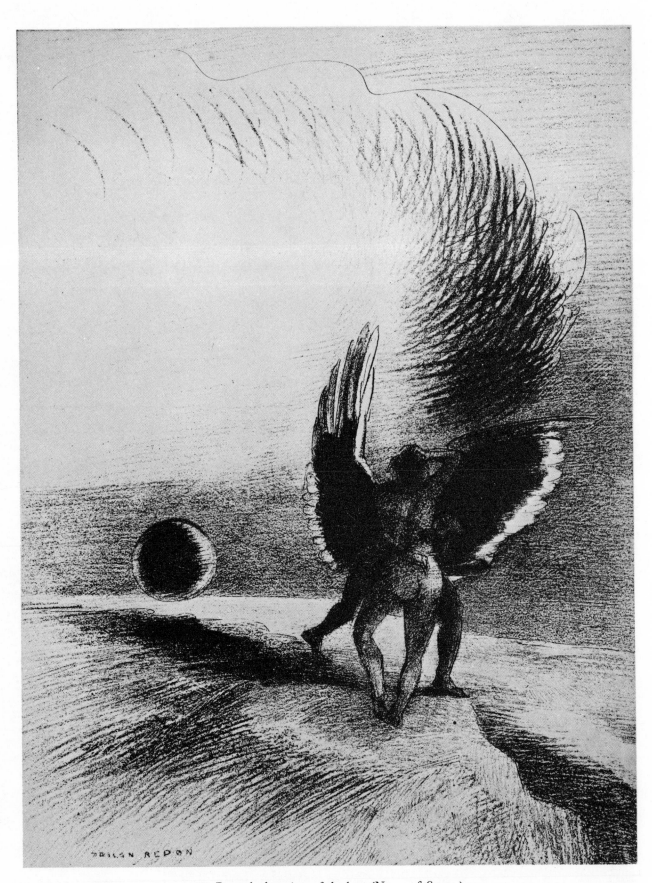

88 Beneath the wing of shadow (No. 4 of *Songes*)

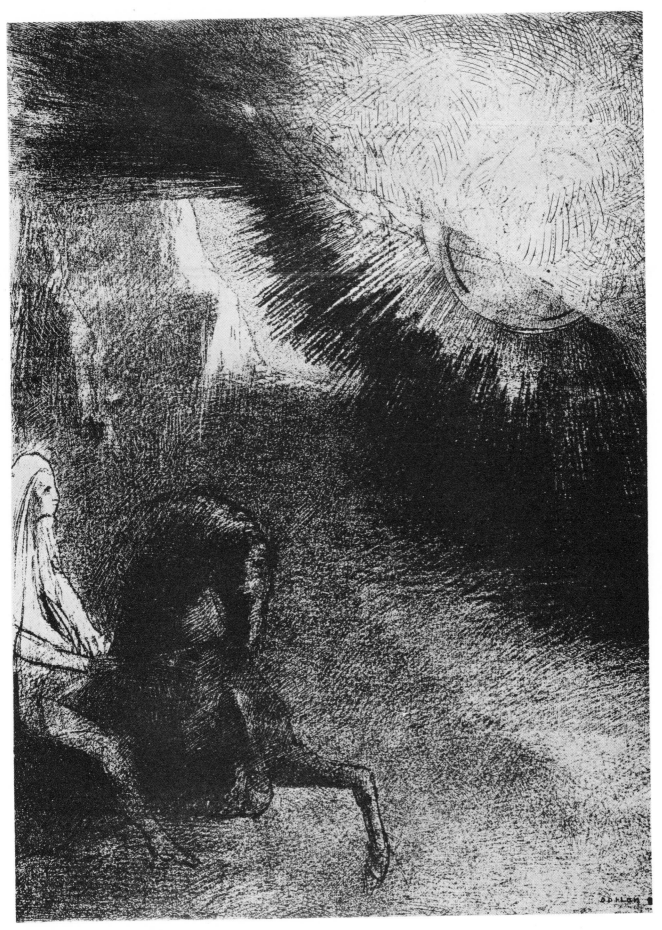

89 Pilgrim of the sublunary world (No. 5 of *Songes*)

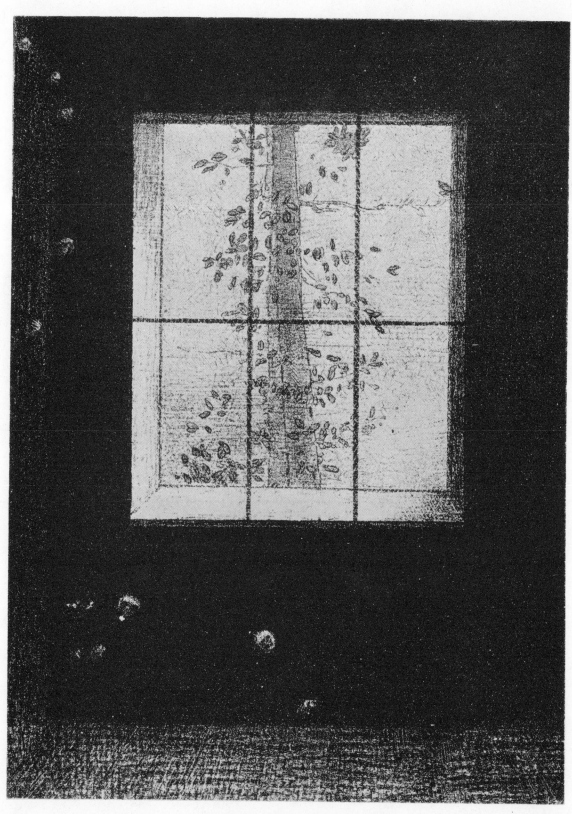

90 Day (No. 6 of *Songes*)

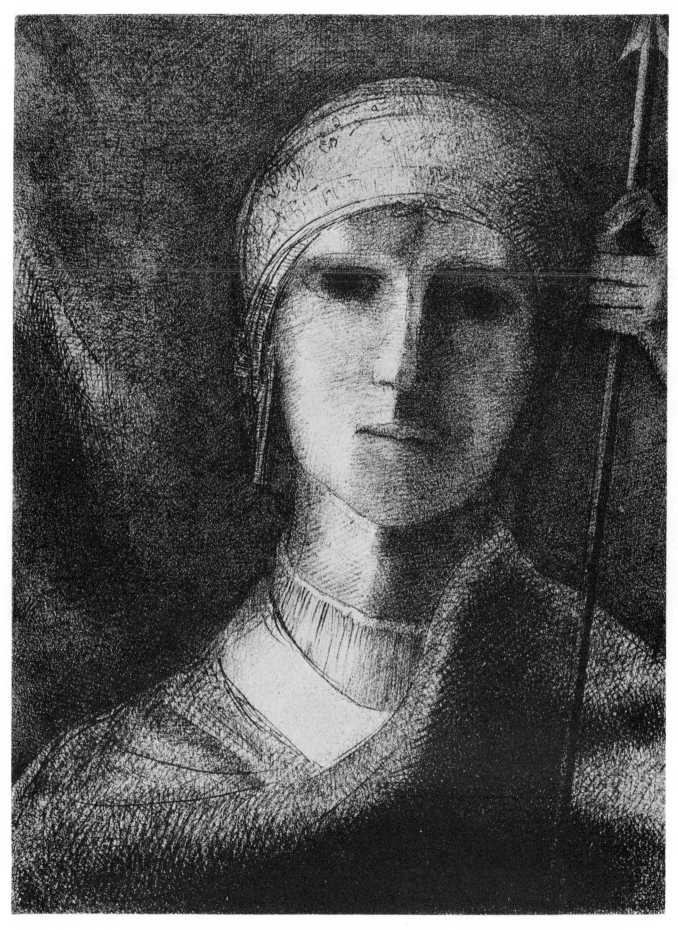

91 Parsifal

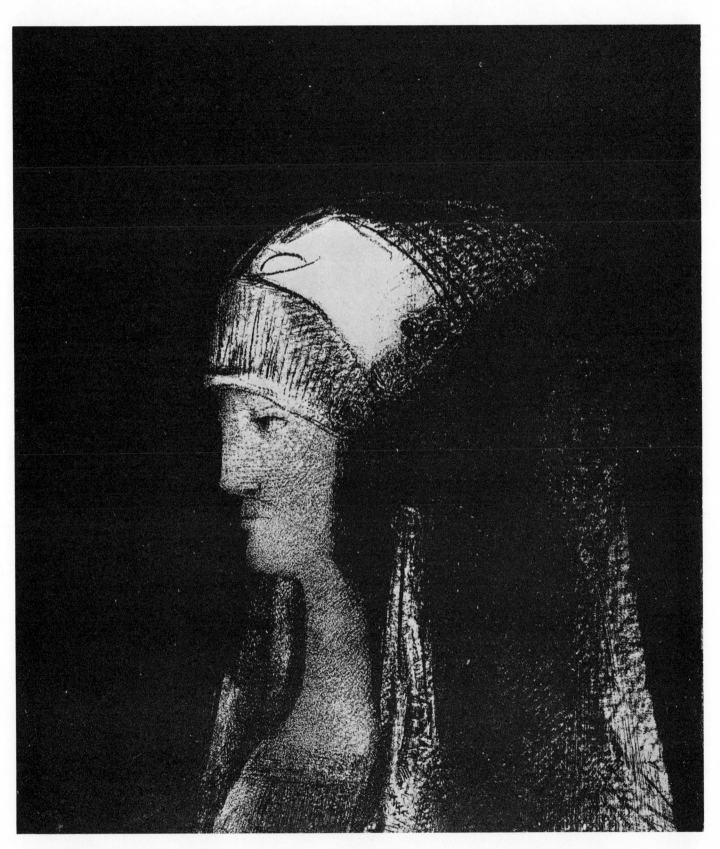

92 Druid Priestess

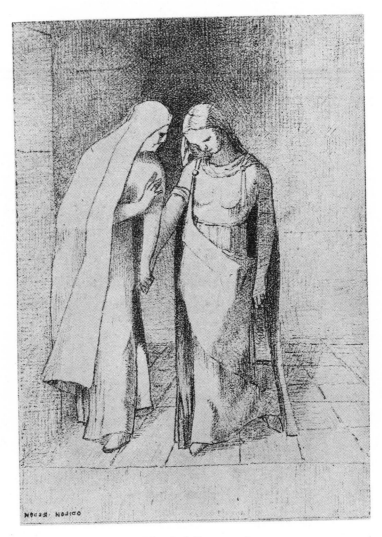

93 Mystical Conversation

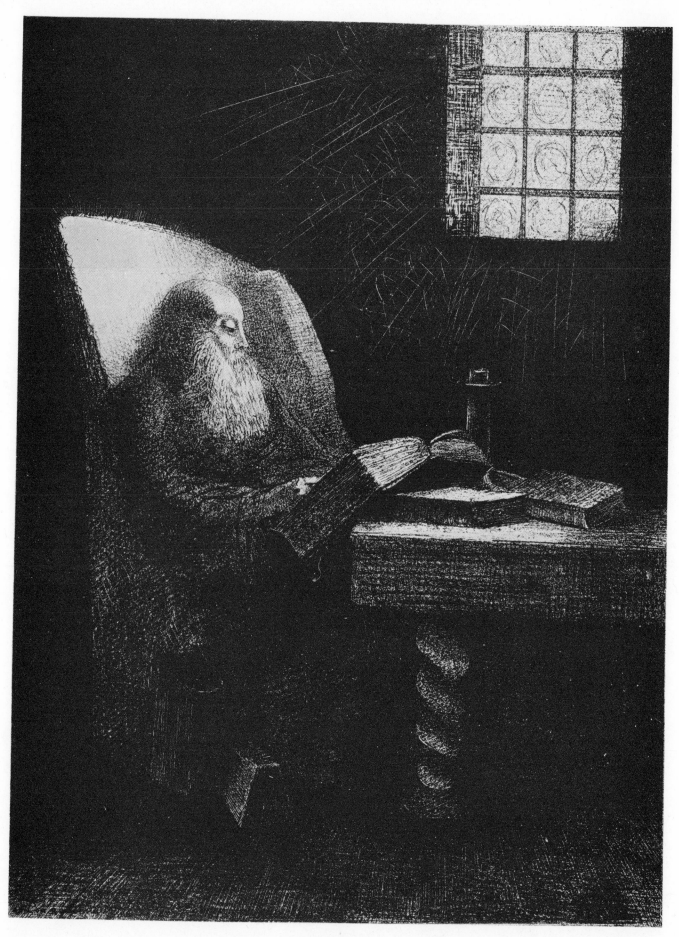

94 The Reader

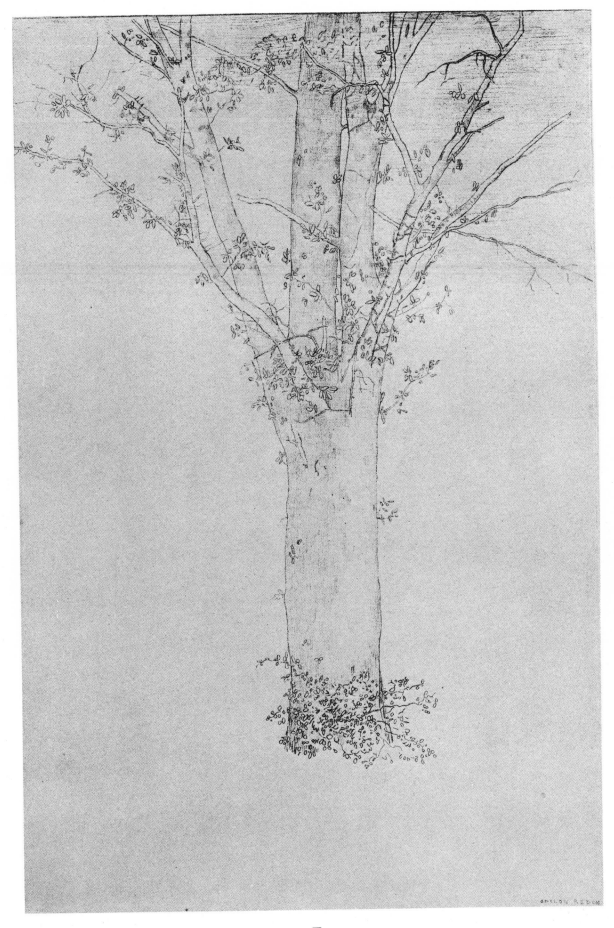

ODILON REDON

95 Tree

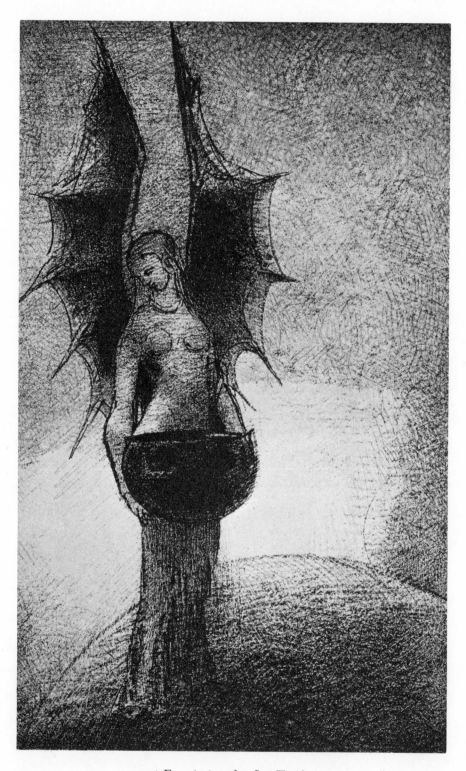

96 Frontispiece for *Les Ténèbres*

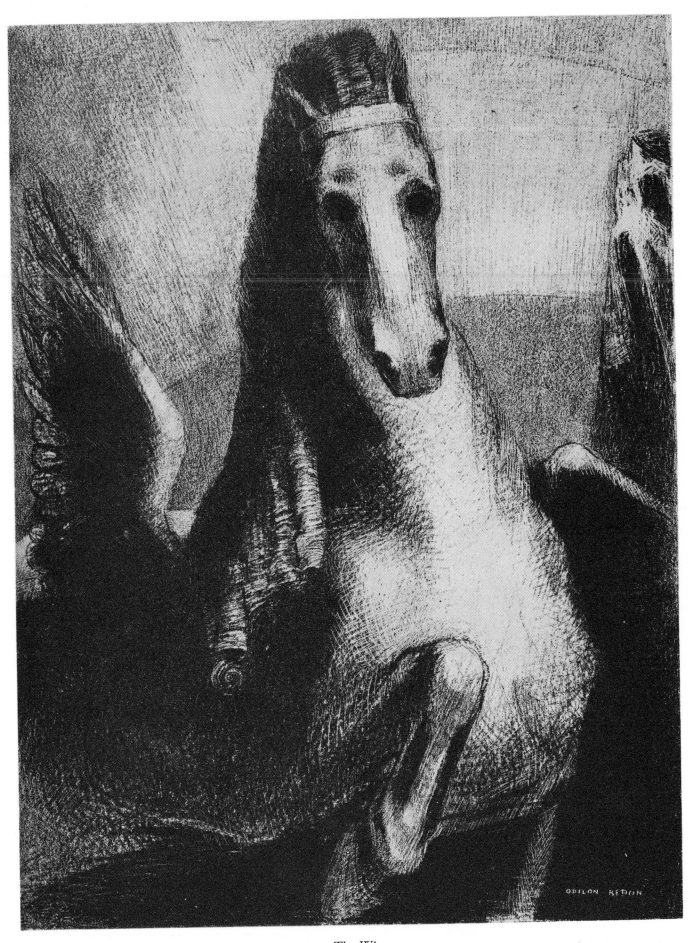

97 The Wing

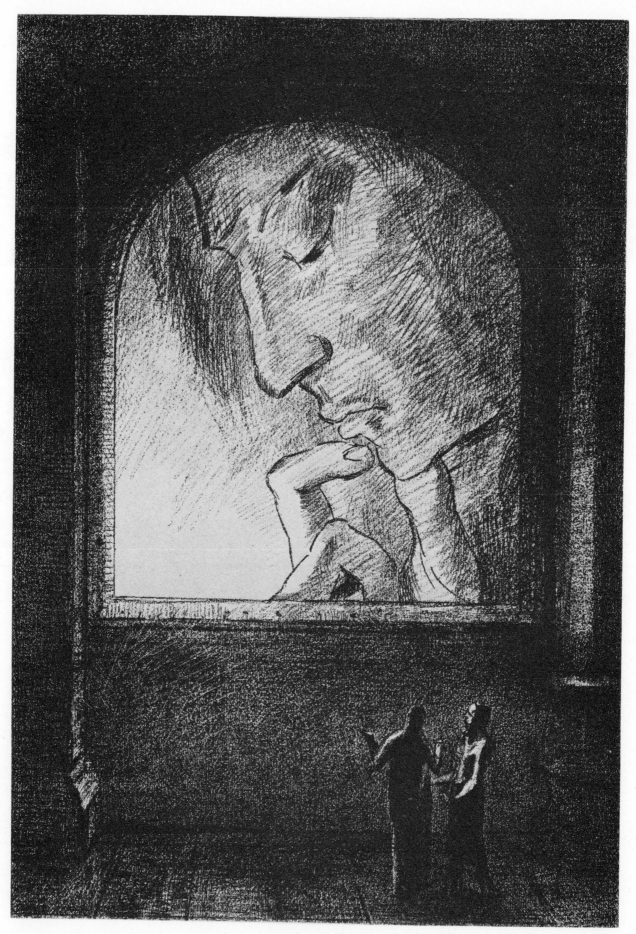

98 Light

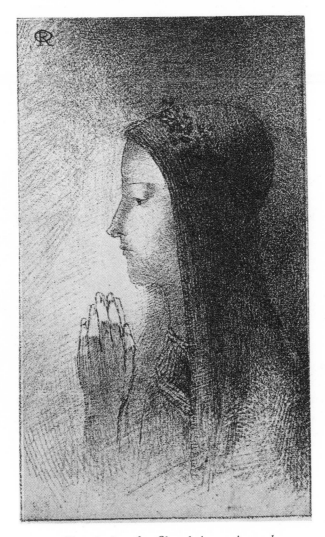

99 Frontispiece for *Chevaleries sentimentales*

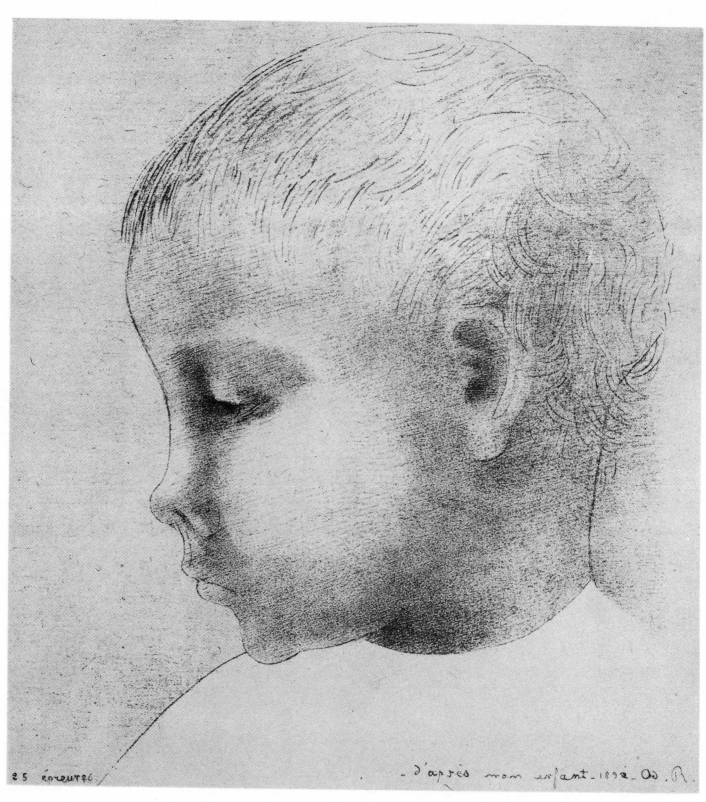

100 My Child

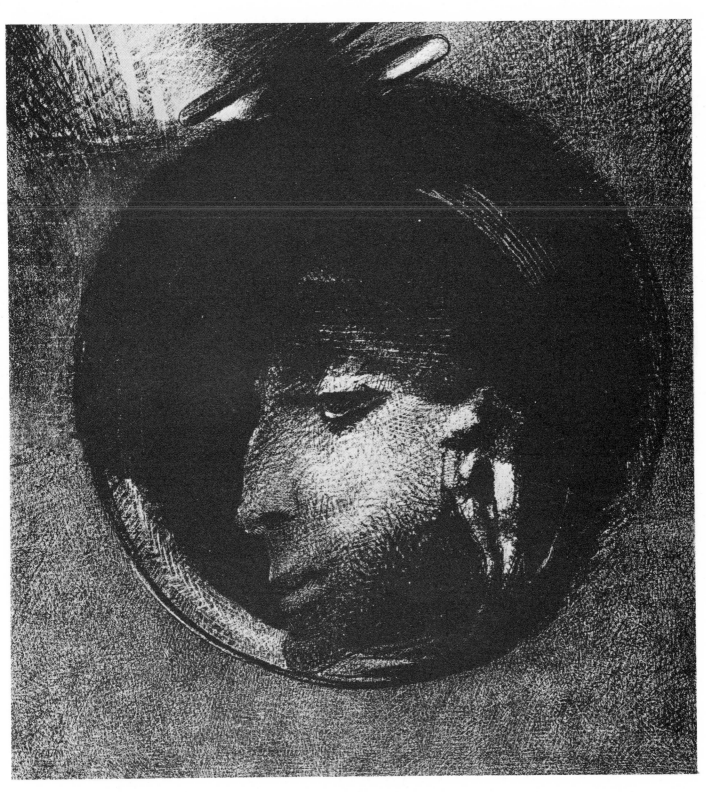

101 Auricular Cell

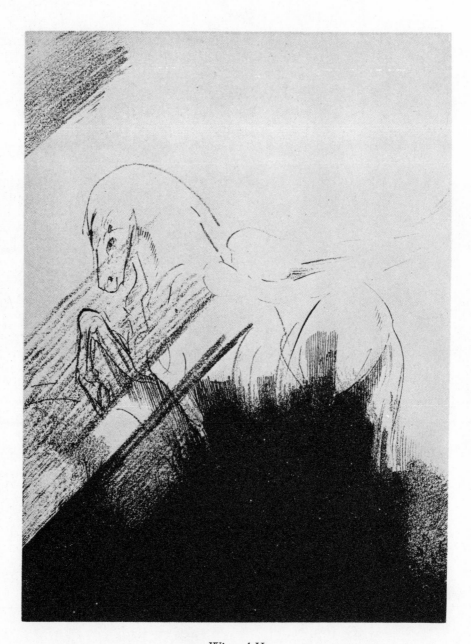

102 Winged Horse

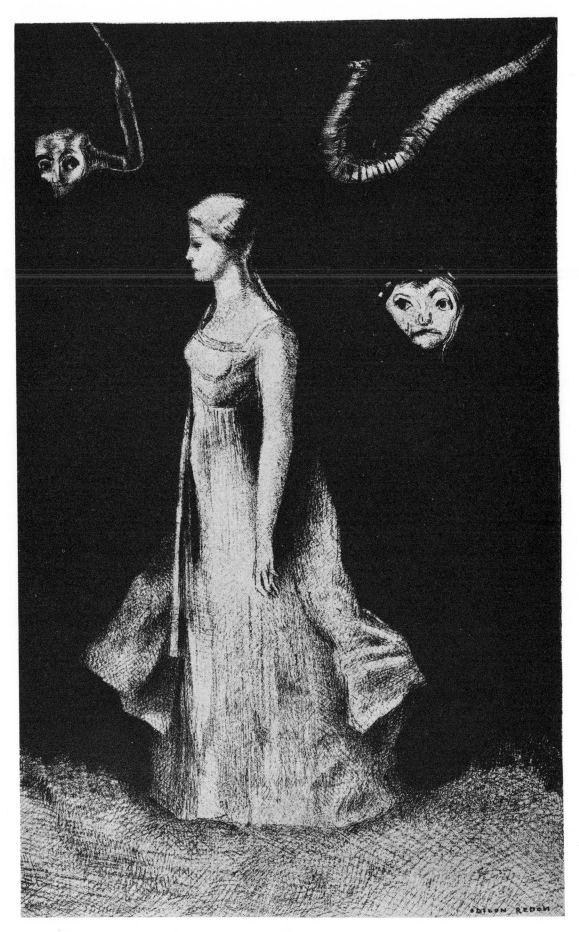

103 Obsession

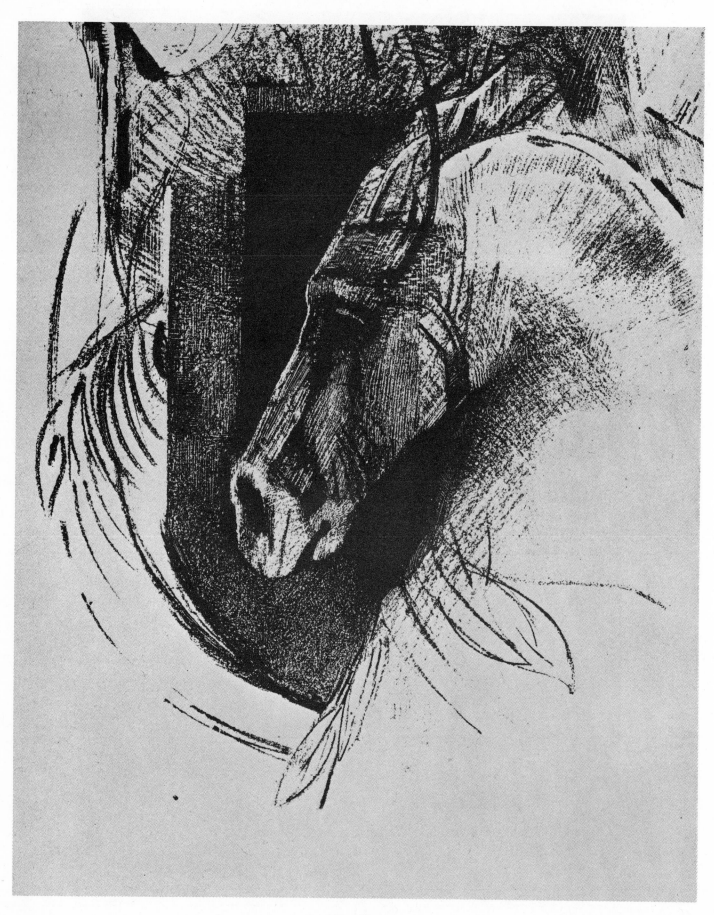

104 The Charger

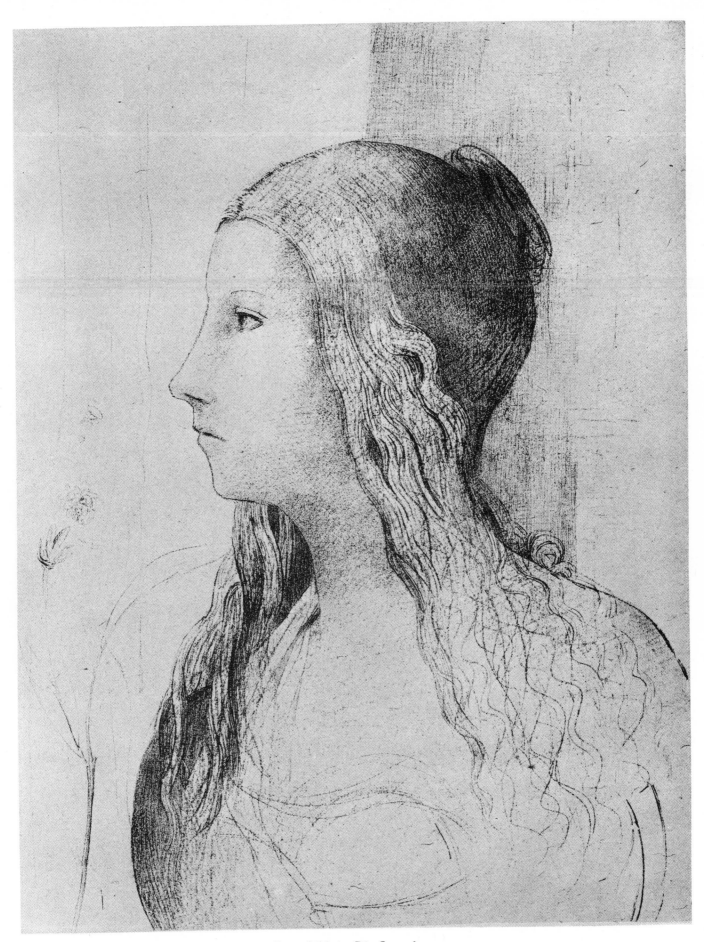

105 Brünnhilde in *Die Götterdämmerung*

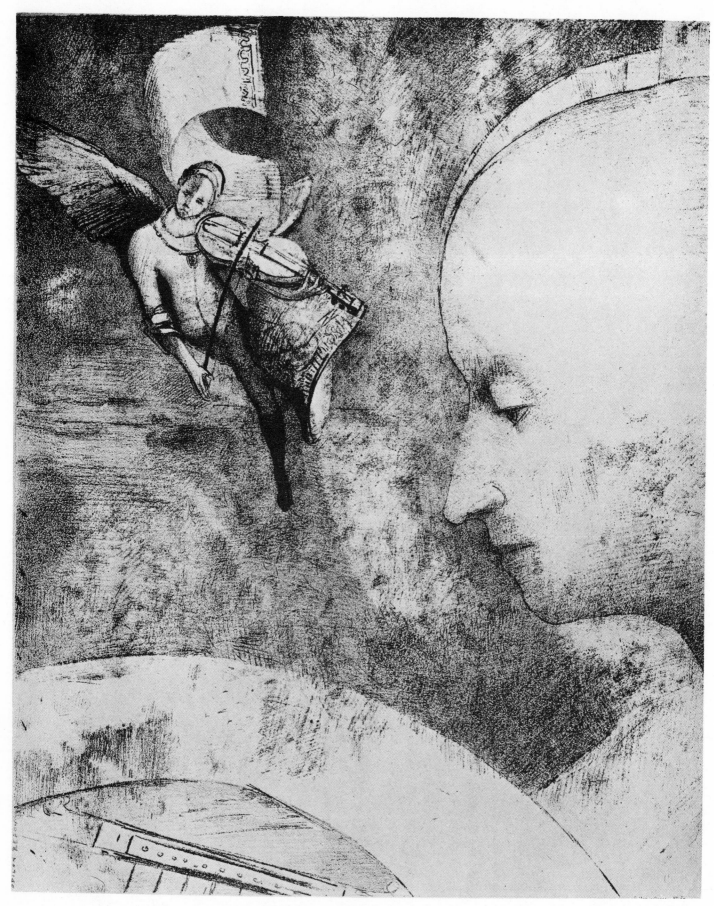

106 The Celestial Art

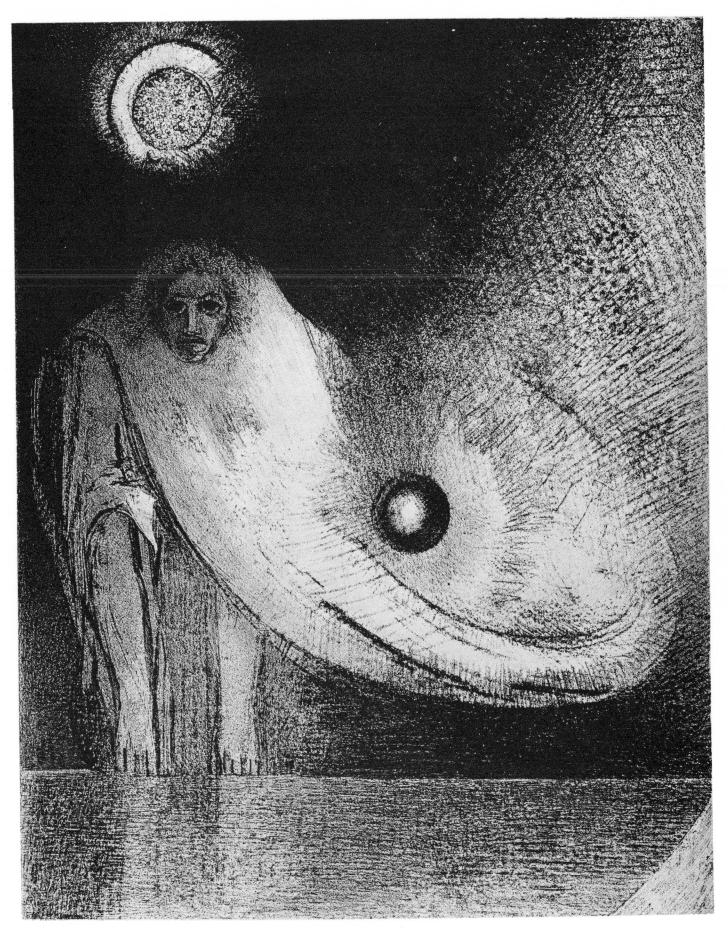

107 The Buddha

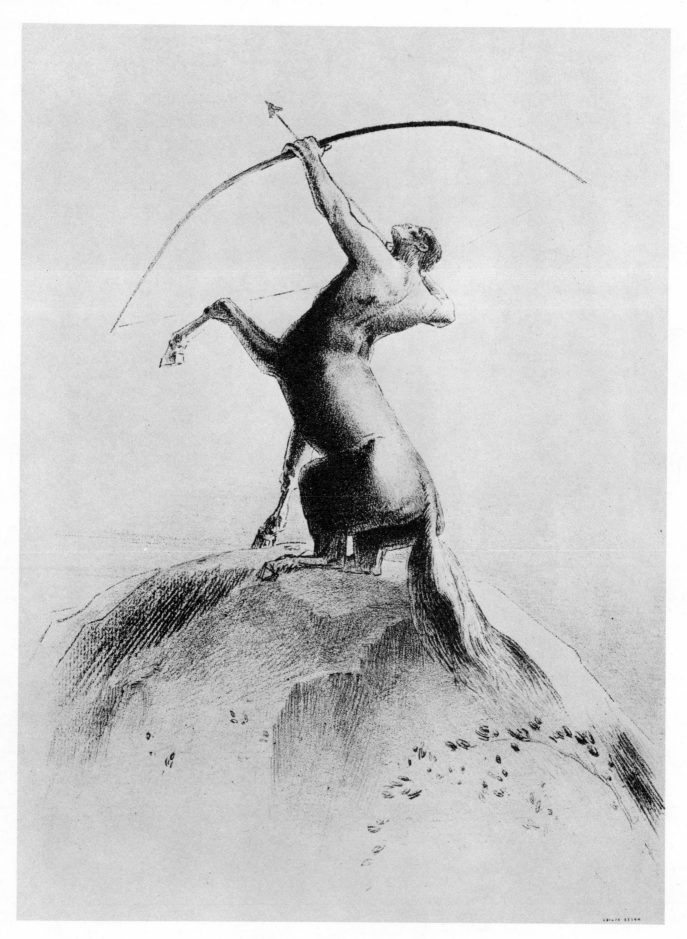

108 Centaur Aiming at the Clouds

LA TENTATION

DE

SAINT=ANTOINE

(3ª SERIE)

Texte de

GUSTAVE FLAUBERT

109 Title plate (= No. 1) of *La Tentation de Saint-Antoine*, 3rd series

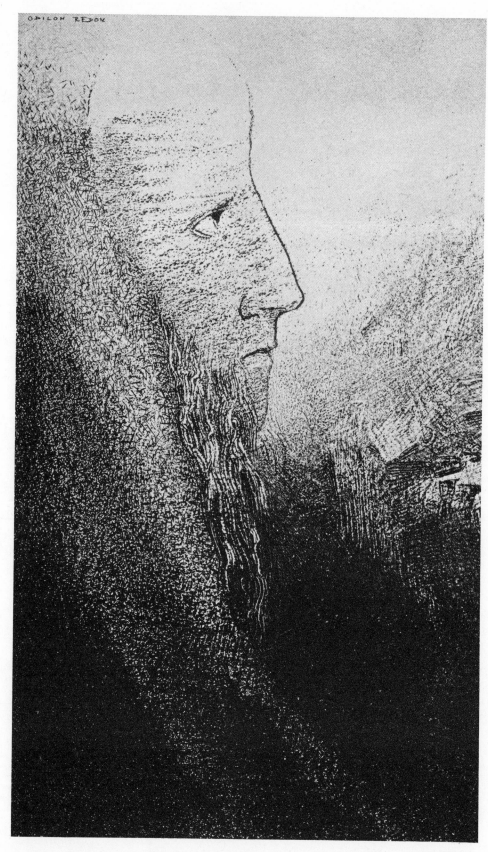

110 Saint Anthony: "Help me, O my God!" (No. 2 of *La Tentation*, 3rd series)

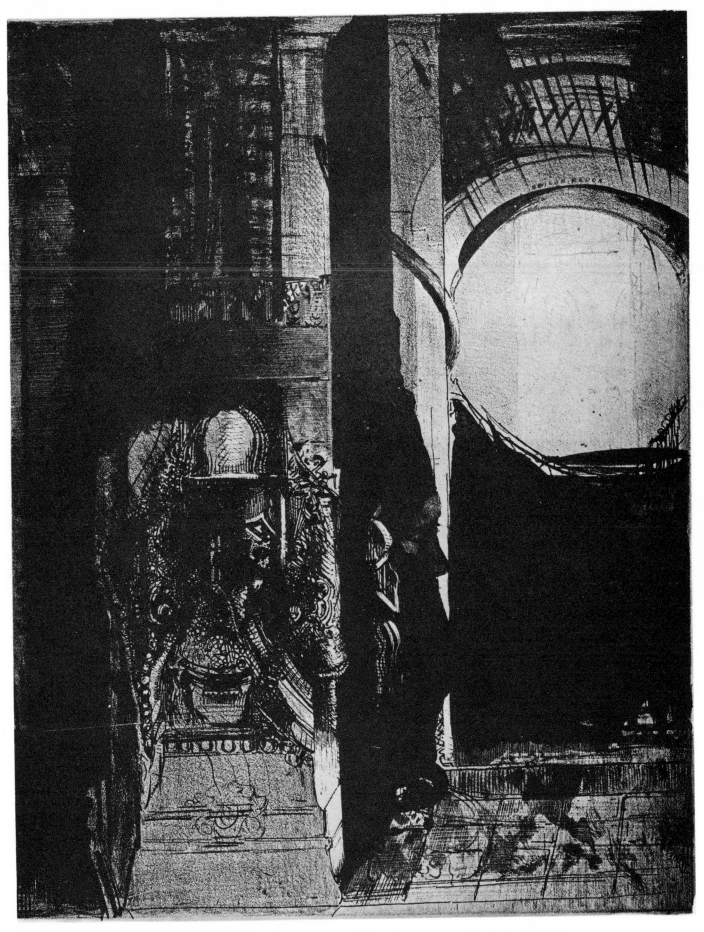

111 And on every side are columns of basalt (No. 3 of *La Tentation*, 3rd series)

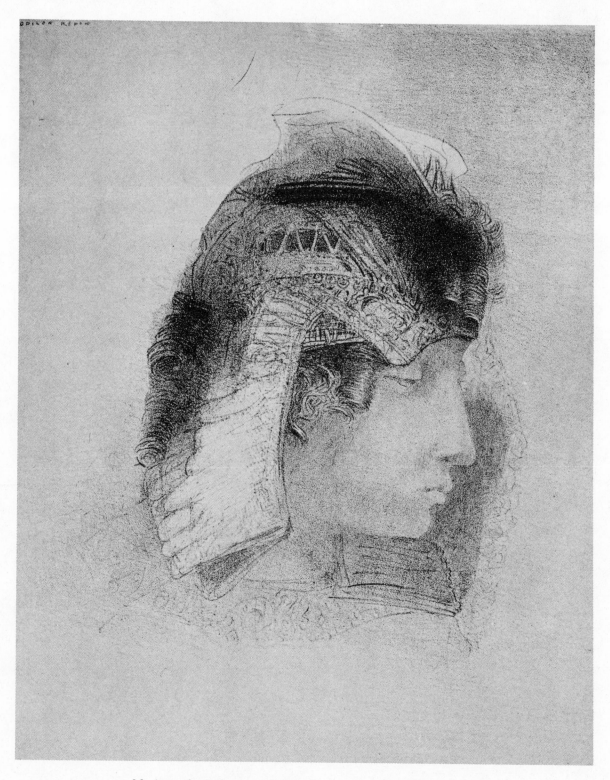

112 My kisses have the taste of fruit (No. 4 of *La Tentation*, 3rd series)

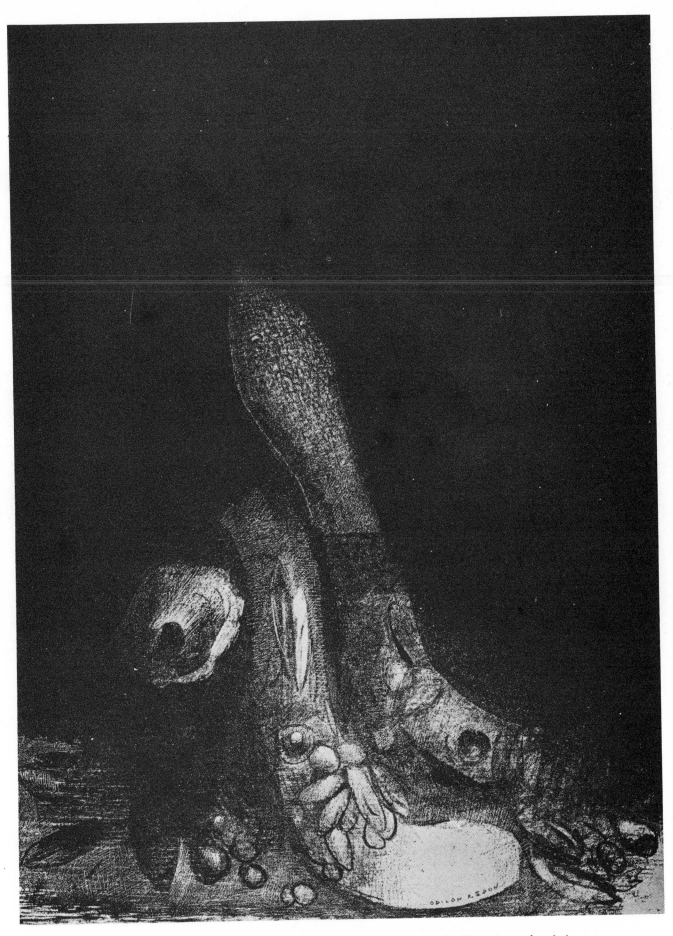

113 Flowers fall and the head of a python appears (No. 5 of *La Tentation*, 3rd series)

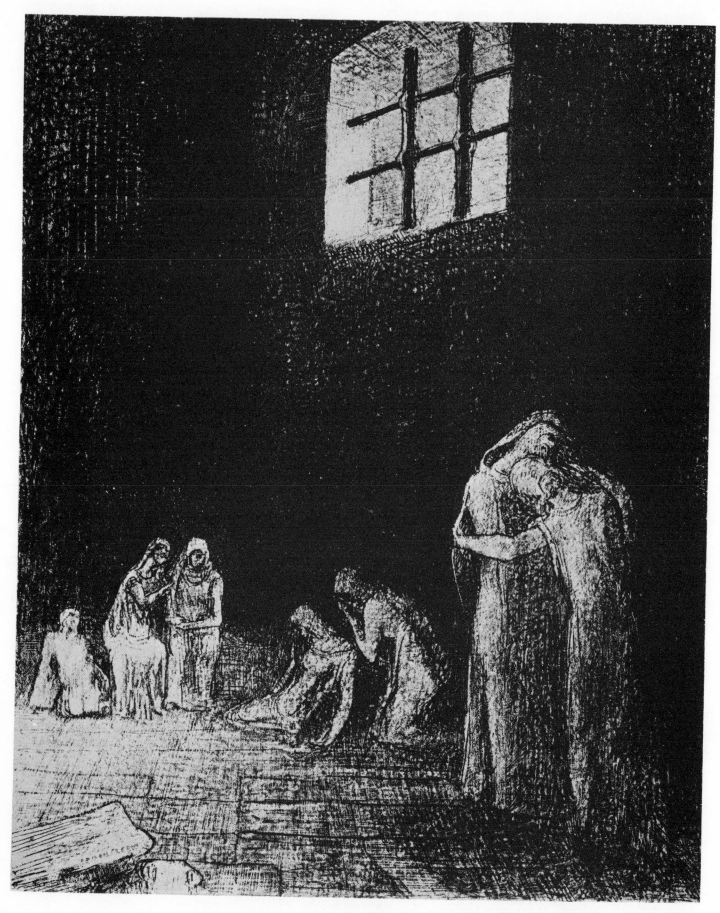

114 In the shadow are people, weeping and praying (No. 6 of *La Tentation*, 3rd series)

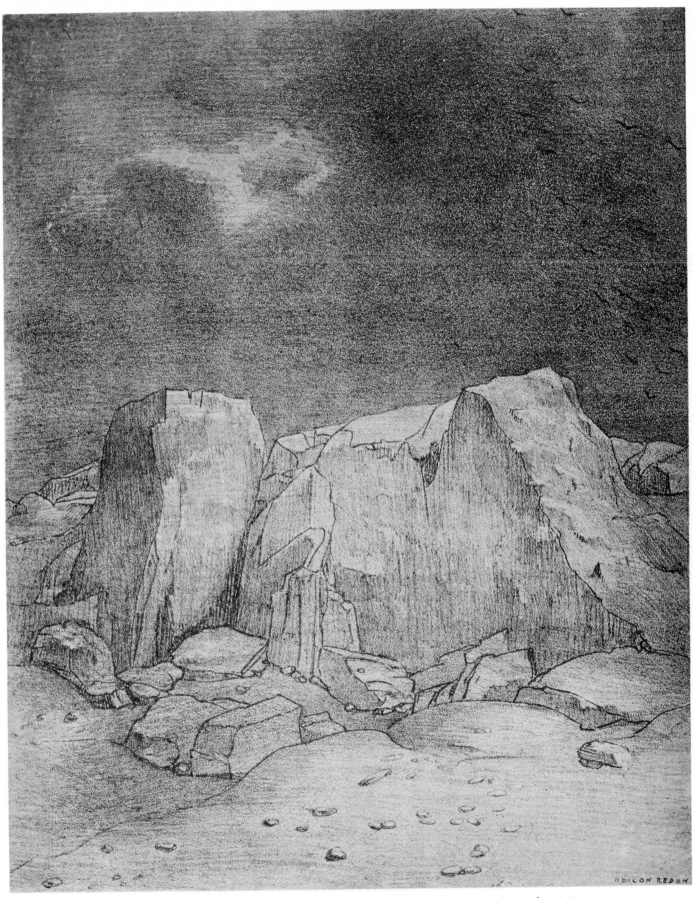

ODILON REDON

115 And he discerns an arid, knoll-covered plain (No. 7 of *La Tentation*, 3rd series)

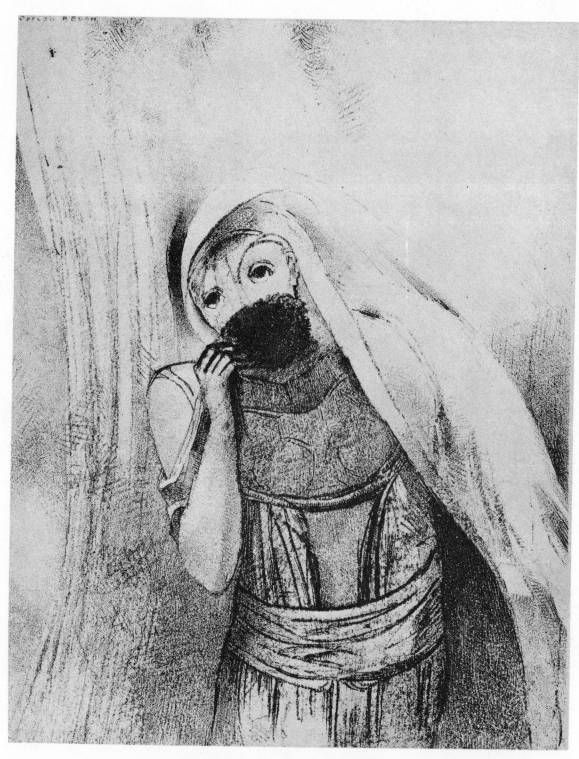

116 She draws from her bosom a sponge (No. 8 of *La Tentation*, 3rd series)

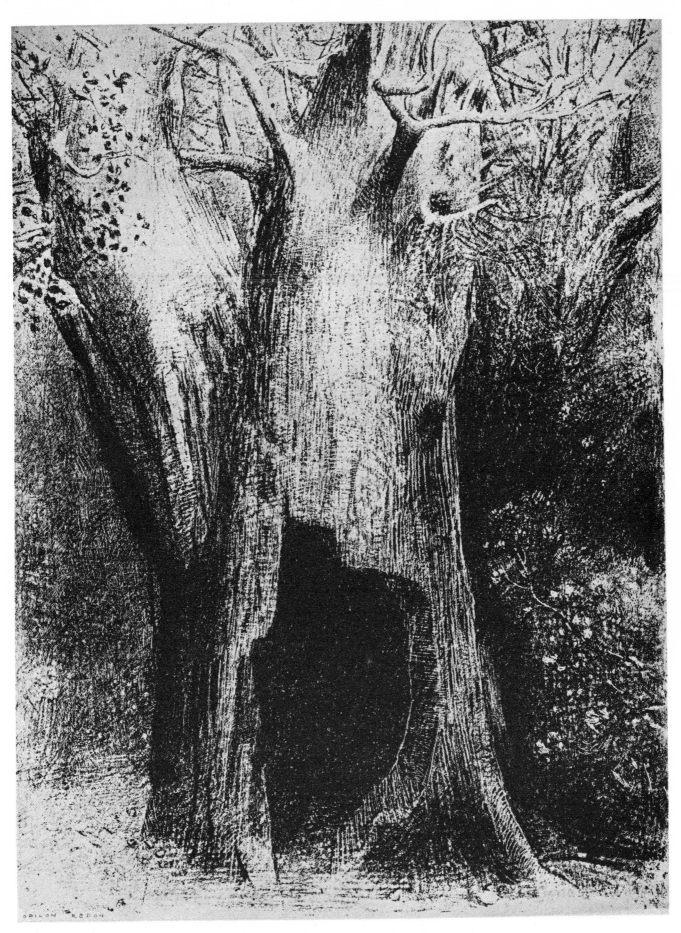

117 I plunged into solitude (No. 9 of *La Tentation*, 3rd series)

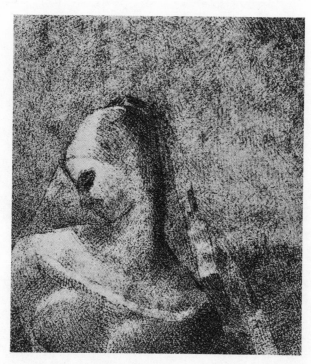

118 Helena – Eunoia (No. 10 of *La Tentation*, 3rd series)

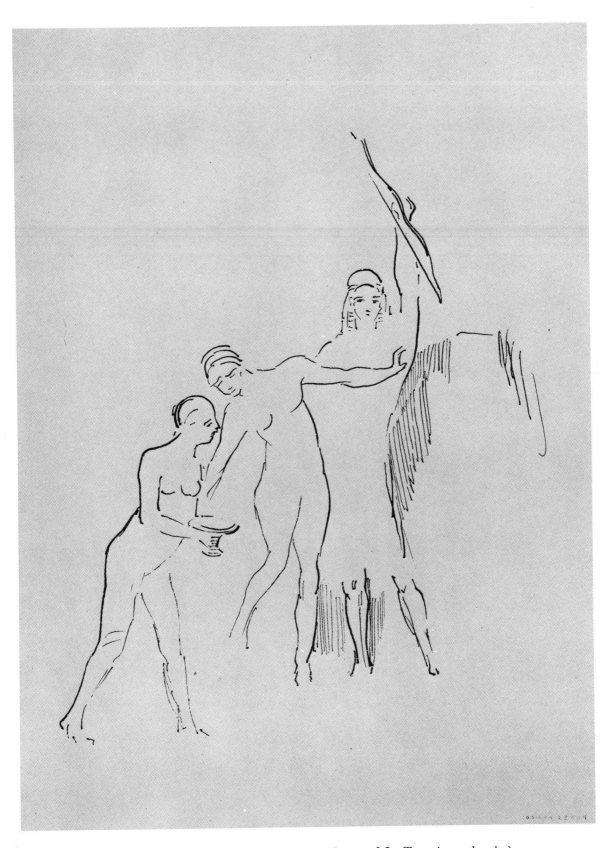

119 Immediately three goddesses arise (No. 11 of *La Tentation*, 3rd series)

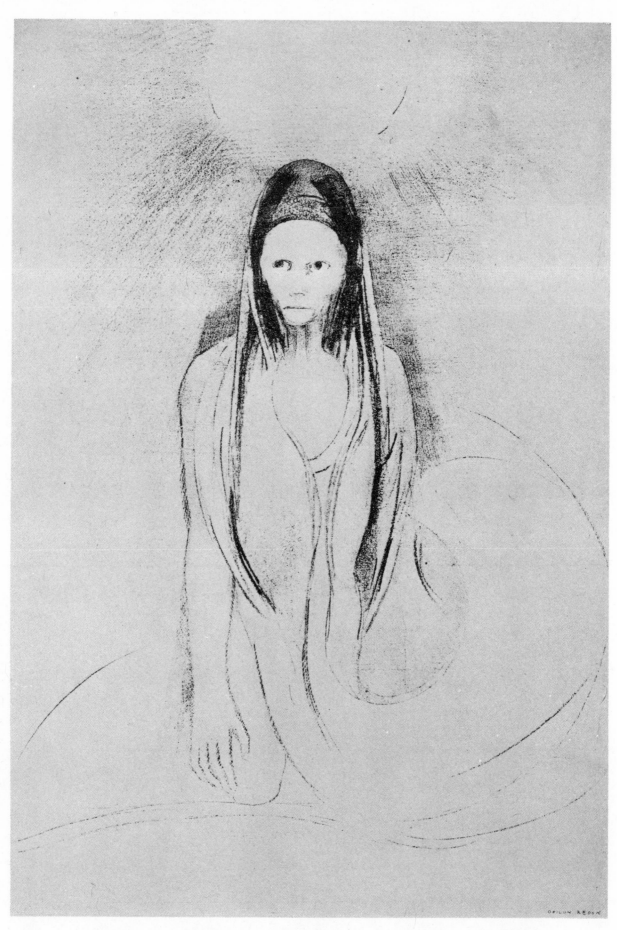

120 Intelligence was mine! I became the Buddha (No. 12 of *La Tentation*, 3rd series)

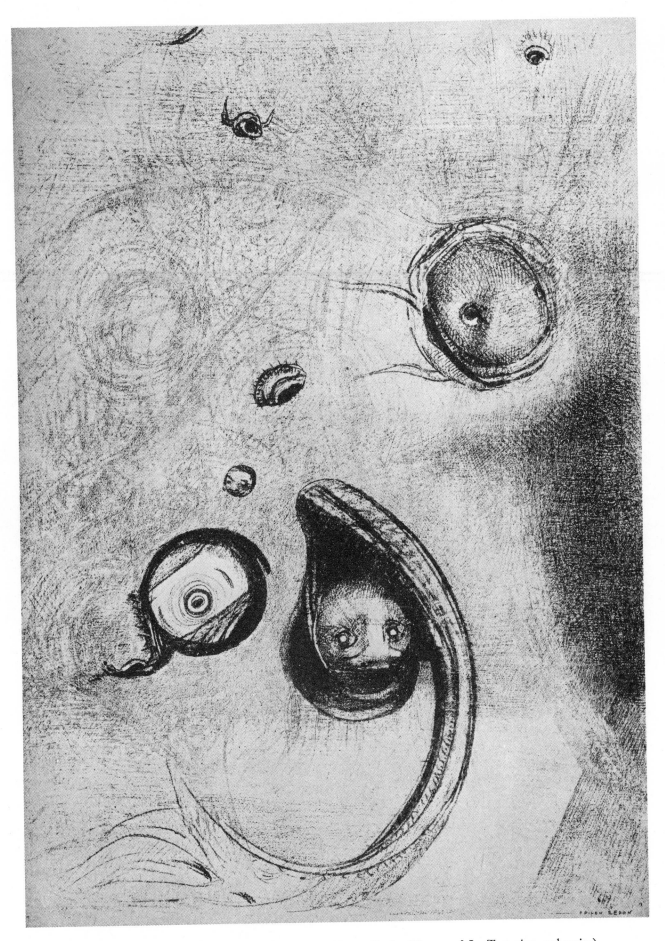

121 And that eyes without heads were floating like mollusks (No. 13 of *La Tentation*, 3rd series)

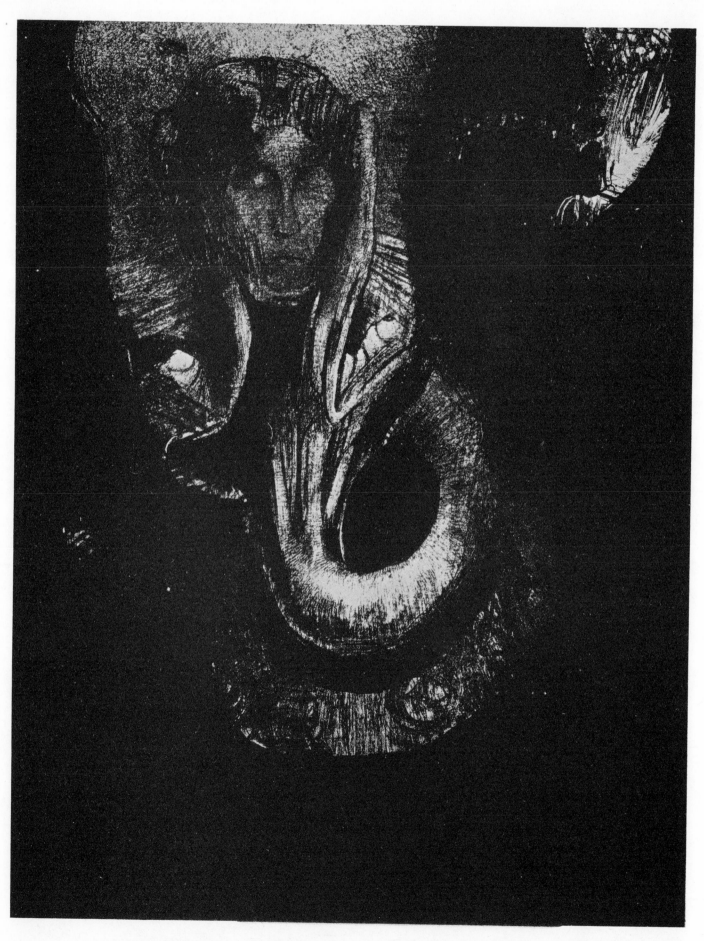

122 Oannès: "I, the first consciousness of chaos . . ." (No. 14 of *La Tentation*, 3rd series)

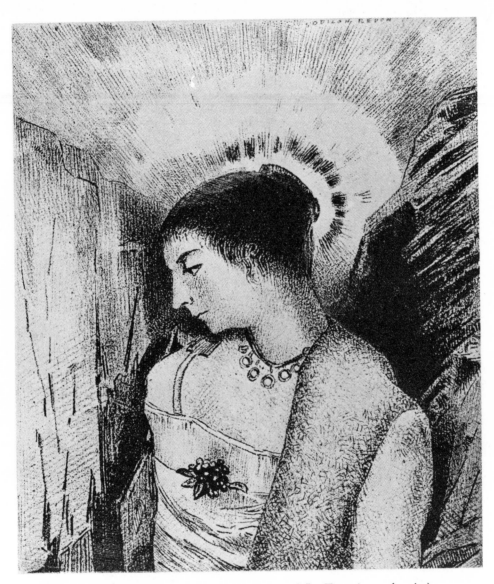

123 Here is the Good Goddess (No. 15 of *La Tentation*, 3rd series)

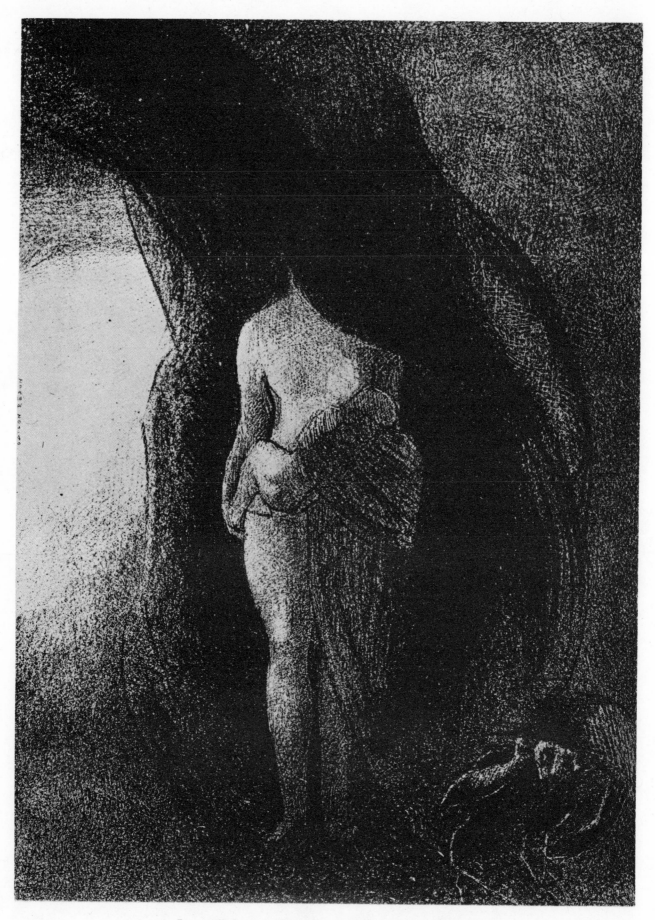

124 I am still the great Isis! (No. 16 of *La Tentation*, 3rd series)

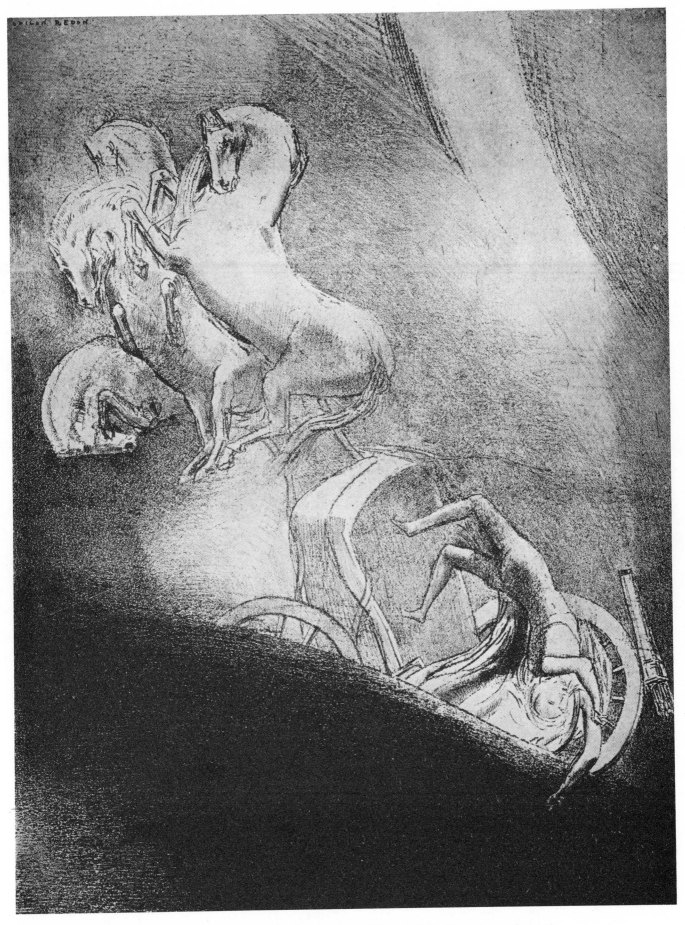

125 He falls head foremost into the abyss (No. 17 of *La Tentation*, 3rd series)

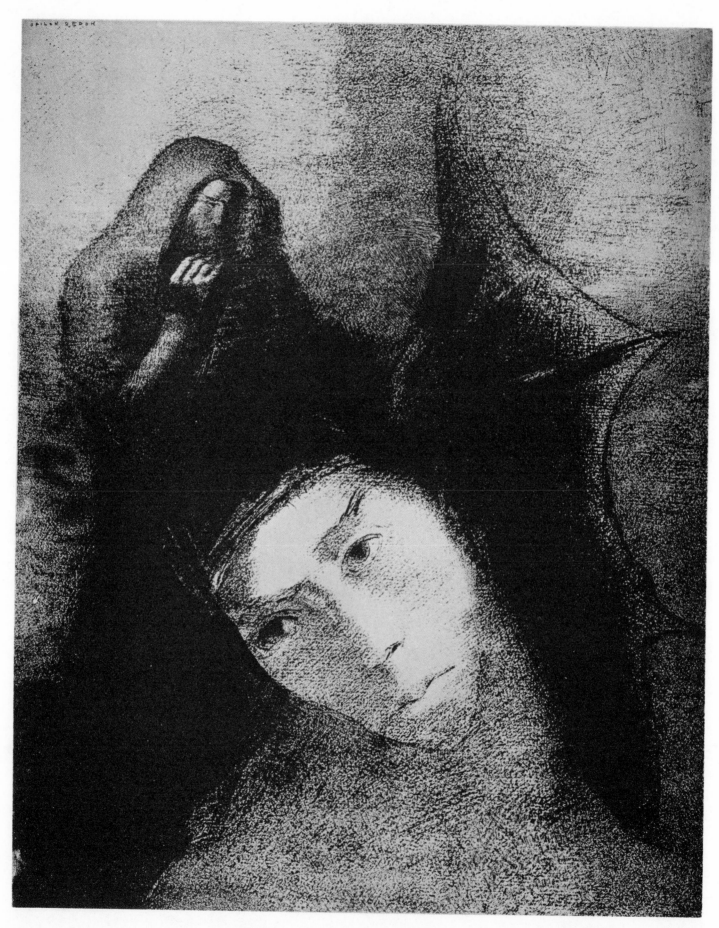

126 Anthony: "What is the object of all this?" (No. 18 of *La Tentation*, 3rd series)

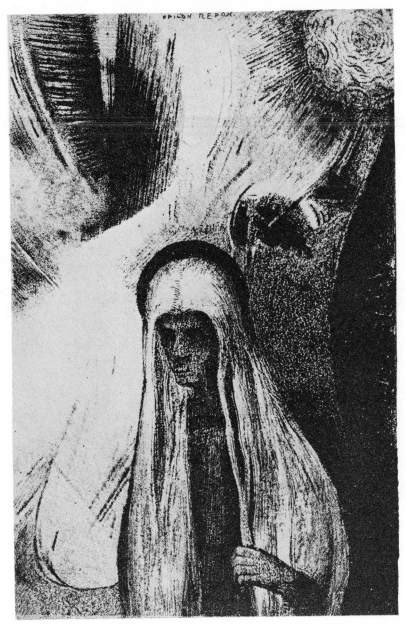

127 The Old Woman: "What are you afraid of? . . ." (No. 19 of
La Tentation, 3rd series)

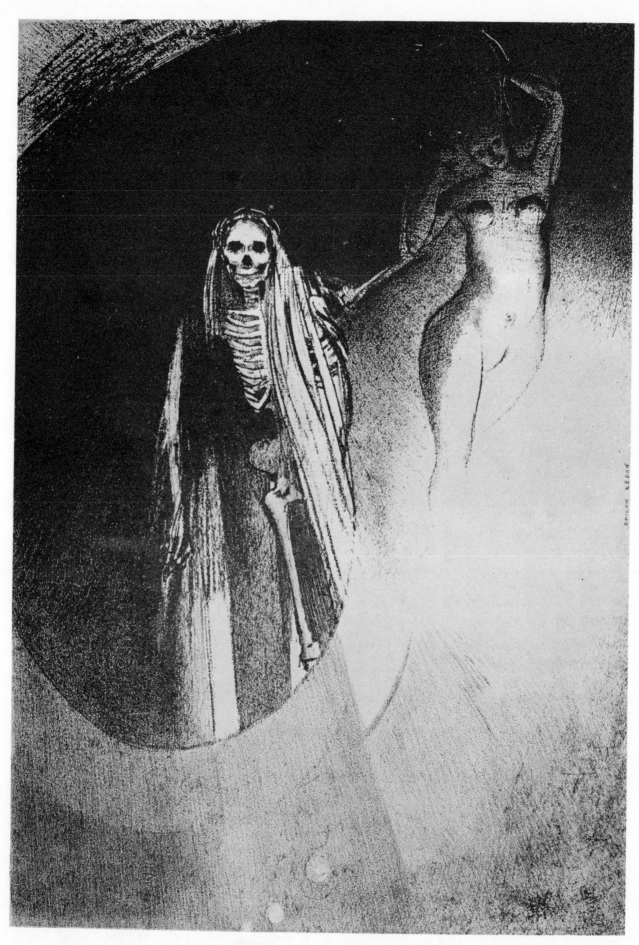

128 Death: "It is I who make you serious . . ." (No. 20 of *La Tentation*, 3rd series)

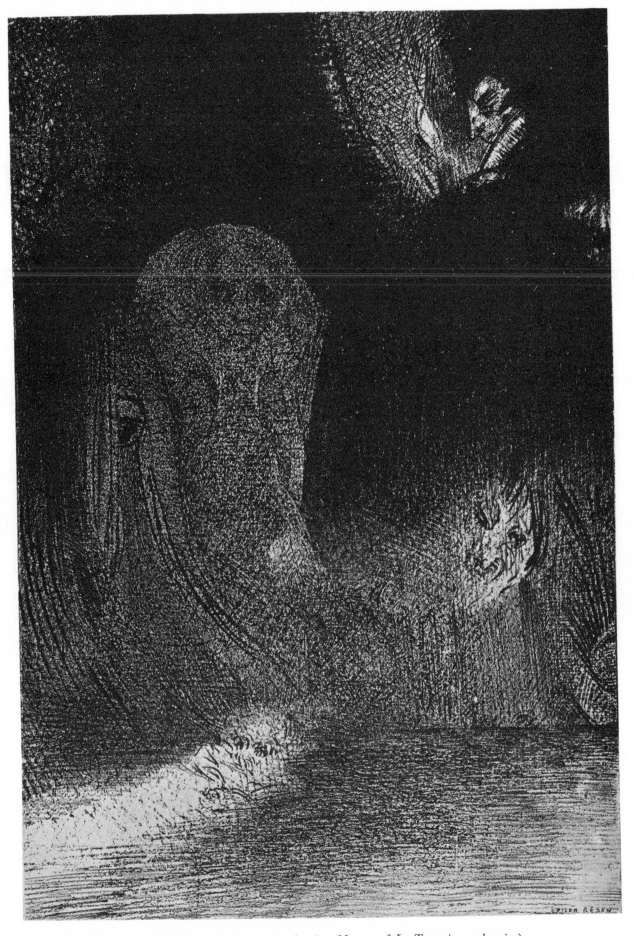

129 I have sometimes seen in the sky (No. 21 of *La Tentation*, 3rd series)

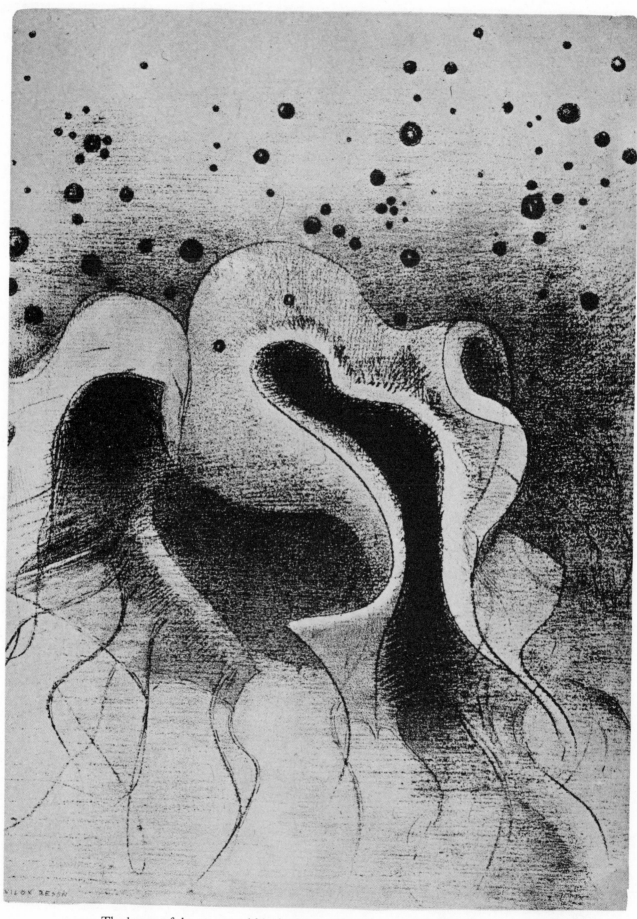

130 The beasts of the sea, round like leather bottles (No. 22 of *La Tentation*, 3rd series)

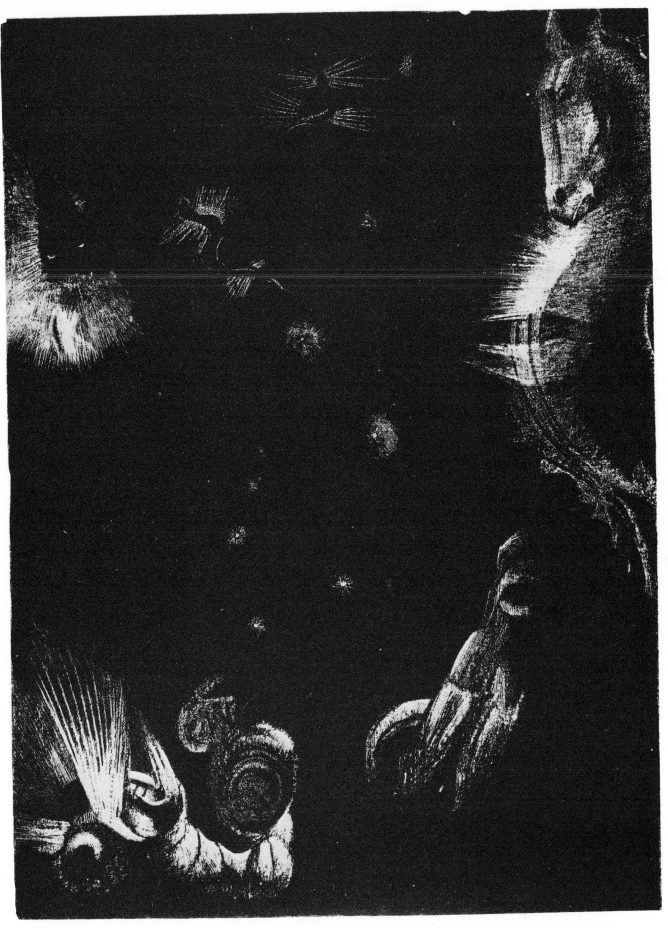

131 Different peoples inhabit the countries of the Ocean (No. 23 of *La Tentation*, 3rd series)

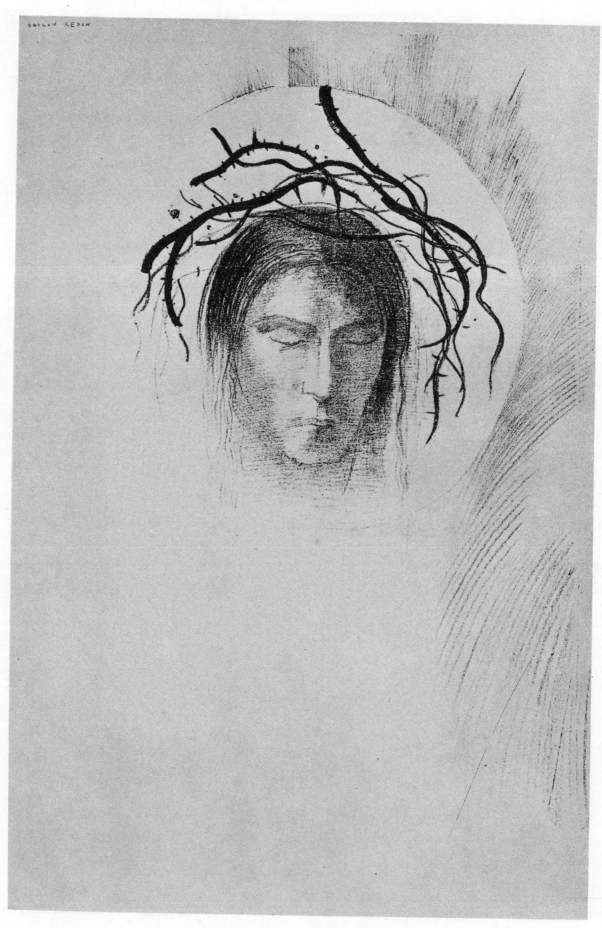

132 Day appears at last (No. 24 of *La Tentation*, 3rd series)

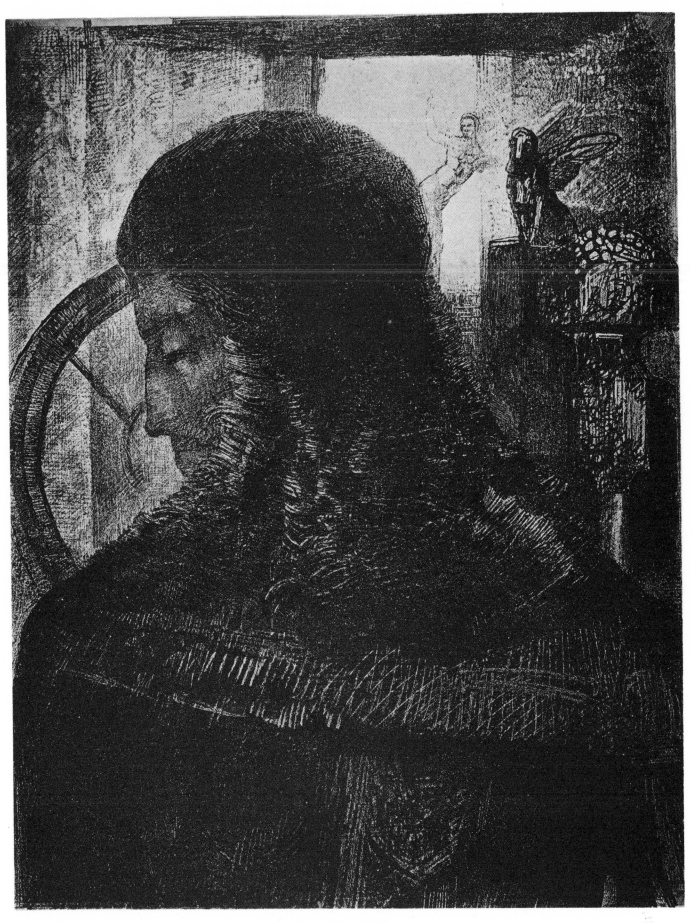

133 Old Knight

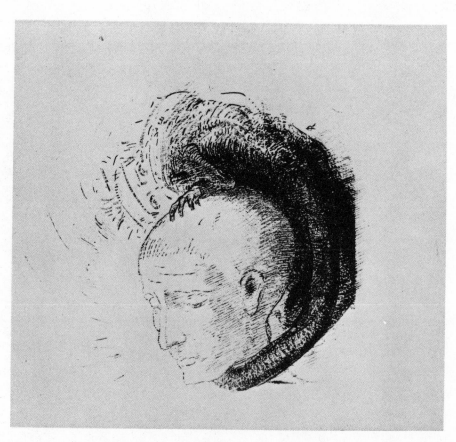

134 Frontispiece for *Le Mouvement idéaliste en peinture*

Texte de BULWER – LYTTON

LA MAISON HANTÉE

Traduction RENÉ PHILIPON

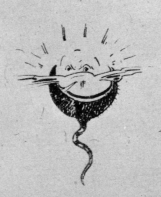

6 Lithographies à 80 Exemplaires

ODILON REDON

1896

135 Title of *La Maison hantée*

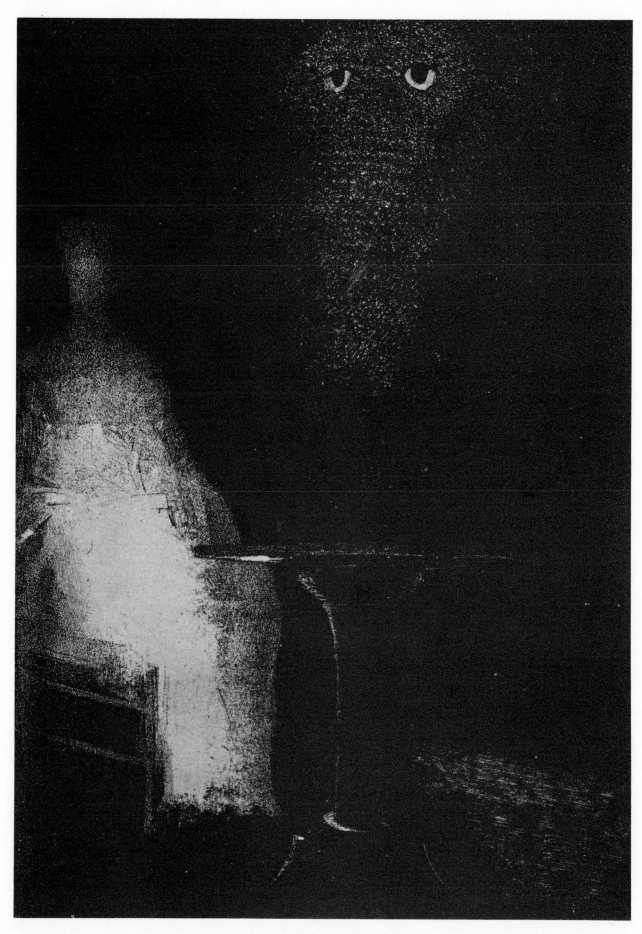

136 I continued to gaze on the chair (No. 1 of *La Maison hantée*)

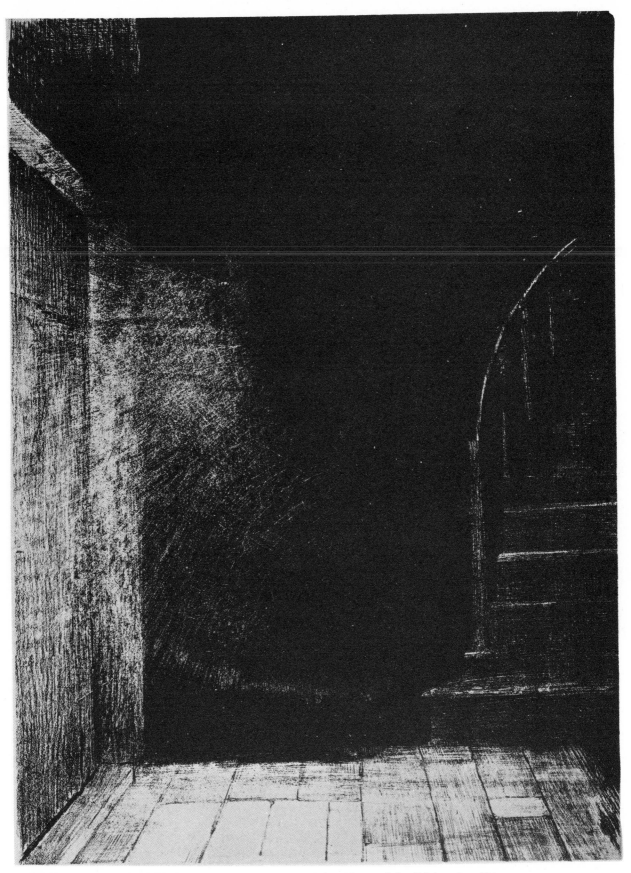

137 We both saw a large pale light (No. 2 of *La Maison hantée*)

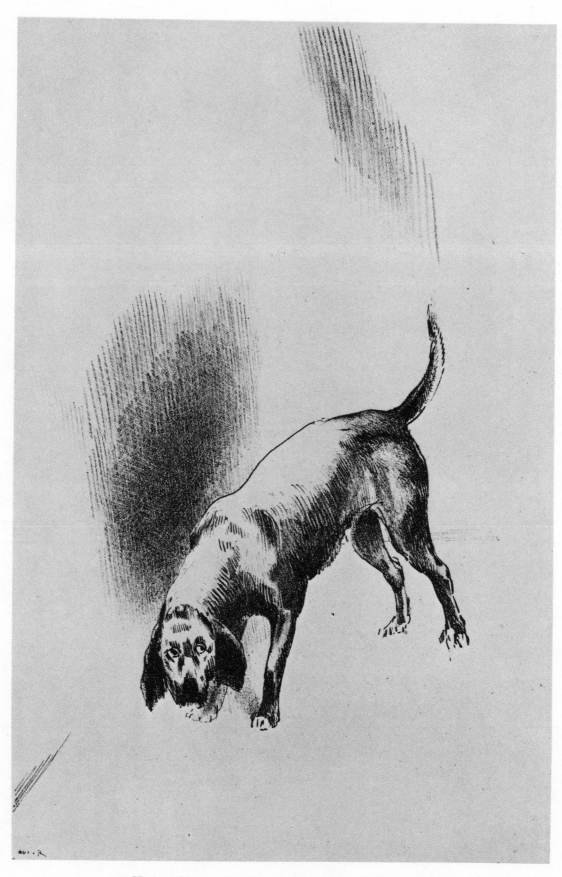

138 He kept his eyes fixed on me (No. 3 of *La Maison hantée*)

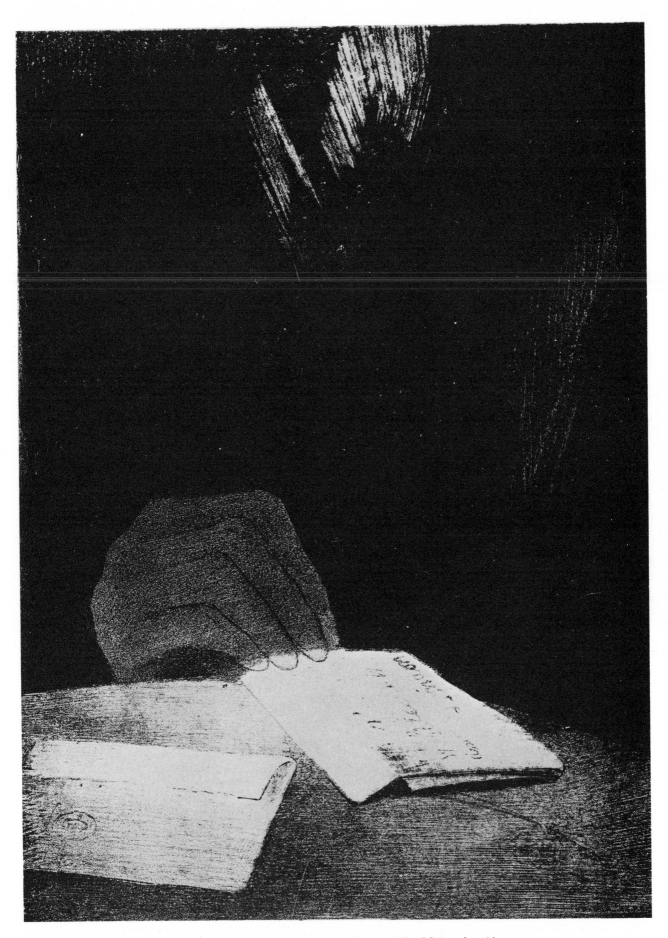

139 It was a hand, seemingly (No. 4 of *La Maison hantée*)

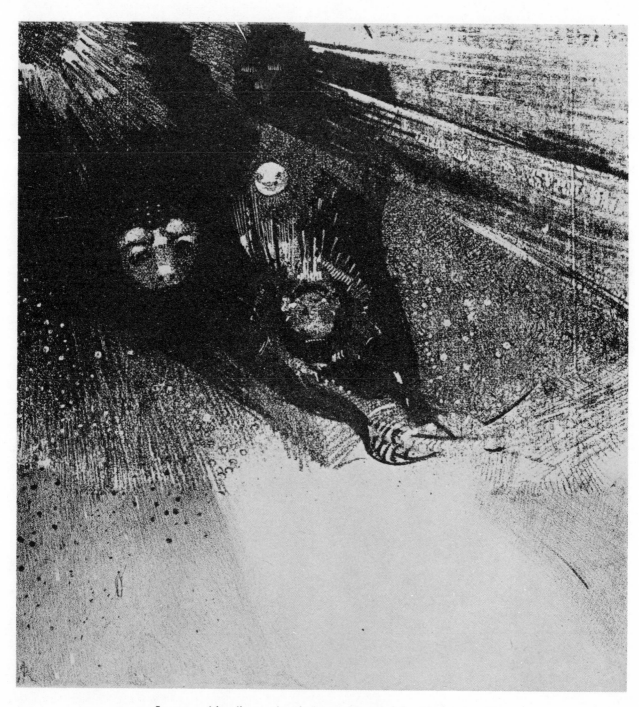

140 Larvæ so bloodless and so hideous (No. 5 of *La Maison hantée*)

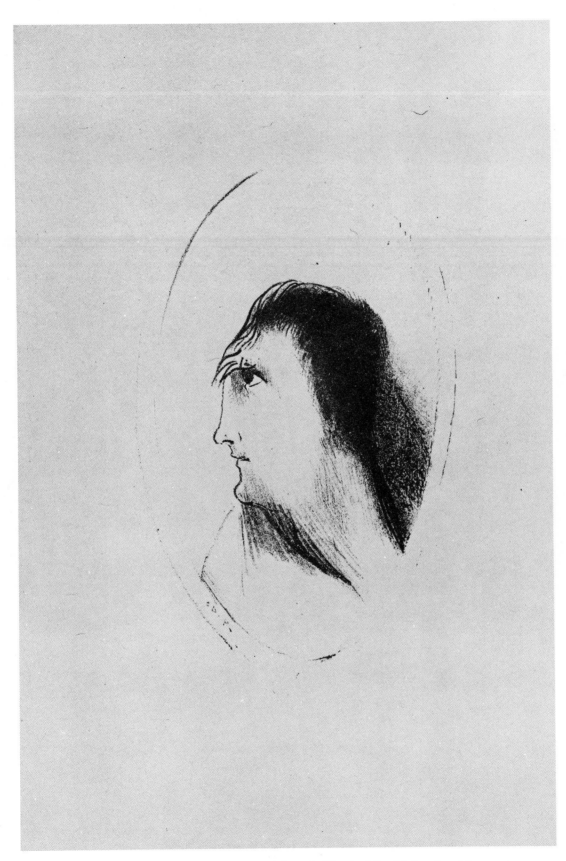

141 The width and flatness of frontal (No. 6 of *La Maison hantée*)

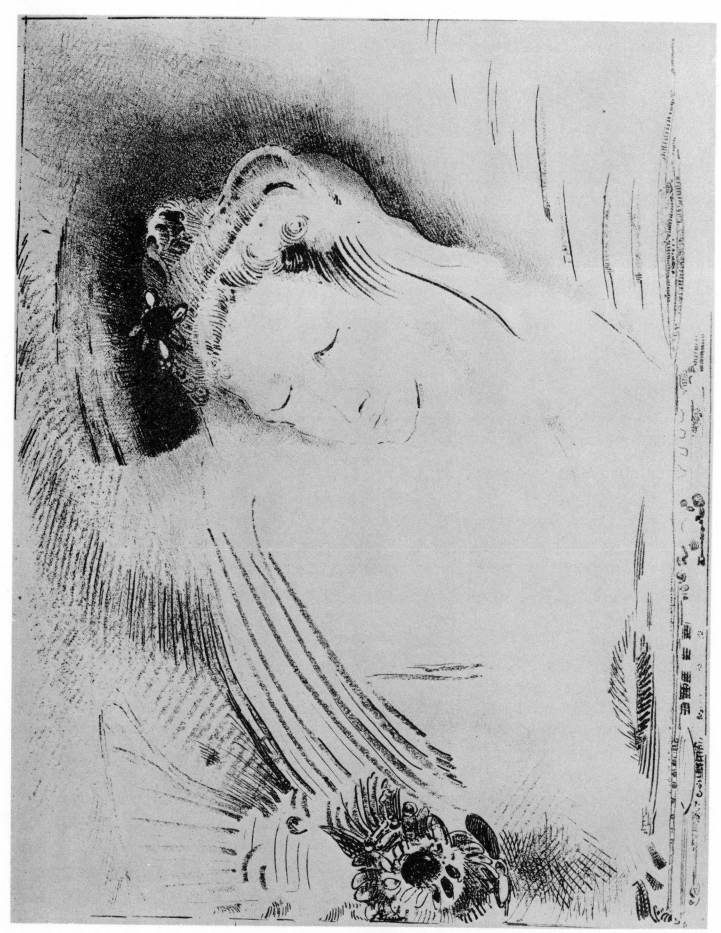

142 The Shulamite

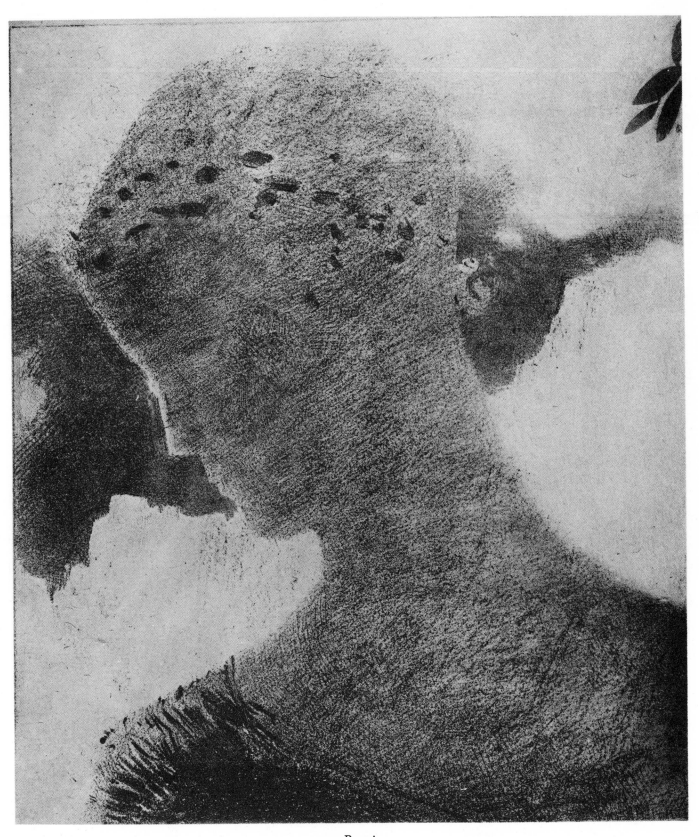

143 Beatrice

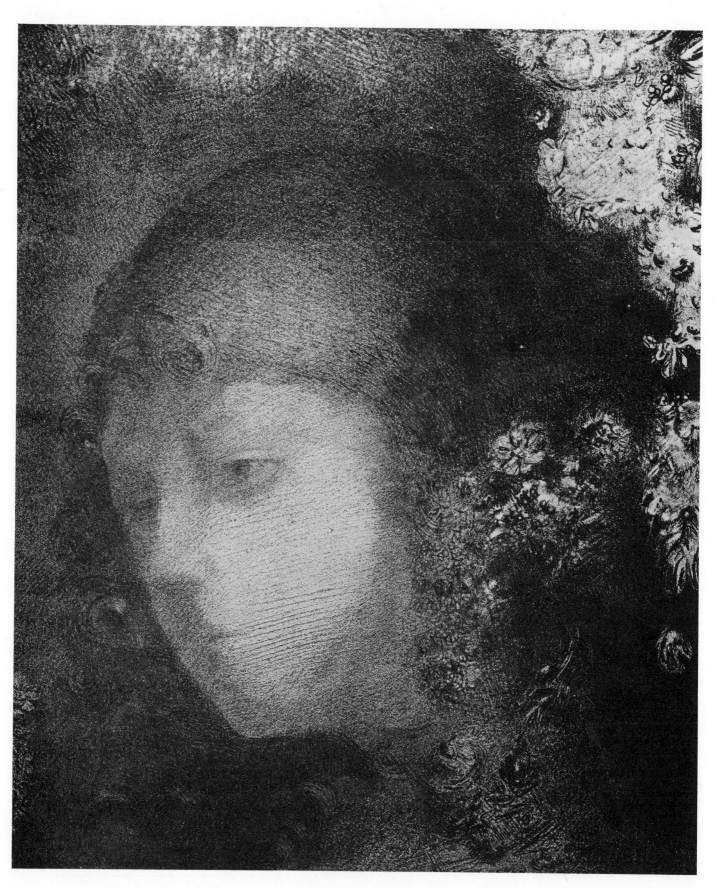

144 Child's Head with Flowers

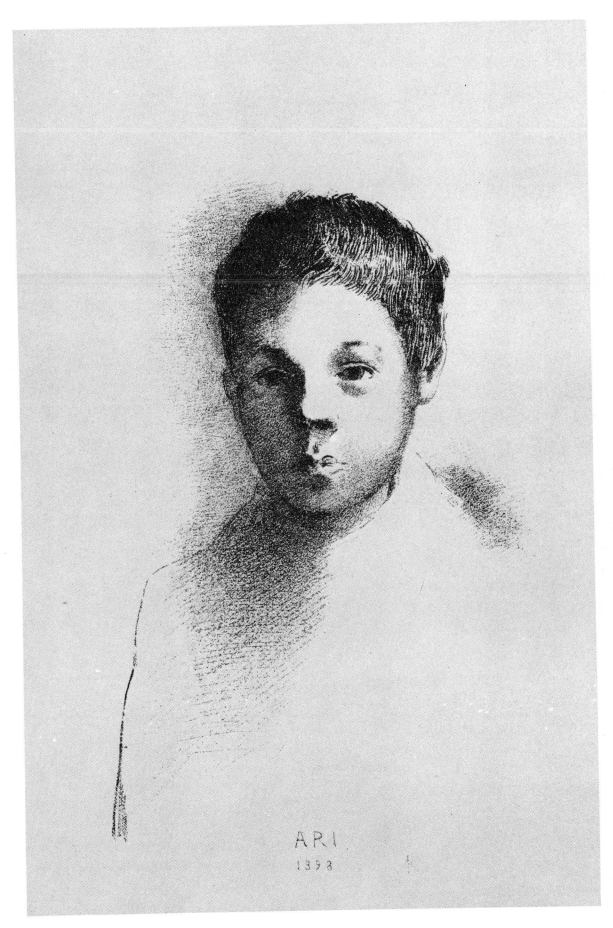

ARI
1898

145 Arï

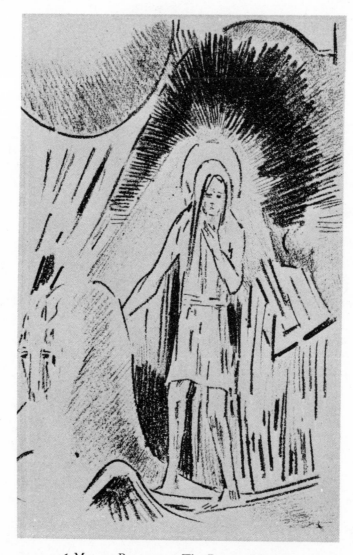

146 Man on Pegasus OR The Poet and Pegasus

147 Sleep

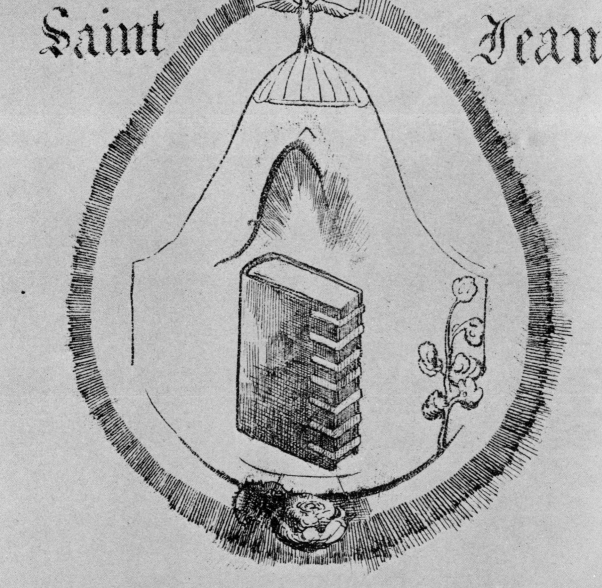

148 Cover of *Apocalypse de Saint-Jean*

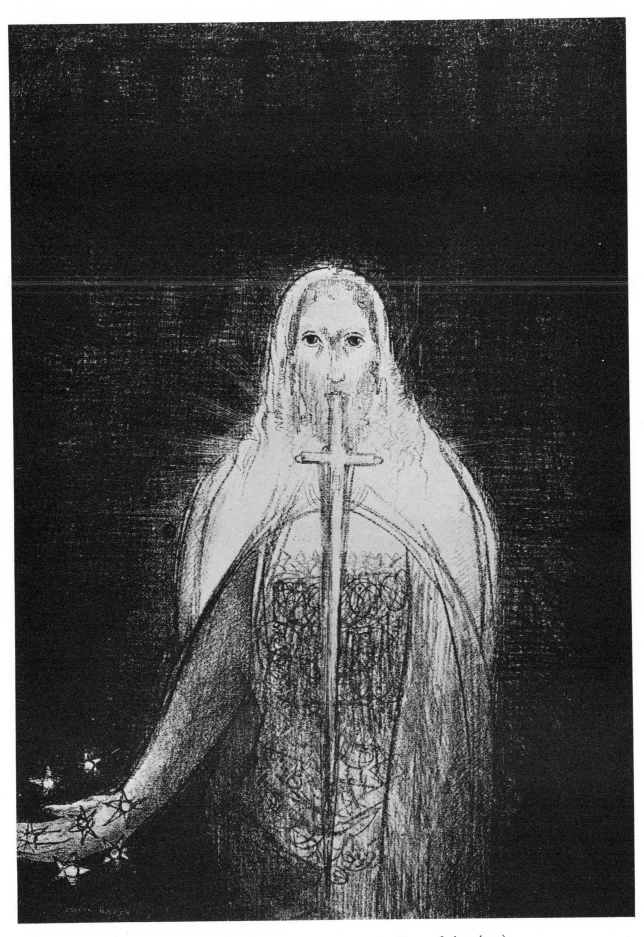

149 And he had in his right hand seven stars (No. 1 of *Apocalypse*)

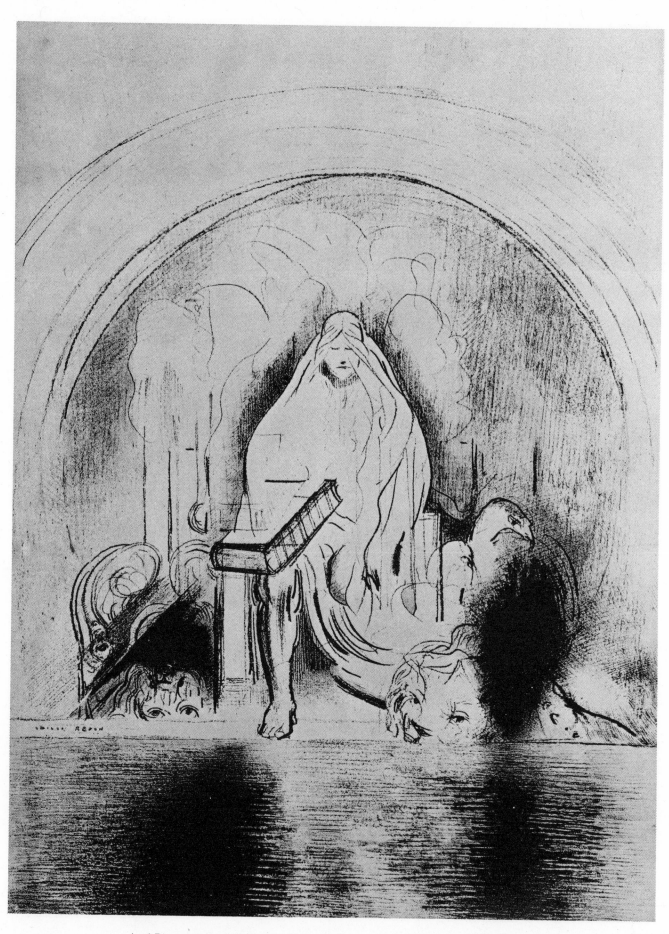

150 And I saw in the right hand of him that sat on the throne (No. 2 of *Apocalypse*)

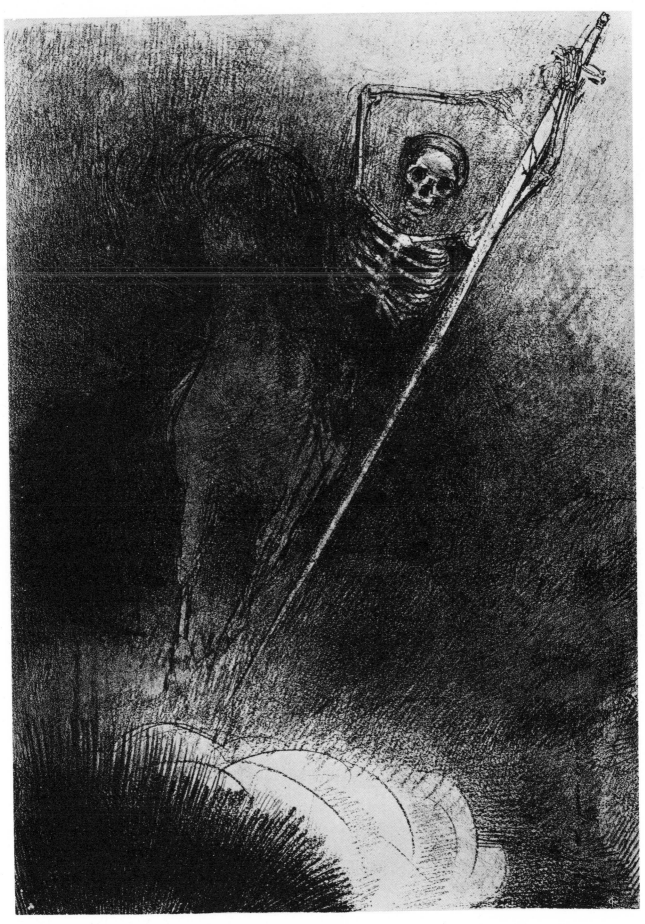

151 And his name that sat on him was Death (No. 3 of *Apocalypse*)

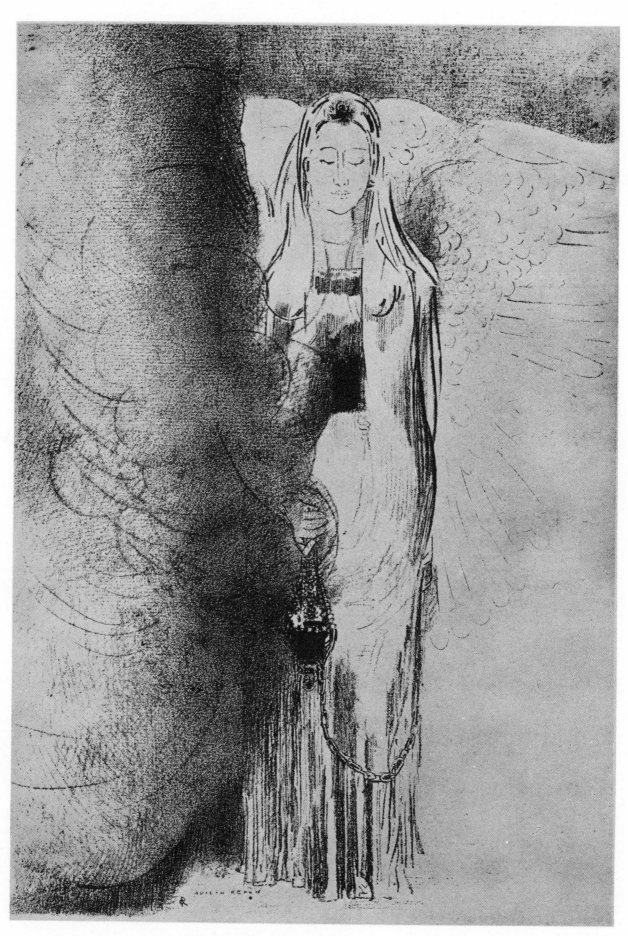

152 And the angel took the censer (No. 4 of *Apocalypse*)

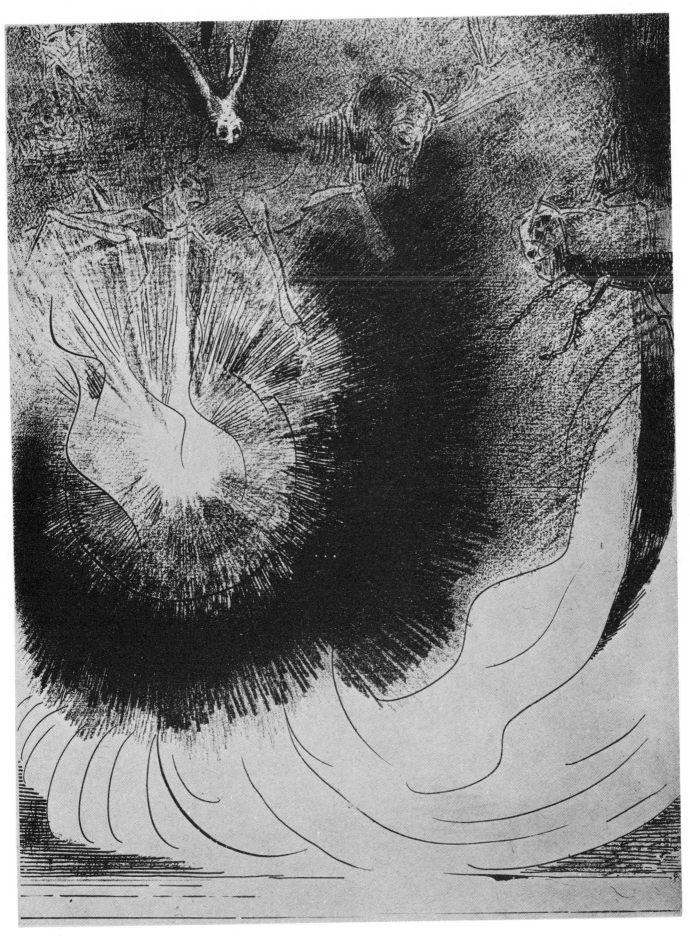

153 And there fell a great star from heaven (No. 5 of *Apocalypse*)

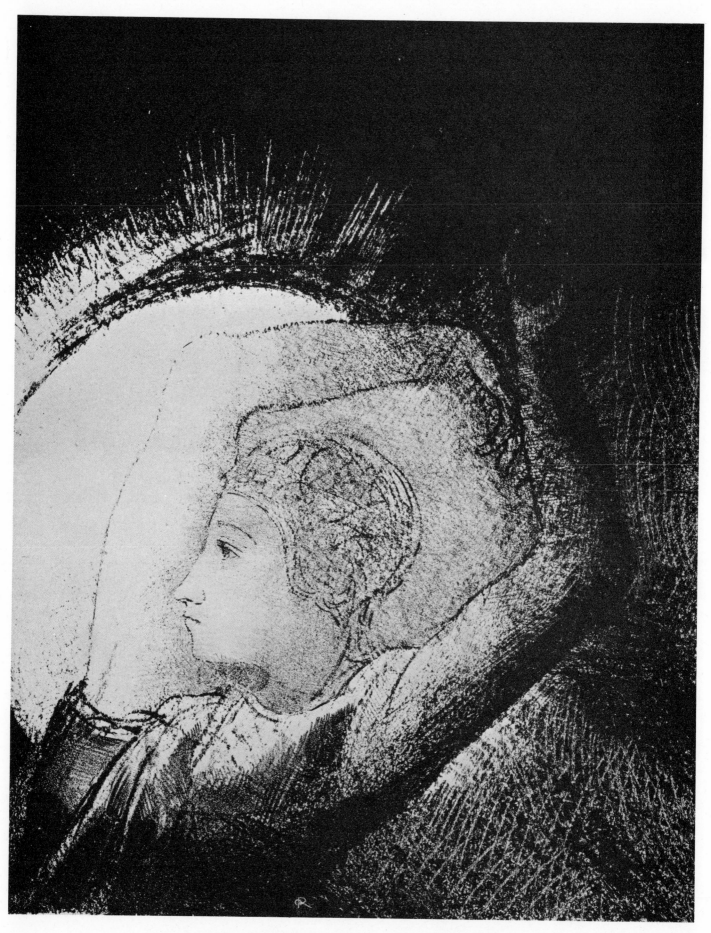

154 A woman clothed with the sun (No. 6 of *Apocalypse*)

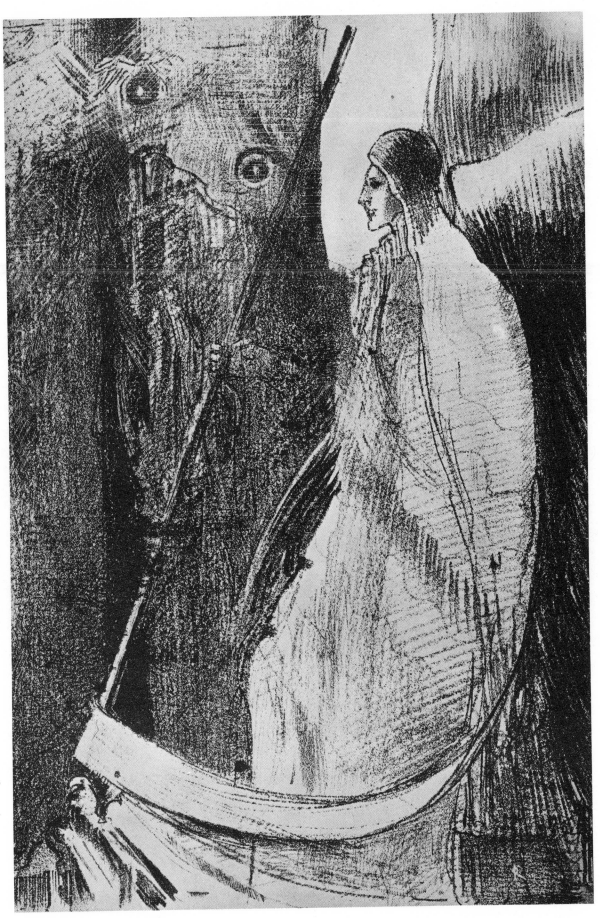

155 And another angel came out of the temple (No. 7 of *Apocalypse*)

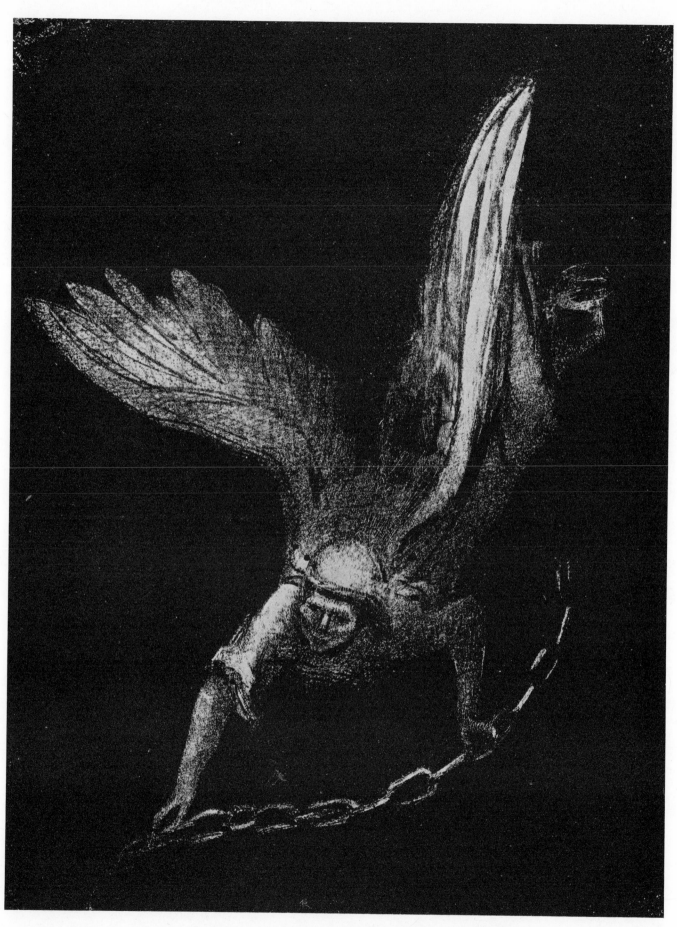

156 And I saw an angel come down from heaven (No. 8 of *Apocalypse*)

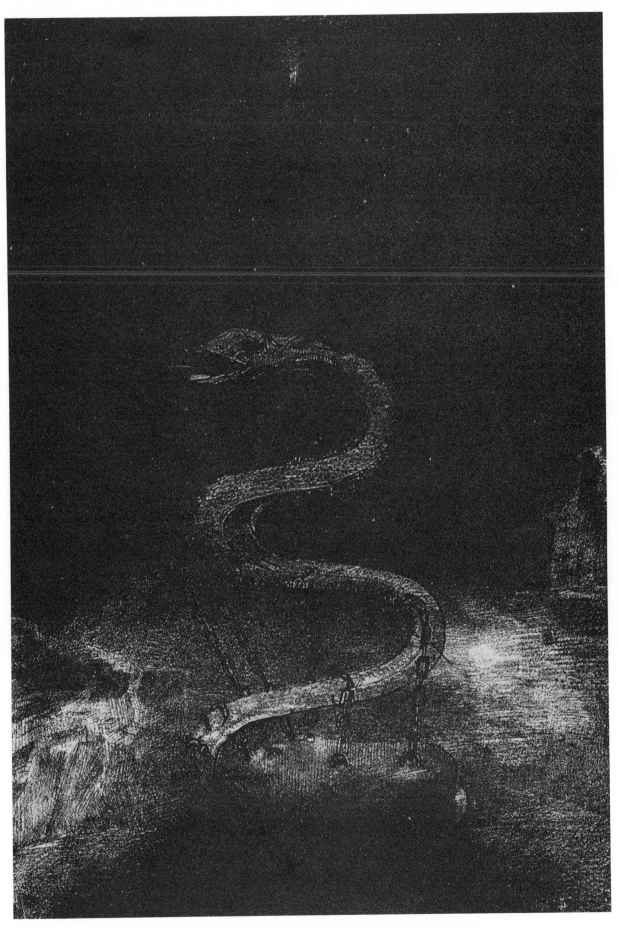

157 And bound him a thousand years (No. 9 of *Apocalypse*)

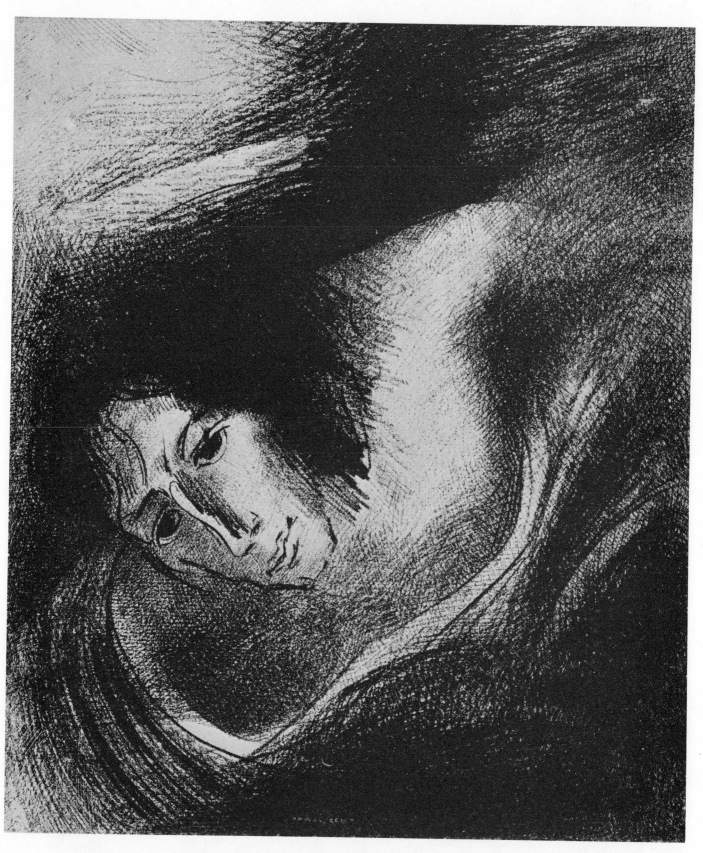

158 And the devil that deceived them (No. 10 of *Apocalypse*)

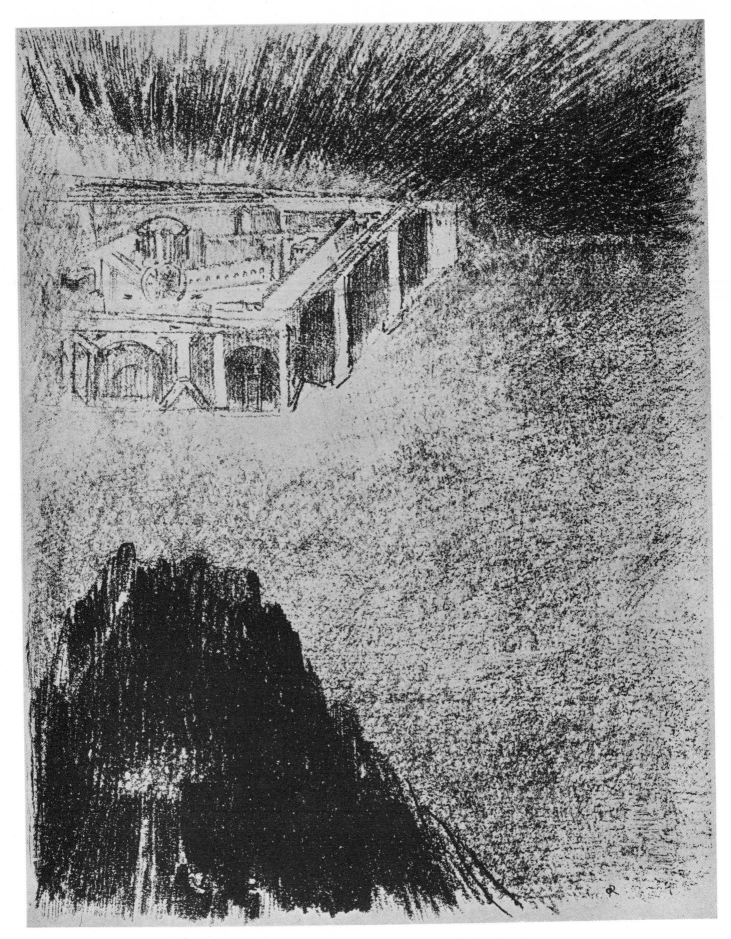

159 And I John saw the holy city (No. 11 of *Apocalypse*)

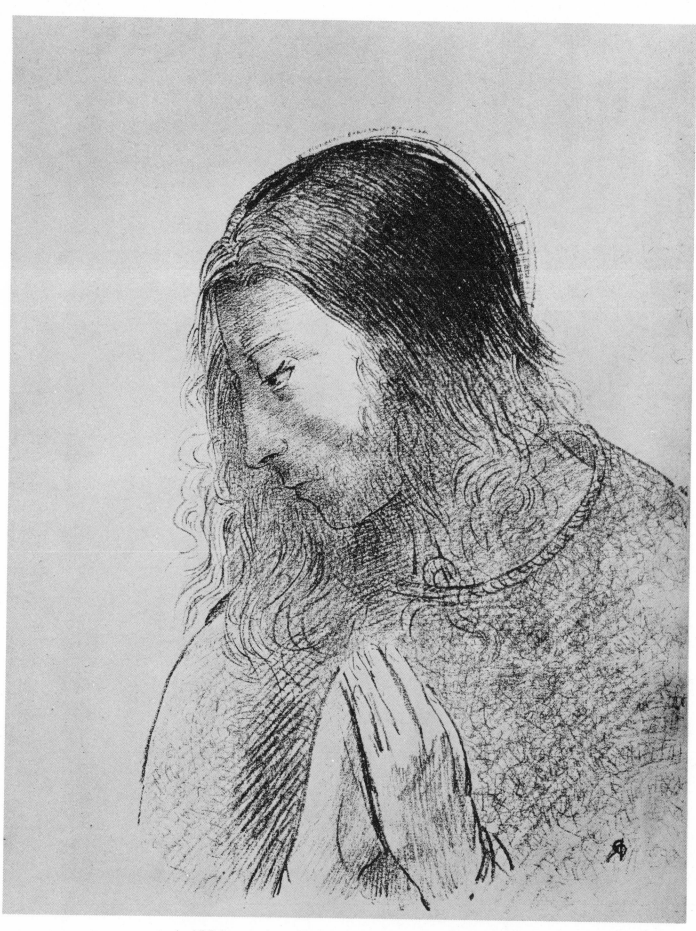

160 And I John saw these things, and heard them (No. 12 of *Apocalypse*)

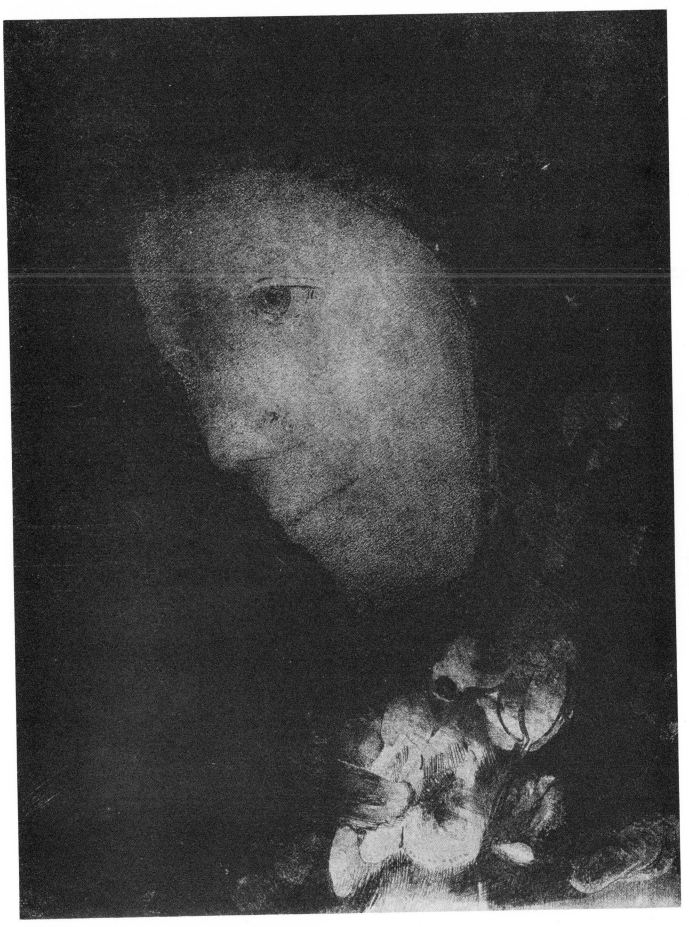

161 Head of **Woman** with Corsage of Flowers

162 Untitled trial lithograph

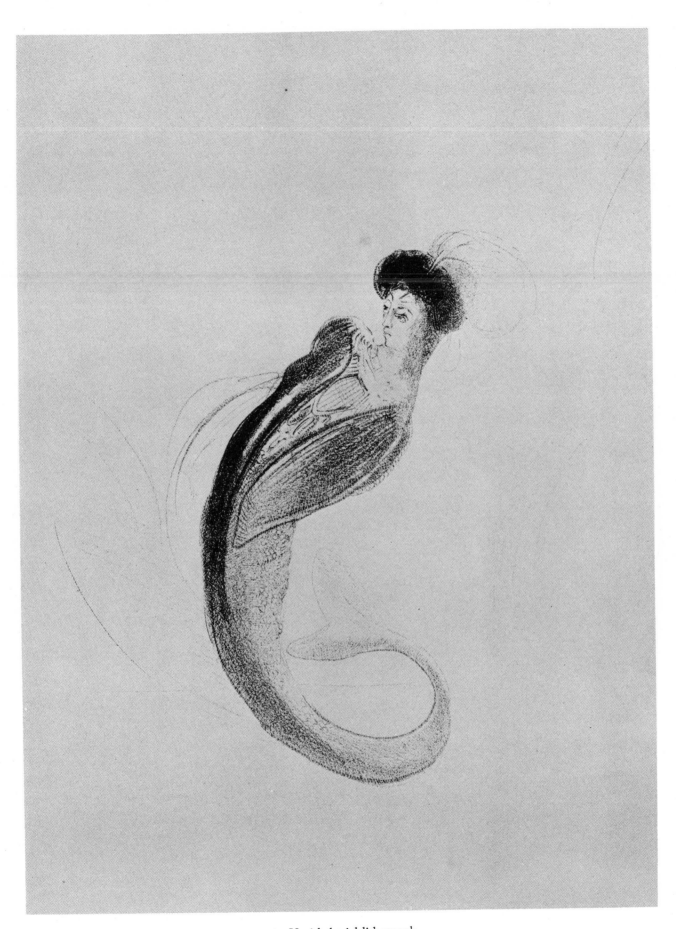

163 Untitled trial lithograph

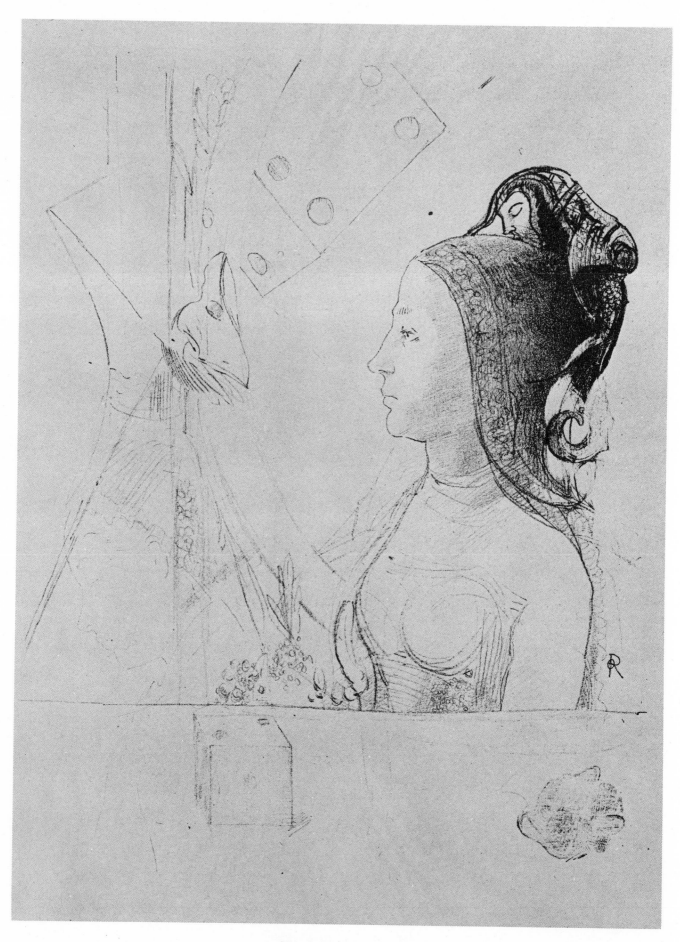

164 Untitled trial lithograph

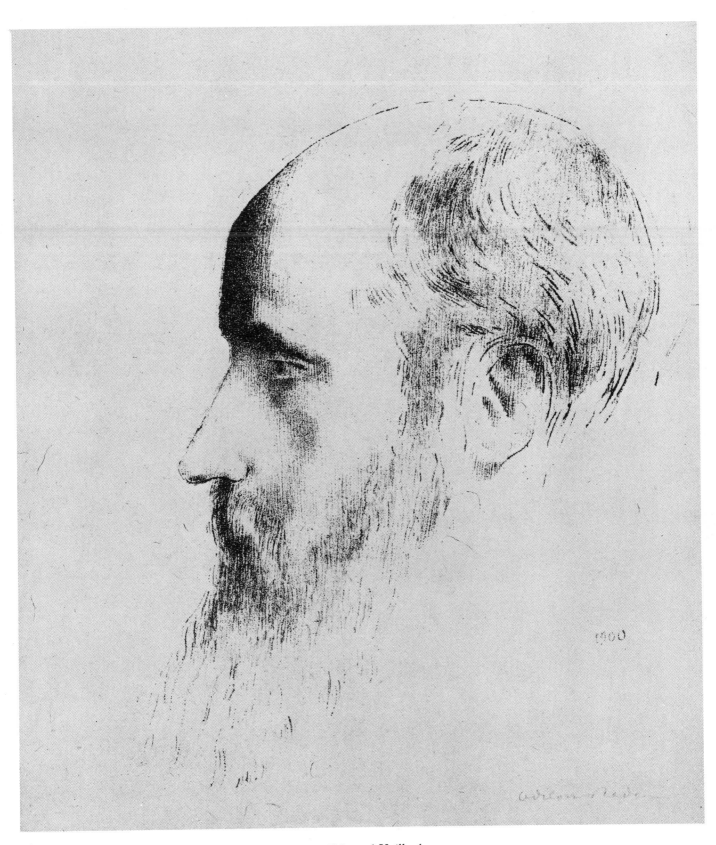

165 Edouard Vuillard

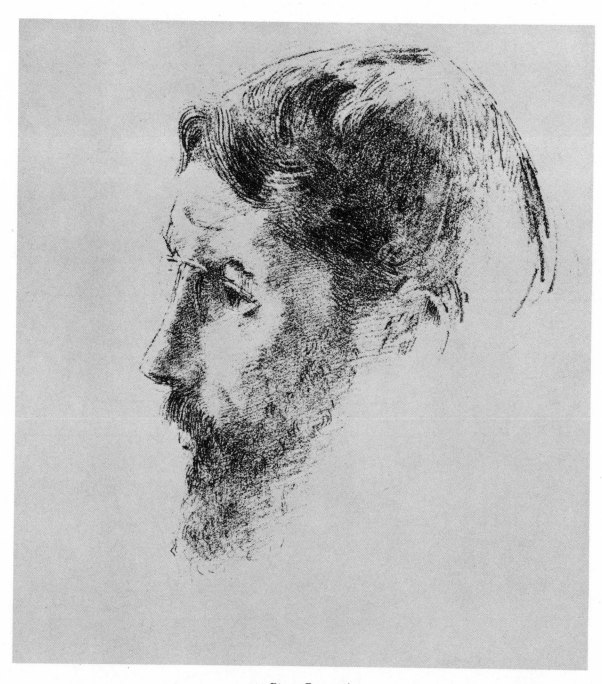

166 Pierre Bonnard

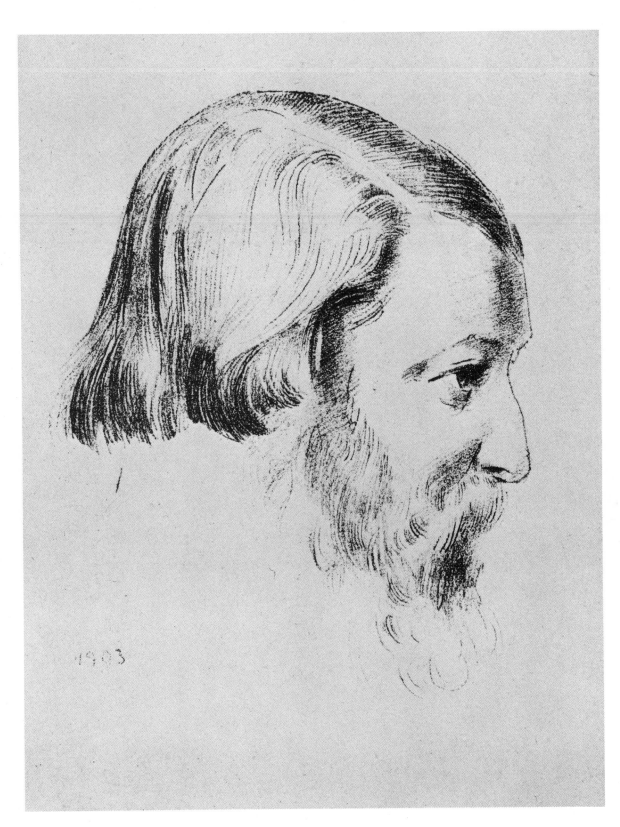

167 Paul Sérusier

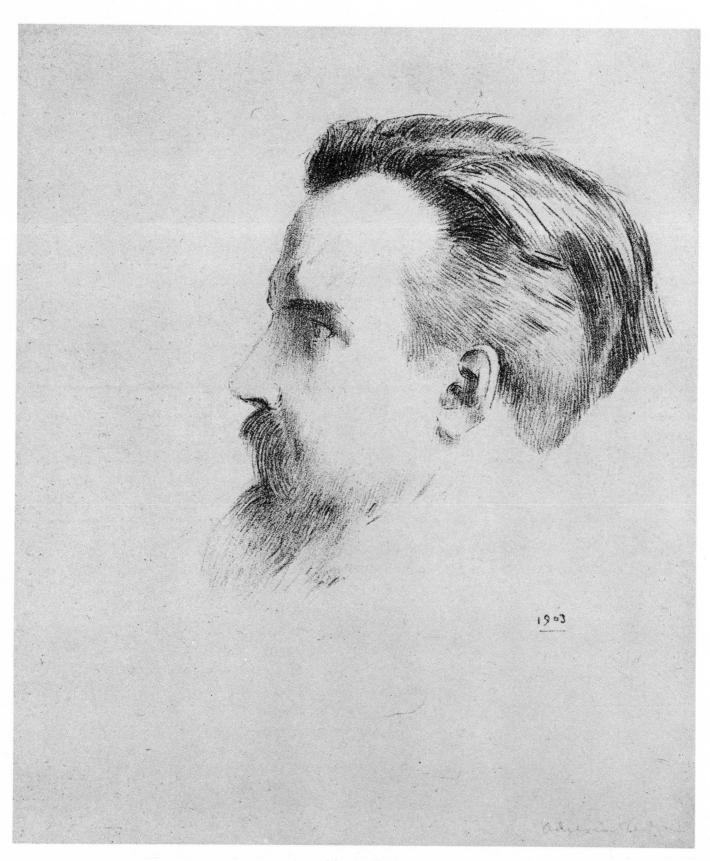

1903

168 Maurice Denis

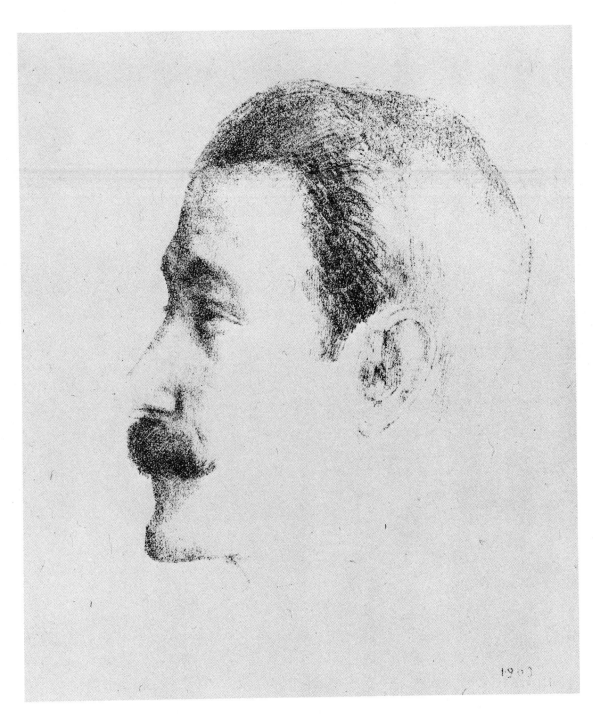

169 Ricardo Viñes

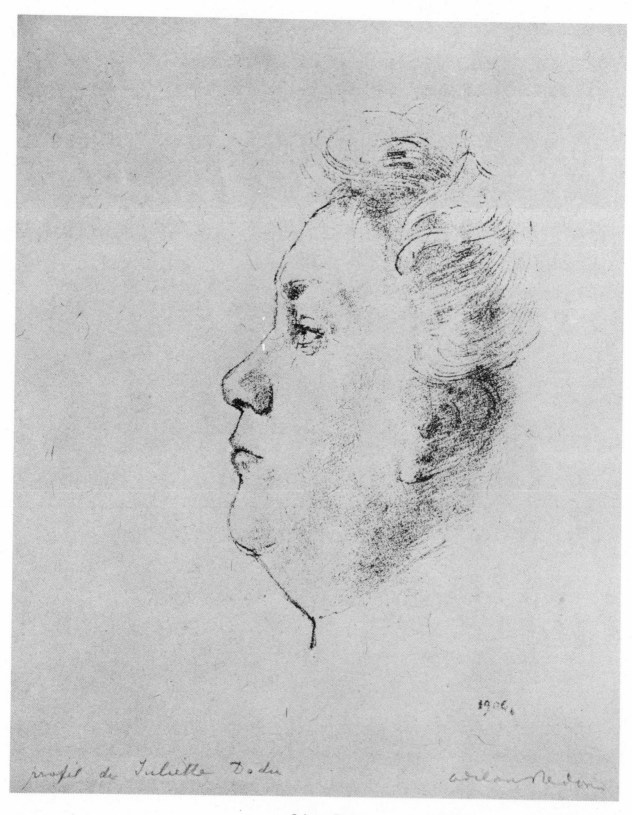

profil de Juliette Dodu odilon redon

170 Juliette Dodu

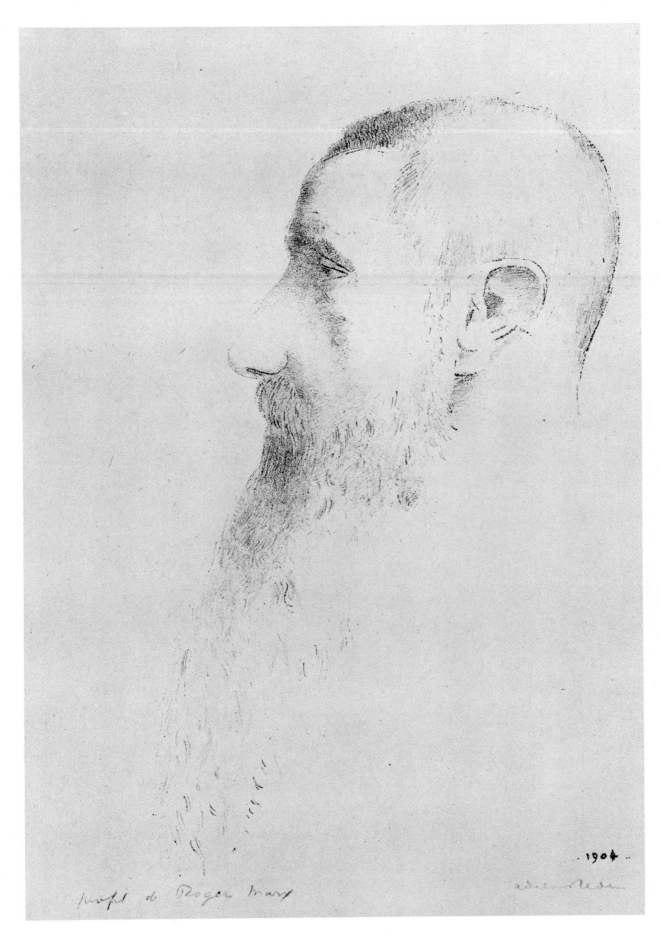

profil de Roger Marx

1904

171 Roger Marx

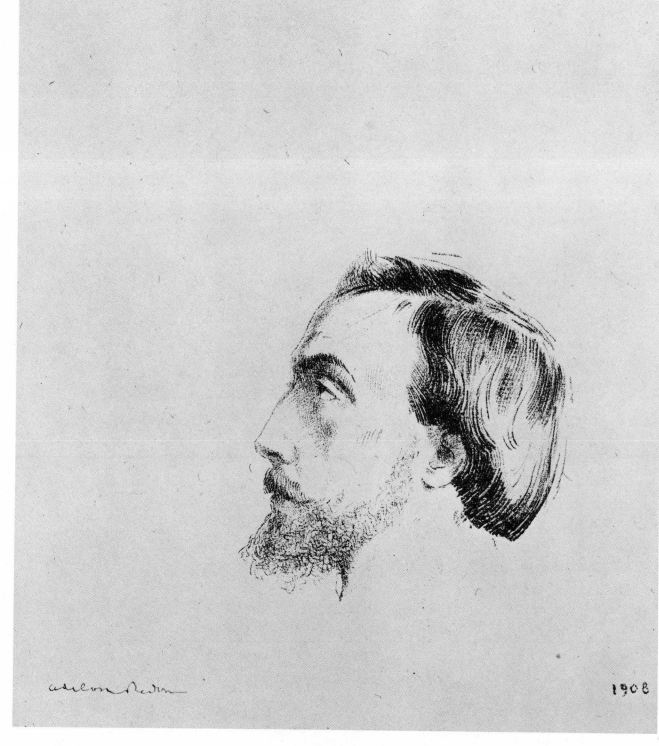

172 Miguel Llobet

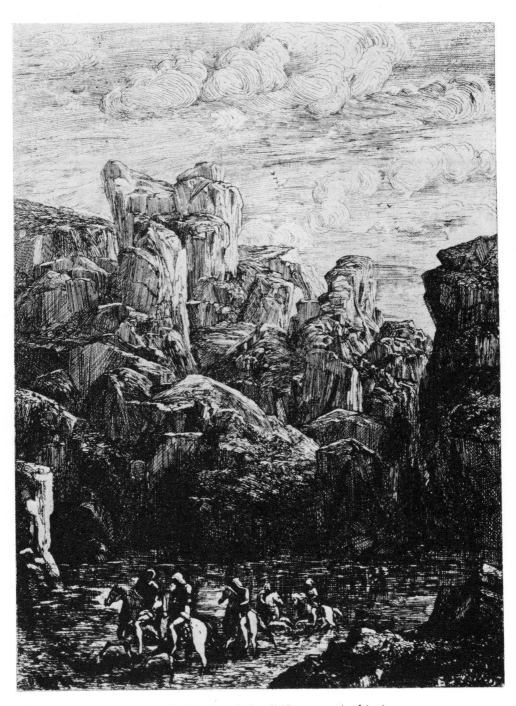

173 The Ford, with Small Horsemen (etching)

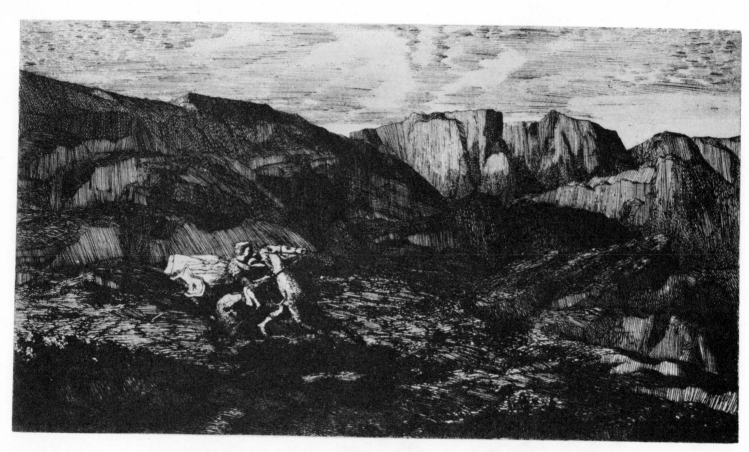

174 Fear (etching)

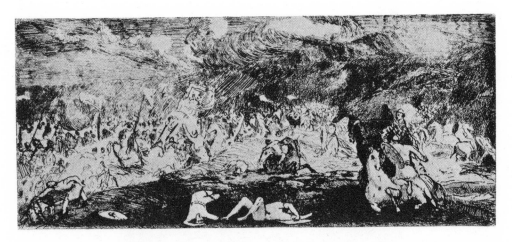

175 Battle (etching)

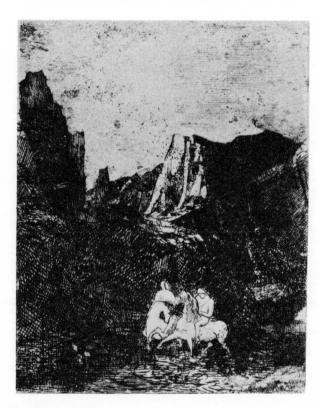

176 The Two Small Horsemen OR Combat of Horsemen (etching)

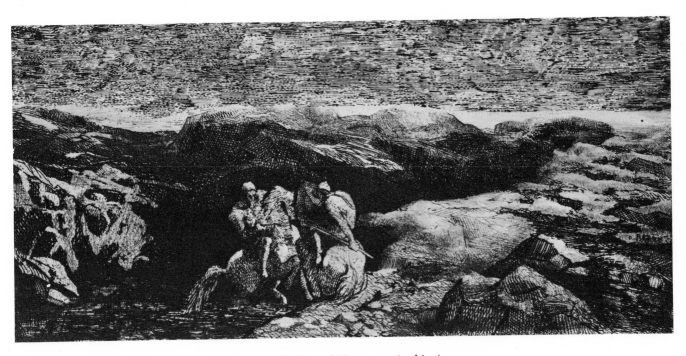

177 Combat of Horsemen (etching)

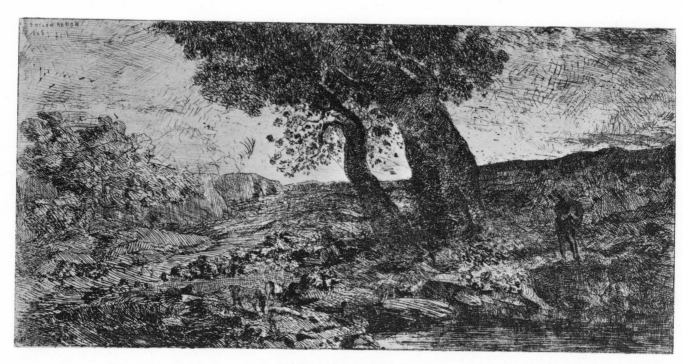

178 Two Trees (etching)

179 Chapel in the Pyrenees (etching)

180 Horseman Waiting (etching)

181 Horseman in the Mountains (etching)

182 Horseman under a Stormy Sky (etching)

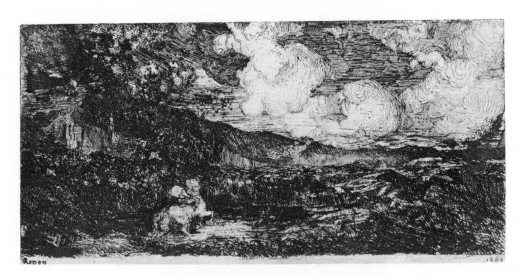

183 Horseman Galloping (etching)

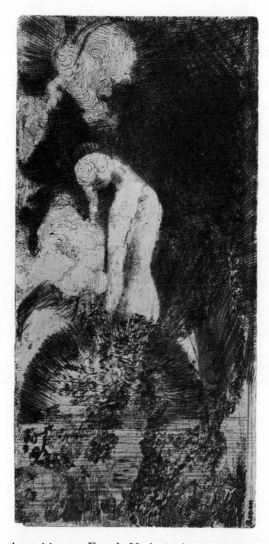

184 Apparition OR Female Nude (etching and drypoint)

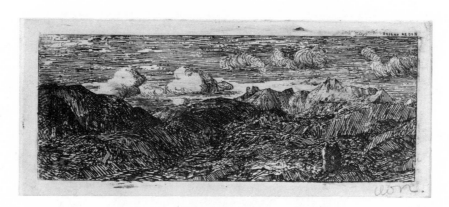

185 Mountainous Landscape (etching)

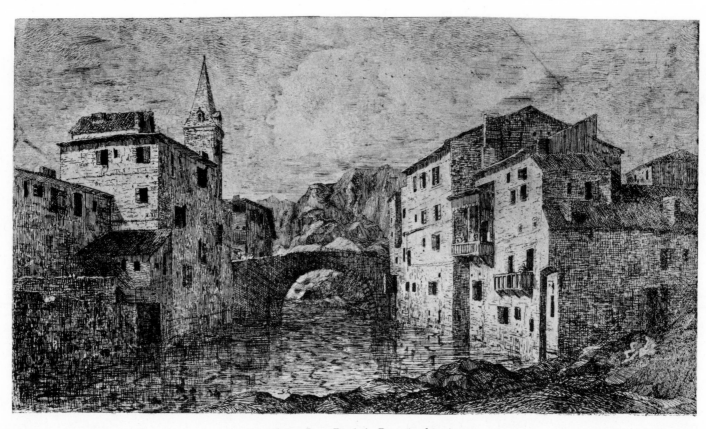

186 Saint-Jean-Pied-de-Port (etching)

187 Sketch of Heads and Leaves (etching)

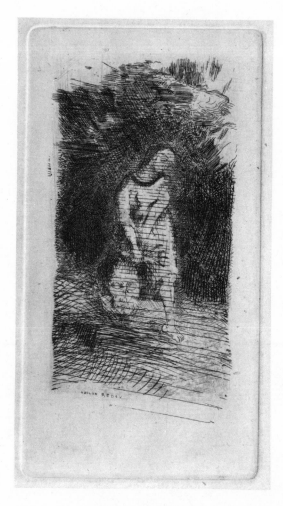

188 David (etching)

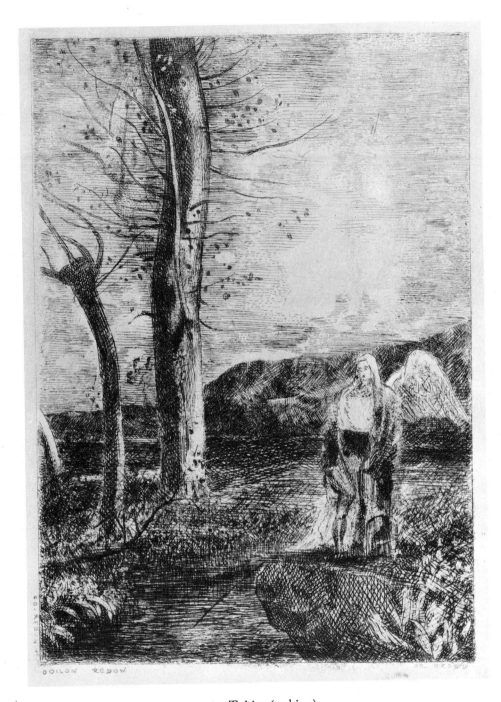

189 Tobias (etching)

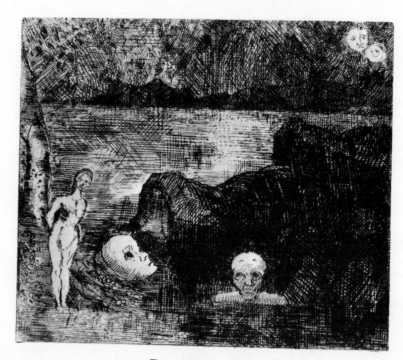

190 Dream Vision (etching)

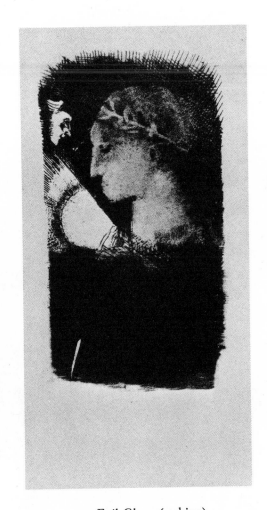

191 Evil Glory (etching)

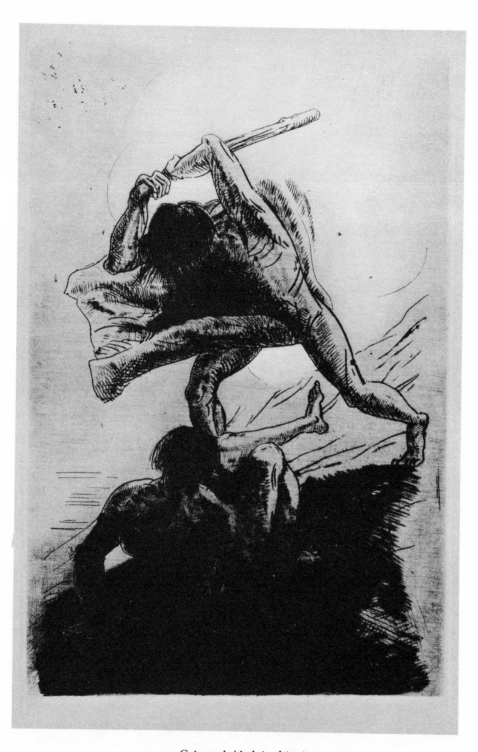

192 Cain and Abel (etching)

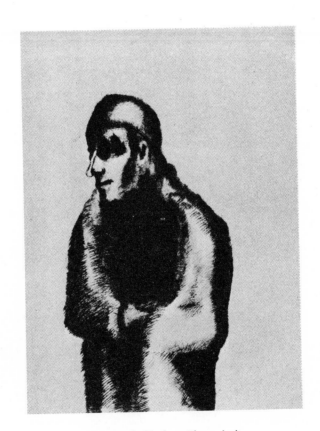

193 Little Prelate (drypoint)

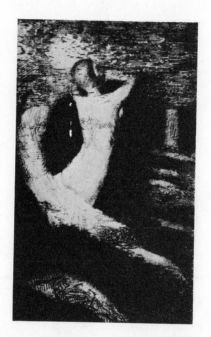

194 Passage of a Soul (etching); frontispiece for *La Passante*

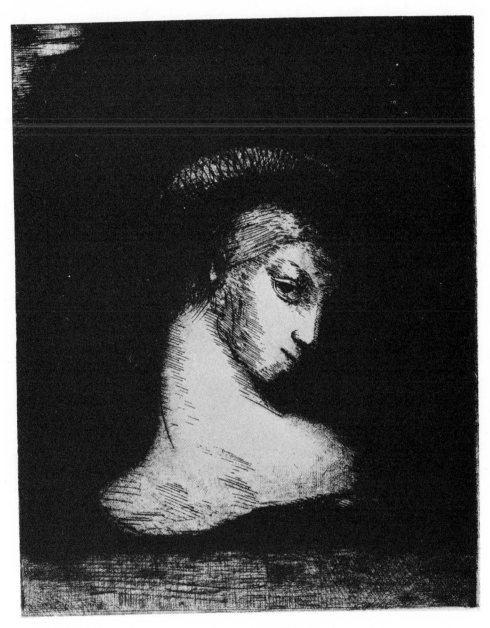

195 Perversity (etching)

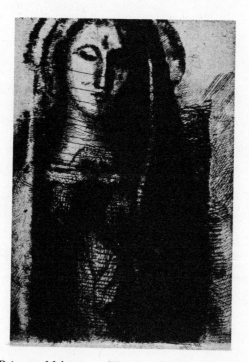

196 Princess Maleine OR The Small Madonna (etching)

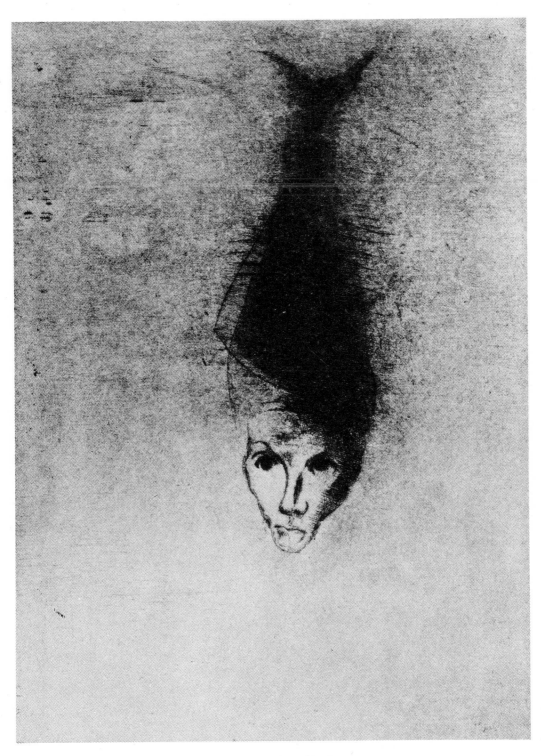

197 Skiapod (etching)

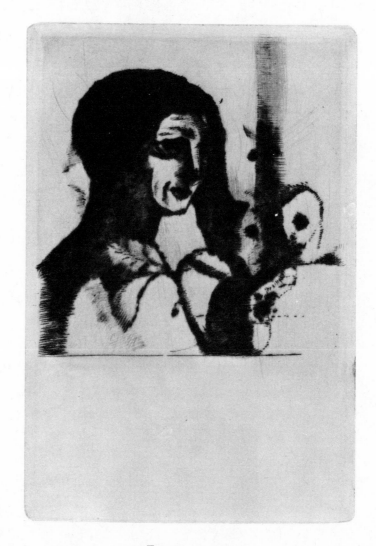

198 Enigma (drypoint)

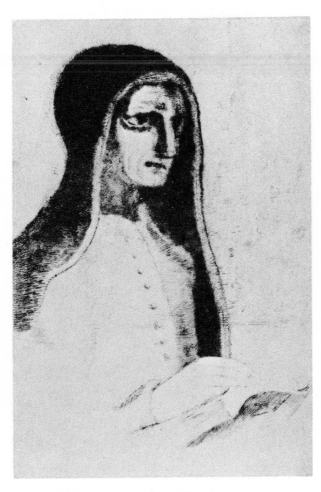

199 The Book OR Saint Theresa (drypoint)

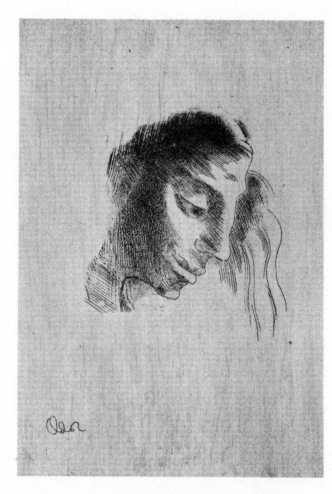

200 Ex-Libris (etching)

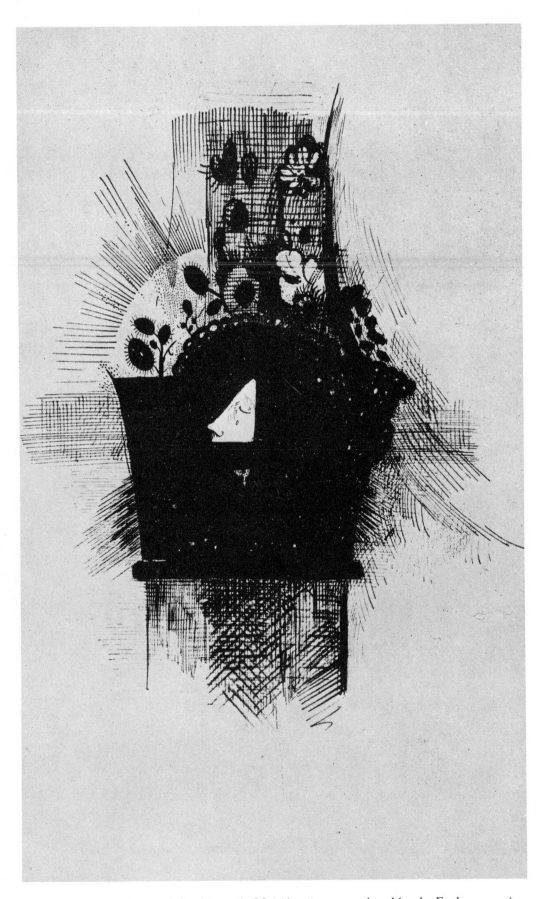

201 Cover (= No. 1) of *Les Fleurs du Mal* (drawings reproduced by the Evely process)

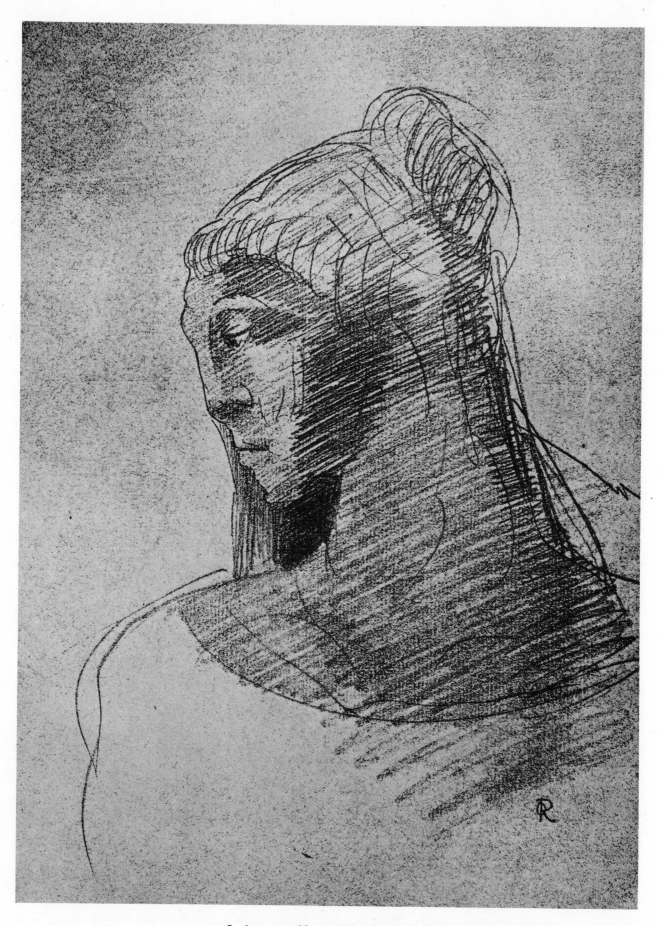

202 I adore you (No. 2 of *Les Fleurs de Mal*)

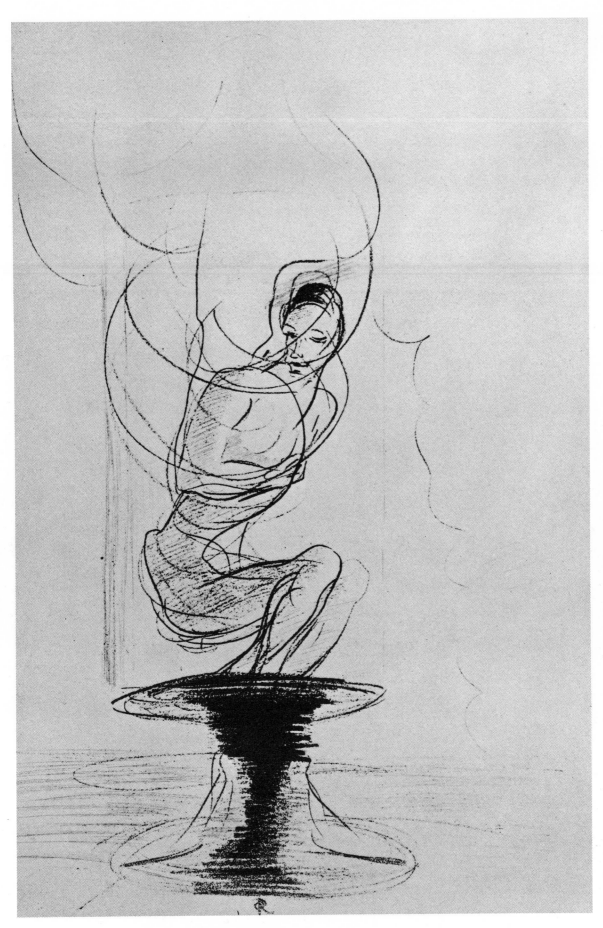

203 Sometimes one finds an old reminiscing flask (No. 3 of *Les Fleurs du Mal*)

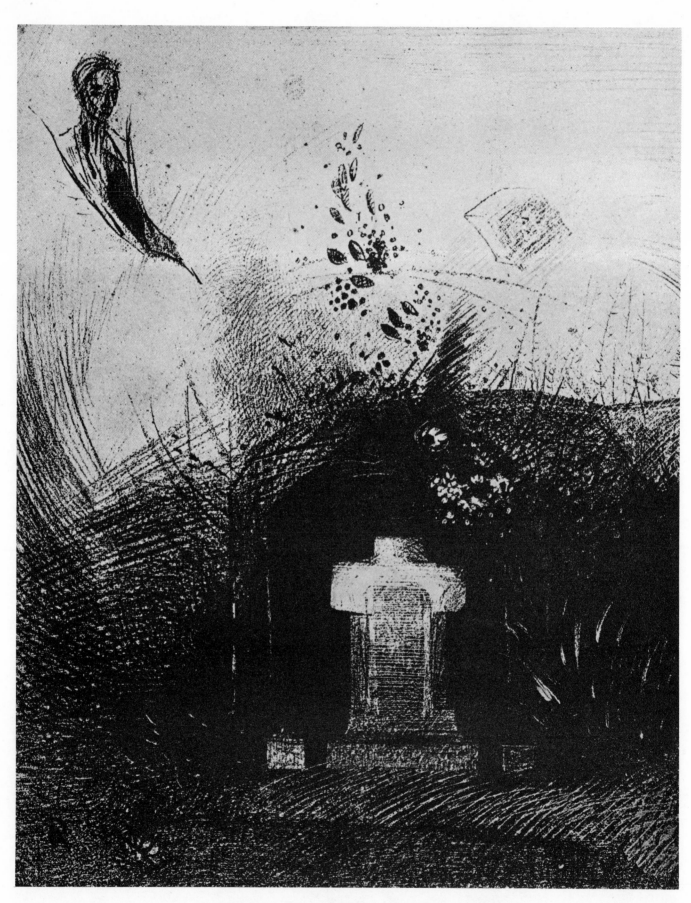

204 If on a close dark night (No. 4 of *Les Fleurs du Mal*)

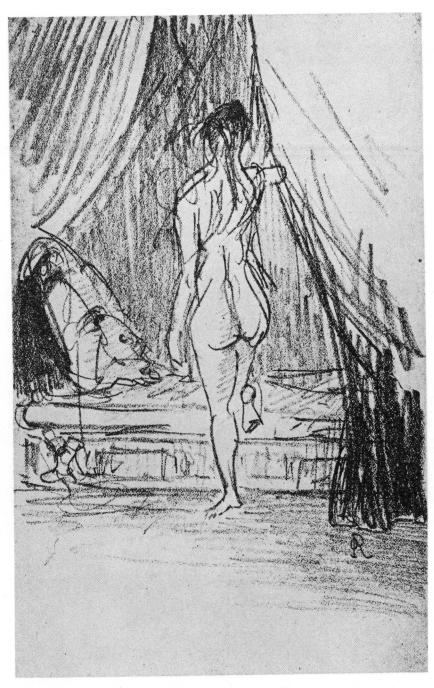

205 Pleasure, elastic phantom! (No. 5 of *Les Fleurs du Mal*)

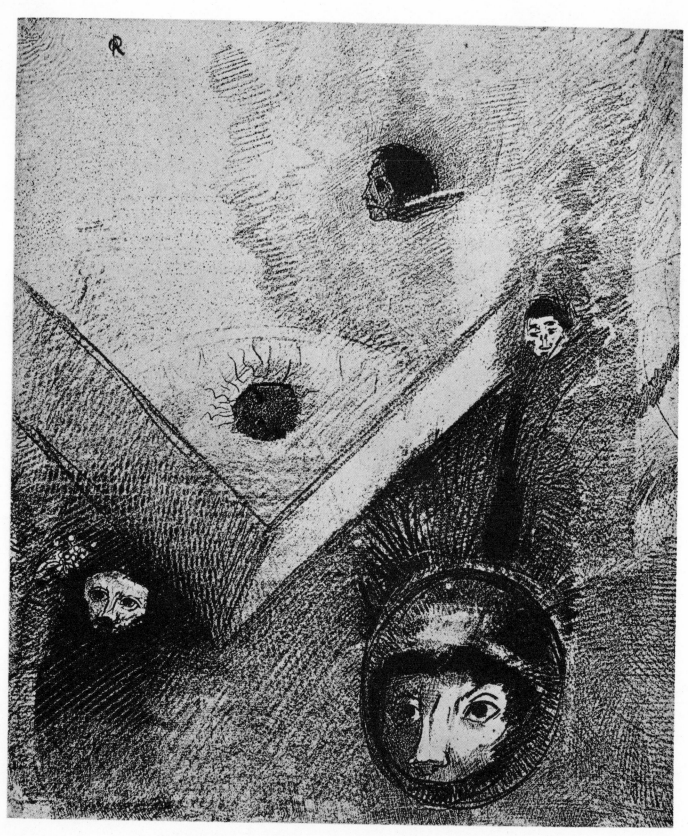

206 On the backdrop of our nights (No. 6 of *Les Fleurs du Mal*)

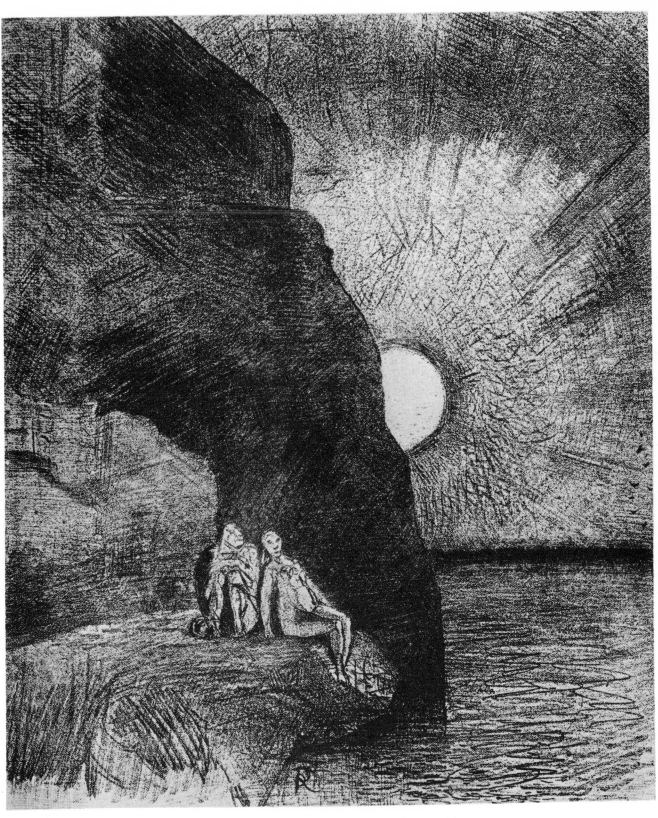

207 Ceaselessly by my side the demon stirs (No. 7 of *Les Fleurs du Mal*)

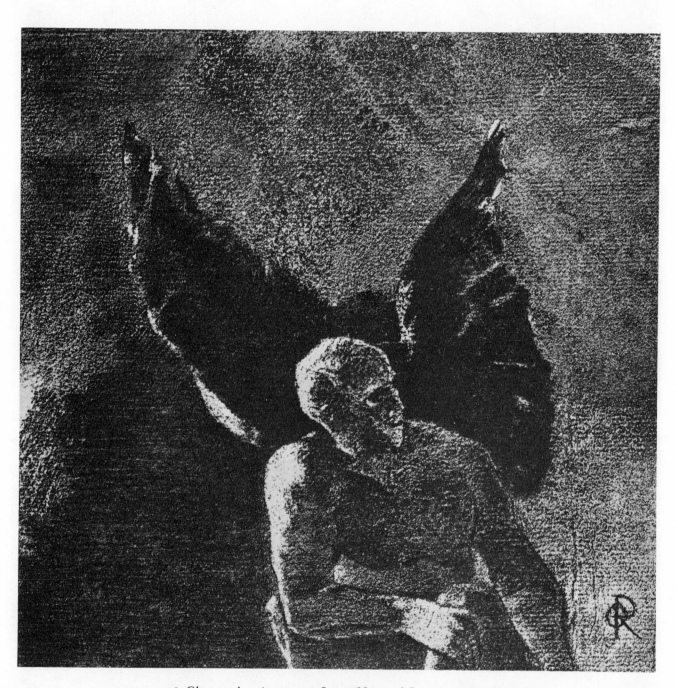

208 Glory and praise to you, Satan (No. 8 of *Les Fleurs du Mal*)

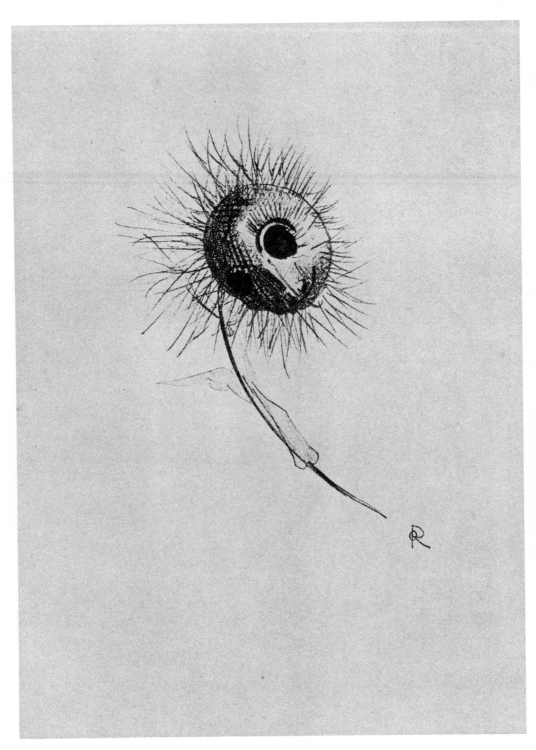

209 Tailpiece (No. 9 of *Les Fleurs du Mal*)